decorative FOLK ART

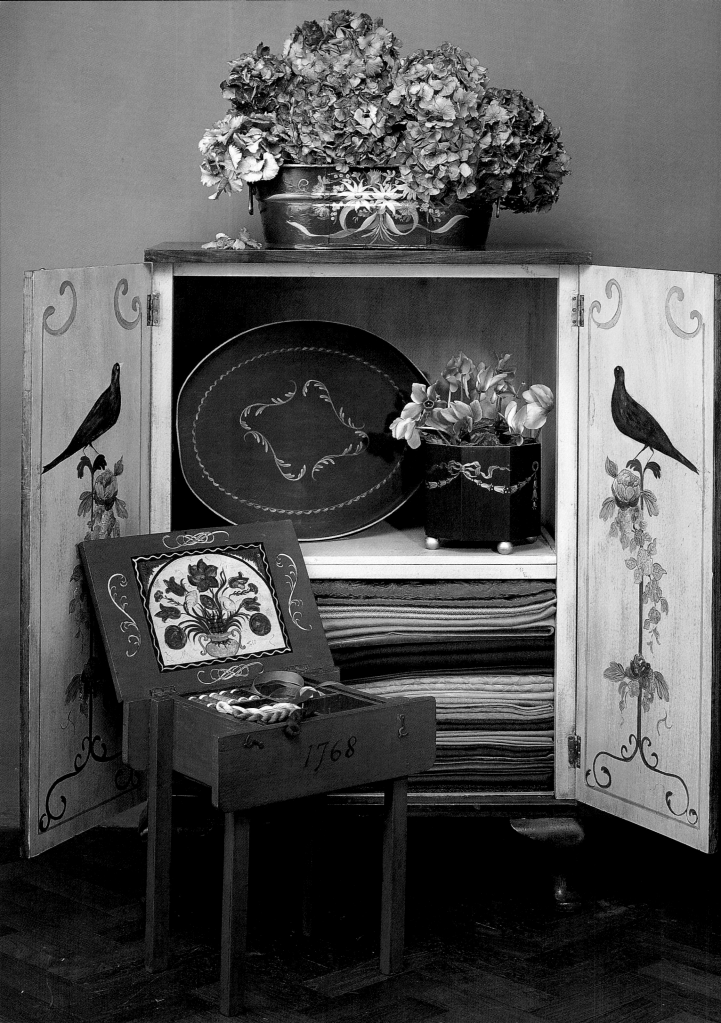

decorative FOLK ART

Exciting Techniques to Transform Everyday Objects

SYBIL EDWARDS,
CHRIS MOORE & LYNETTE BLEILER

David & Charles

To Mike for nudging

Acknowledgements

In the beginning there was Bridget Haworth. Thank you for being the spark. A very special thanks for the generous assistance of Chris Moore and Lyn Bleiler as major contributors. Thank you to the David & Charles team especially Alison Elks and Brenda Morrison for your ongoing support, time and humour. To Irene Cob of Chroma Acrylics, Australia, and Michael Kay at Tomas Seth & Co., UK, thank you for the generous supply of Jo Sonja products and all your advice. Shirley Miller at Loew Cornell, thank you for the generous supply of brushes. To the Moore family in Australia including Bruce and Simon, you were amazing. Others for whose participation I extend my thanks are Andrew Perkins, Lowell Bleiler, Jon Prudence, Jenny Sykes, Neil Murison, the Jerome family, Sue Pearson, Des Polkinghorne, Laura Barnes and Dorothy Smibert. For the loan of the Australian floral tub, thank you Glynn Howie. And, finally, thank you to all my extended family and friends including my new Aussie ones for making the project so enjoyable by your sharing and caring.

We are greatly honoured by the inclusion of a project by Jo Sonja Jansen (page 100). Thank you for your generous donation.

A DAVID & CHARLES BOOK

Book design by Diana Knapp

Photography by Paul Biddle

Copyright © Sybil Edwards 1994

First published 1994

Sybil Edwards has asserted her right to be identified as author of this work in accordance with the Copyright, Designs and Patents Act 1988.

A catalogue record for this book is available from the British Library.

ISBN 0 7153 0148 9

Typeset by GREENSHIRES ICON, Exeter
and printed in Germany by Mohndruck GmbH
for David & Charles
Brunel House Newton Abbot Devon

CONTENTS

CHAPTER	1	INTRODUCTION	6
CHAPTER	2	BASIC MATERIALS	10
CHAPTER	3	COLOUR SENSE	14
CHAPTER	4	BRUSH CONTROL	20
CHAPTER	5	BRUSH STROKE TECHNIQUES	28
CHAPTER	6	PREPARING AND BASE COATING	62
CHAPTER	7	BACKGROUND EFFECTS	66
CHAPTER	8	PATTERN TRANSFER	72
CHAPTER	9	FINISHING TOUCHES	76
CHAPTER	10	20 PROJECTS STEP-BY-STEP	78

* *Traditional Folk Art* 80
* *International Folk Art* 110
* *Period Adaptations of Folk Art* 130
* *Fruit and Floral Adaptations* 142
* *Innovative Adaptations of the Folk Art Technique* 156

LIST OF SUPPLIERS 166

BIBLIOGRAPHY 167

INDEX 168

...INTRODUCTION...

A celebration of folk art painting, in this book you will find a wide range of ideas for decorating your home, some of which you may not have thought of as part of the folk art 'family'. We will show you how easy it is to learn the folk art painting technique, and we have chosen a series of twenty attractive step-by-step projects to illustrate its application. We also show you how the techniques can be adapted to any motif you might like to use as decoration. Whether the look you wish to achieve is traditional, period or ethnic, almost anything is possible once you have learned the basic skills.

We have written this book both for people who have the urge to paint but are not quite convinced they can, and for people who know they can, but are looking for a battery of ideas to inspire them. The technique begins simply, with a few very easily learned basic strokes – no more than two or three. We build upon these with slight variations, twists, shakes and pivots, through which a wide range of painted effects are created. As you will see in chapter 5, mastering just one or two simple strokes will enable you to complete a project you can feel proud of.

New technology, in the case of both paints and brushes, is also available to make painting easier. Most of the projects here use safe, non-toxic, water-based products throughout. Such products are very forgiving of errors – if you make a mistake, you have some margin of time for correction before the paint dries – just wipe it off and start again! Should the paint have already dried, it can be wiped off using isopropyl alcohol. New brush shapes are also available: a 'miracle wedge' will allow you to make ribbons and bows with little effort, or if you wish to paint ducks' feathers, you could choose a 'filbert' brush.

WHAT IS FOLK ART?

A straightforward definition of folk art is difficult. Today's folk art painting has two main reference points. The first is the rustic styles of furniture painting practised in Europe between 1650 and the late nineteenth century, at a time when decorative arts were in vogue. The second is the unique and rather curious styles of painting produced by subcultures living within an area dominated by another culture, for example the aboriginal or native arts of Australia or North America. This is also referred to as 'ethnic' art. A third, more spurious, reference point is 'tourist' art which results from merging ethnicities. Tribal expression becomes bastardized as it is absorbed into a nation's visual imagery, the 'shorthand' and distortions in the art always being carefully gauged so as not to compromise the modern-day national image. Haida Indian paintings from Canada are one example, the bark paintings of Mexico another.

The term 'folk art' embraces all of these. It is perceived as having a spontaneous, primitive, naïve or rustic air about it which is unaffected by commercial values. Sadly this last point is often not borne out in practice. However, this book does not presume to judge the accuracy of others' definitions and introduces for the first time a

This collection of prettily painted items looks very striking, at a modest cost for the decorative artist.

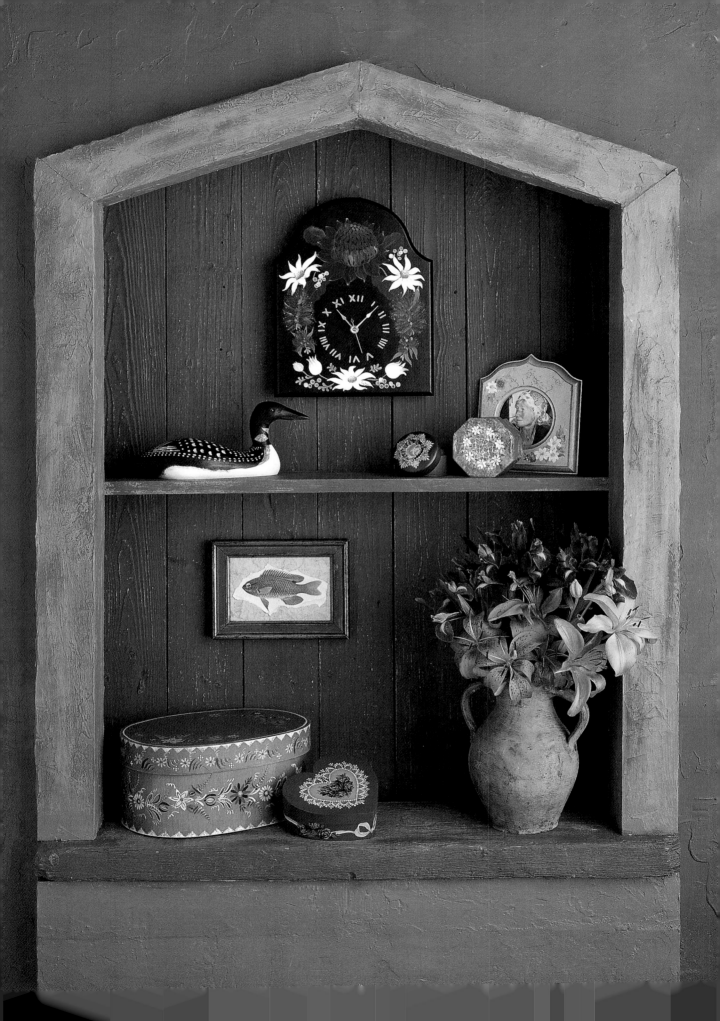

wide range of projects, some of whose folk art pretensions are less clear than others. In some cases you may feel that the label 'decorative' art would be more appropriate.

Whilst European trends naturally have a strong influence on the western mind, travel and greater exposure to foreign cultures has broadened the field of interest in both folk and ethnic art. Moreover, there is a wider appreciation of its ethnological and anthropological importance as part of the history of nations.

EUROPEAN FOLK ART 1650–1890

A number of misconceptions apply to this era, in which furniture painting dominated. First, that it was a hobby produced by the 'folks at home'. In fact it was a serious commercial pursuit, providing a livelihood in the same way that other arts such as portraiture, fresco painting, or decorative crafts did. Being classified as 'serious work', it was strictly a man's occupation in those less enlightened times.

Growth in this rustic market was prompted by social custom as well as new trends in furniture styles and domestic living arrangements. With increasing prosperity came greater acquisition, with acquisition came the need for storage, and storage demanded more space. Rooms were enlarged or added, to accommodate new household objects. Chests and armoires became important domestic items, and also provided the perfect painting surfaces. The social custom of the marriage dowry meant a flourishing trade in these items. The family 'showpiece' increasingly became a status symbol to which the cabinet makers and decorative painters responded in ever more opulent and original fashion. Patronage demanded greater skill, knowledge and fashion-consciousness. As Baroque and Rococo came to replace the stylized symbolic expression of the earlier period, the artisan who could best imitate the trends had the fullest order book.

The actual term 'folk art' began to appear towards the end of the nineteenth century. It has been attributed to the European Literati who used it to describe these first attempts by the common man to adapt decorative grandeur of churches, palaces, and grand houses for use in the home. This may seem somewhat derisory, but since the comparison was with the work of artists of the calibre of Michelangelo and the Martin brothers, such an attitude is perhaps understandable. The folk art label was therefore originally a 'class' one.

FOLK ART OF NATIVE OR ABORIGINAL PEOPLES

Nowadays people use the labels 'folk' and 'ethnic' interchangeably, but the term 'ethnic' is perhaps more descriptive in this context because it refers to a subculture rather than having a class origin. It could perhaps be said that it is this genre of art which is the quintessential folk art, because it was originally produced by the creator, if not for his own personal use, then for the use of other members of his circle. Moreover, its motifs were highly symbolic, and it did not involve any form of barter or exchange. Such works were produced for a specific purpose, either to provide important survival information, to generate good fortune or a bountiful harvest, or to avert a disaster. Faith in symbolic potency was a fundamental belief; aesthetic values were secondary.

The catalogue of symbols that have percolated down from antiquity to the present is a very familiar one. Their origins, however, are often unknown or imprecise; some may have come into existence at the hands of small groups of people living in close proximity sharing a common system of symbols and beliefs, subsequently becoming universal symbols expressing notions common to all humanity. The yin-yang device from China, the furled palm leaf from India or Persia, the sun sign, the tree of life – all point to an obscure yet rich past whose meaning and aesthetic appeal are timeless.

Even in the midst of today's technological age, we are able to witness a few native cultures 'coming of age'. Take the Aboriginals of Australia:

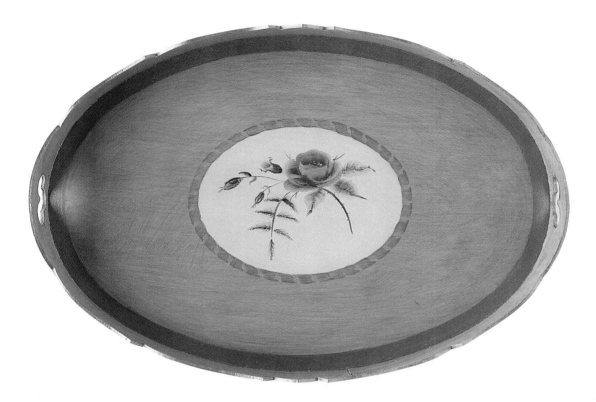

Classical tray with glazed background and cameo rose motif.

Aboriginal and modern cultures are merging, and their art incorporates elements of both the old and the new. The bold images of Australian Aboriginal Art reinstate the 'dreamings' of a past life, but the use of flamboyant acrylic colour is a break with tradition. It is to be hoped that the timeless symbols will survive the acculturation process and not be reduced to purely decorative motifs.

In European cultures, a strong symbolic language also once flourished, and much folk painted furniture incorporated symbolic themes in highly stylized motifs. Some, such as the bird, were pagan in origin, only later combining with Christian ideology. Their specific purpose was to ward off evil spirits and misfortune. The movement from paganism to Christianity and thence to a more secular age is reflected in art through the ages, and no less so in folk art.

THE FOLK ART MOVEMENT TODAY

Whilst European folk art during its heyday did encompass the embellished splendour of the high Baroque and Rococo styles, it stopped short of the neo-classical movement. The neo-classical era saw a return to more restrained forms and symbols using Grecian and other classical models. It favoured gentle colours and themes, with furniture and decor designed to complement each other. Today's folk artists are picking up the threads and reviving the old traditions.

In North America, however, the folk art tradition has never seriously faded, but has followed a trail of steady development. Folk art practitioners have learned and adapted the folk art technique to more subtle themes, especially florals; indeed, some painting styles are reminiscent of the 'finer' art traditions of the skilled craftsmen and decorators of the neo-classical era.

From folk art to fine art this book has something for everybody, novice and addict alike. Enjoy your hobby – happy painting!

BASIC

D ecorative painting need not be expensive. It can be done with minimal supplies to be found in your local craft store, art/stationery supplier, hardware store, or even in your own home. Five tubes of paint (red, yellow, blue, black, white), a brush, a jar of water, and a cheap palette will start you off nicely.

When selecting your materials, there are a number of brands to choose from. The projects in this book use Jo Sonja's Acrylic Gouache paints. Brushes were selected from the Raphael and Loew Cornell ranges.

BRUSHES

Reasonable quality brushes are your most important initial investment. You will not paint a perfect stroke with a brittle, out of shape brush.

Use what is available in your area keeping in mind that synthetic bristles are recommended for use with acrylic paint as they are chemically similar. Such brushes are quick to clean because paint and other liquids are easily released from the bristles. Synthetic hair is also less prone to breakage and more durable on most surfaces.

Synthetic brushes are also suitable for oils and alkyd paints, although sable brushes with soft, springy natural hair are more suitable for heavier oils. For best results, keep one set of brushes for acrylics and another for oils and alkyds.

When purchasing your brushes, check carefully to make sure the bristles are not damaged. Liner and round brushes should come to a point with no stray hairs and flat brushes should have a good chisel edge with all the bristles lined up in a narrow row.

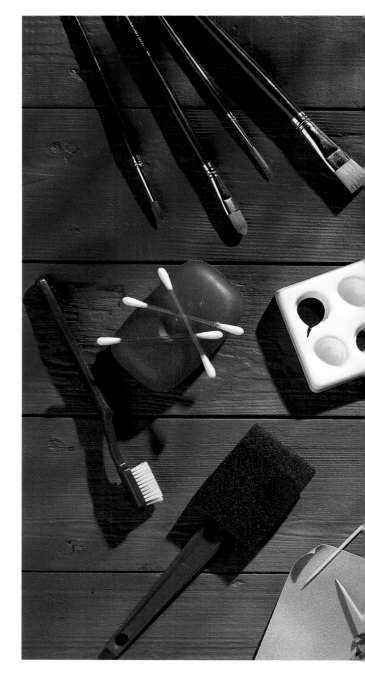

MATERIALS

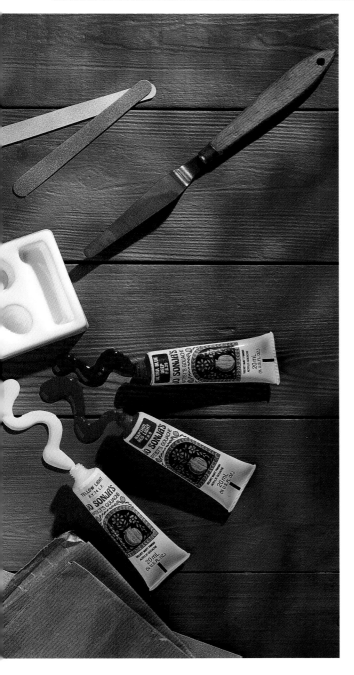

- No. 12 (½in/12mm) large flat brush for base coating
- No. 8 (⁵⁄₁₆in/8mm) flat brush or shader
- No. 4 round brush
- No. 1 liner (with hairs approximately ¾in/18mm long)

Once you are familiar with these brushes, you can add other sizes as well as speciality brushes as your budget allows, such as rake or filbert brushes.

BRUSH CARE AND CLEANING

Well cared for brushes will last for years. This care begins as soon as you remove the protective wrapper or plastic tube. (Plastic tubes should not be replaced as this may damage the bristles.)

You will notice that new brushes are stiffened with a glue sizing which must be removed before you begin to paint. First, gently bend the hairs between your fingers to ease the stiffness, then dip the brush in cool water. Stroke the bristles against a bar of mild soap, rinse with lukewarm water, and blot on a paper towel. If you plan to use oil medium with your brushes repeat this step using thinners or turpentine.

Paints, brushes and a palette on which the paints are mixed comprise the basic equipment. Avoid using a kitchen plate as a palette unless kept exclusively for this purpose. Shorter mixing palette knives are best for paint mixing, but a longer version will suffice if it is ready to hand.

When loading the brush, take care that the paint does not work its way up into the ferrule as it is difficult to remove from this area. Never allow paint to dry on a brush (acrylics are relatively fast drying), and do not leave brushes to stand in water or solvents for an extended time or they will lose their shape.

After using acrylic paints, clean your brushes thoroughly. Wipe the brush across a paper towel or cloth to remove excess paint, then, using cool water, stroke the bristles over a bar of mild soap or liquid soap (anything stronger could damage the bristles), rinsing several times. Repeat until no colour remains. Very cold or hot water should not be used, as extreme temperatures can cause the paint to harden before it is removed from the brush. As an alternative to soap, many brush manufacturers sell special brush-cleaning liquids.

Once cleaned, return the bristles to their original shape using your fingers and some soap. Remember to rinse out the soap before starting your next painting session. Store brushes upright (bristles up) in glass jars or similar or lay them flat in commercially available brush holders. An old tennis ball tube provides a good storage container.

After using oil or alkyd paint, clean brushes thoroughly using thinner (white spirit). Any remaining residue may be removed using soap and water as described above. When the brush is perfectly clean, again shape the bristles before storing.

When handling oil paints, thinners, etc., avoid unnecessary contact such as shaping the bristles in your mouth or cleaning the brush in the palm of your bare hand.

Keep old brushes with stray bristles as they may be useful for one of the many unusual techniques you will encounter.

PAINTS

Whether you choose acrylic or oil paints, and whether they are dispensed from a tube or a jar is really down to personal preference or availability. Oil paints, including alkyds, are oil-based whereas acrylics are water-based.

For beginners, acrylics are highly recommended for a number of reasons. They are water- rather than oil-based, thus cleaner to work with and to clear up. They are fast drying, enabling quick results, and, although water-based, acrylics are both tough and durable. Finally, they are safe, non-toxic formulations.

All the major brands of acrylic paints are good. Brands such as Jo Sonja's, Liquitex, Delta Ceramcoat, Decoart and Folk Art are acrylic gouaches, specially developed for the decorative art market; other manufacturers such as Winsor & Newton and Rowney's sell under the general label 'acrylic' only. Decorative paint brands have the benefit of greater opacity. Most manufacturers have also ventured into the area of special effects: metallic and iridescent paints, for example, are now available in most brands.

Since decorative painting is a technique which entails working on various surfaces, an integrated range of ancillary products such as sealers, varnishes and other mediums has also been developed. Most of the above-named companies specializing in decorative products supply an all-purpose sealer for wood, metal and glass, as well as varnish (see chapter 6). Mediums for antiquing, glazing, crackle finishes, and wood graining are also available (see chapter 9).

Whichever brand you choose, follow the manufacturer's directions until you feel comfortable with the product. Improvisation comes later! Not surprisingly, manufacturers often advise against using one of their products in conjunction with somebody else's. You can in fact mix brands, but you cannot in general mix water-based and oil-based paints. Oil-based decoration will adhere to a water-based background, but then the final varnishing coat must be oil-based. Until you are thoroughly familiar with the various paint properties, it is best to stick to one system.

COLOUR CONVERSION CHART

Manufacturers do not all use the same name or colour descriptors for their paints. A colour conversion chart with some of the major brands is given on page 19.

PALETTE

In theory, almost anything may be used as a palette providing it is flat and light in colour, but do not be tempted to grab a kitchen plate since invisible residues of paint are not good for the digestive tract! Disposable strip paper palettes are a good choice for both the mixing of colours and brush blending. Palette paper with a wax-coated finish is suitable for acrylics whereas parchment is best for oils and alkyds.

A commercial innovation which can be easily replicated consists of an air-tight plastic container, a thin sponge sheet which is saturated with water, and a treated piece of paper which is soaked overnight. The container is turned upside down so that the lid becomes the base on which the sponge sheet and treated paper sit. When dispensed onto this sheeting acrylic paint will remain workable for some time provided the lid is replaced after each painting session.

Kitchen towels or coffee filters can be substituted for the treated paper. When it appears to be drying out, fresh water should be added to the sponge from where it is absorbed into the paper. (A word of caution: don't be tempted to wet the paper from above with a sprayer as this encourages the colours to run together.)

PALETTE KNIFE

Although tiny amounts of paint can be mixed with your brush, it is less wasteful to use a palette knife both for mixing paint and for extracting paint from jars. Knives are available in plastic or metal. Remember to clean the palette knife after each use to prevent it becoming clogged with dried paint.

MISCELLANEOUS SUPPLIES

- **Water basins** You may wish to graduate from a glass jar to a commercial water receptacle specially designed to help work the colour out of your brush.
- **Stylus** A special implement used for adding dots to your work. Toothpicks, knitting needles, or the end of a paint brush are just as good.
- **Sponge brushes** These are available in various widths and are useful for applying sealers, base coats and varnishes. They also have the advantage of leaving no brush marks.
- **Toothbrush** An old toothbrush is the ideal implement with which to apply fly-specking (see page 76).
- **Sandpaper** Several grades from medium to very fine are recommended. There is less waste if you cut a large sheet into quarters.
- **Strong brown paper grocery bags or parcel wrapping paper** Unprinted brown paper acts like fine-grained sandpaper.
- **Emery boards** These are very useful for sanding small awkward areas.
- **Cotton swabs/Q Tips** Dipped in paint, these make raspberries or wattle flowers. They are also useful dampened with water to erase mistakes.
- **Tracing paper** or 'onion skin' is used to transfer designs.
- **Chalk pencils/pastel pencils** These are very useful for transferring designs. The method is explained on page 72.

As you progress with this hobby, you will no doubt discover even more materials and methods to use. There are no hard and fast rules.

COLOUR

BASIC STARTER PIGMENTS

Napthol Red (R), Cobalt blue (B), Yellow Light (Y), Black (BL), White (W).

These five pigments are recommended as the basic palette to begin decorative painting. The first three colours alone will reproduce the Colour Star opposite and indeed are the basis of all colour. The addition of black and white will enable you to vary the lightness and darkness of the colours. A range of traditional, classical and rose formulations can be mixed using just these five pigments.

THE COLOUR STAR

PRIMARY COLOURS: RED, BLUE, YELLOW
The basic hues from which all colour stems (triangles outlined in black).

SECONDARY COLOURS: Orange (O), Green (G), Violet (V)
Mixed from two primary colours equally (triangles outlined in grey).

Traditional Colours

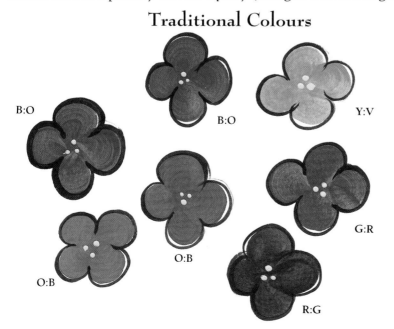

B:O

B:O

Y:V

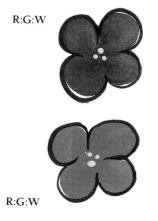

R:G:W

G:R

O:B

O:B

R:G

R:G:W

SENSE

TERTIARY COLOURS: Olive, Slate, Russet
Mixed from two secondary colours equally. Also called 'earth' colours (central circles).

INTERMEDIATE COLOURS
'In-between' colours made by mixing adjoining primary and secondary colours (diamonds outlined in black and grey).

COMPLEMENTARY COLOURS
Colours opposite each other on the colour star: red–green, blue–orange, yellow–violet.

The flower groupings illustrate the rich colours resulting from mixing complementary colours. In each case only a tiny amount of the complementary colour has been added. Beside each flower is the colour recipe. The first initial indicates the main colour; the second, the tiny amount of complementary colour. In the Classical grouping, white is the main component of each recipe, creating a pastel effect.

Classical Colours

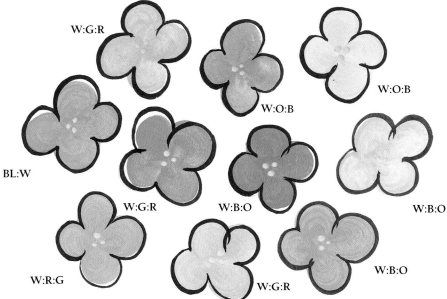

W:G:R

W:O:B

W:O:B

R:G:W

BL:W

W:G:R

W:B:O

W:B:O

Rose Colours

W:R:G

W:G:R

W:B:O

COLOUR CHARACTERISTICS

The Colour Star provides a guide to basic colour mixing. Now we examine three less obvious characteristics of colour that can be used to bring mood and subtlety to your work: **Temperature** (warmth/coolness), **Intensity** (brightness/dullness), and **Value** (lightness/darkness).

TEMPERATURE (MOOD AND SYMBOLISM)

If you cast your eye round the Temperature Star below, two contrasting sensations become apparent: heat and cold with various shades of warmth and coolness between. Each temperature zone also conveys a mood. Red is passionate and fiery, whereas blue is cool and pensive, and so on. These traits of temperature and mood have traditionally given certain colours various symbolic associations which have been repeatedly utilized in decorative and folk painting worldwide.

The colours which have been placed on the Star are the primaries, secondaries and intermediates.

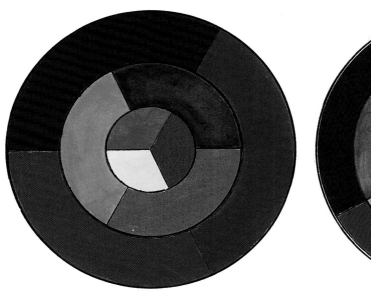

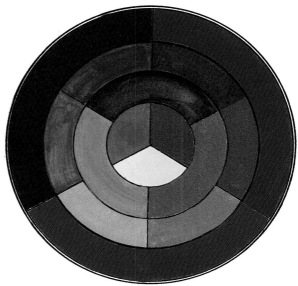

INTENSITY

A second characteristic of colour is its intensity. If you look at the left-hand Colour Wheel, you will see that as you move out from the centre the colour quality, vibrancy, or intensity of the central primaries becomes increasingly subdued or dulled. In this example we go from primary to secondary to tertiary stage.

The intermediate stage between secondary and tertiary shown on the Colour Star on pages 14–15 has been inserted on the right-hand wheel to show an even subtler gradation. Indeed, we could add a quaternary stage with a further intermediate stage between tertiary and quaternary. Eventually the stage is reached where all colour blends into grey uniformity, but in theory the number of possible gradations is infinite.

Changes in intensity

With a limited starter palette as recommended on page 14, it is very easy to subdue the intensity of primary colours, either by using a tiny amount of the complementary colour – the one which is diametrically opposite to the primary (e.g. Napthol Red + Green = Burgundy; Yellow Light + Violet = Mustard Yellow), or by using a touch of black – but use it sparingly to avoid deadening the primary (e.g. Napthol Red + Black = Burgundy; Yellow Light + Black = Spring Green).

You can also use a touch of an earth colour (see page 15). These require quite a lot of mixing, so if you are thinking of increasing your palette, ready-to-use earth colours such as Raw Sienna, Burnt Umber and Payne's Grey will come in very useful.

Grey Value Scale

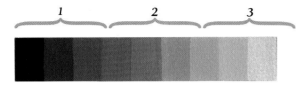

*Grey contains varying proportions of black and white. Adding grey to any pure colour results in a 'tone'. Grey itself also ranges in value from **dark** (1) to **medium** (2) to **light** (3).*

VALUE

A third characteristic of colour is its 'value', i.e. how light or dark it is. This is another way of defining how much black or white the colour has in it. 'Pure' colour consists of a primary colour or a combination of primary colours. Adding black or white pigments tones, shades, or tints the pure colour: adding grey (a mixture of black and white) produces a tone, adding black makes a shade and adding white gives a tint.

Value is described by the words, 'light', 'medium', and 'dark'. A colour with amounts of white added will have a light value; a colour with amounts of grey, a medium value; a colour with amounts of black, a dark value. The amounts of black, white and grey can vary. The grey value scale shows the variation. The scale shows only seven gradations between white and black, but it could have many more.

Red Value Scale

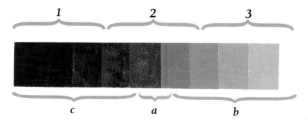

*(a) **Red** – pure elemental colour*
*(b) **Tints of Red** – adding progressively more white*
*(c) **Shades of Red** – adding progressively more black*
*Pure red has a medium value that can be shaded or tinted to **dark** (1) **medium** (2) or **light** (3) values.*

Of course, pure colour has its own intrinsic value too. Yellow, for example, has a light value compared with blue which is relatively dark. Red is in between, so has medium value. When black or white is added, these colours also segment into subdivisions of light, medium, and dark values as shown on the red value scale. (This is a useful scale for mixing colour for roses.)

Now that the principles of temperature, intensity and value have been explained, this diagrammatic guide will help you to make better use of colour:

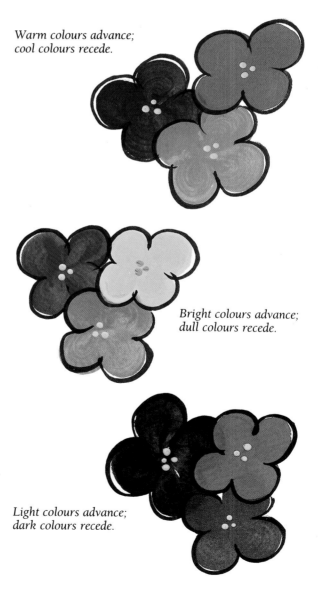

Warm colours advance; cool colours recede.

Bright colours advance; dull colours recede.

Light colours advance; dark colours recede.

THE COMPLETE ACRYLIC COLOUR CONVERSION CHART

JO SONJA's CHROMA ACRYLICS	LIQUITEX	DECOART AMERICANO	DELTA CERAMCOAT	CHROMA PAINTS
Amethyst	Medium Magenta + Brilliant Purple (1:1)	Orchid	Lilac Dust	128 Maroon
Aqua	Turquoise	Desert Turquoise	Laguna	144 Sea Green
Brilliant Green	Christmas Green	Holly Green	Jubilee Green	153 Perm Green Light
Brown Earth	Burnt Umber	Dark Chocolate	Brown Iron Oxide	167 Burnt Sienna
Burgundy	Deep Brilliant Red	Cranberry Wine	Sweetheart Blush	123 Deep Brilliant Red
Burnt Sienna	Burnt Sienna	Burnt Sienna	Burnt Sienna	167 Burnt Sienna
Burnt Umber	Burnt Umber	Burnt Umber	Walnut	161 Burnt Umber
Cad Scarlet	Scarlet Red + Napthol Red Light (5:1)	Cadmium Red	Blaze	115 Scarlet
Yellow Light	Yellow Light Hansa	Lemon Yellow	Bright Yellow	102 Lemon Yellow
Cad Yellow Mid	Brilliant Yellow	Cadmium Yellow	Yellow	105 Cadmium Yellow Medium
Carbon Black	Mars Black	Ebony	Black	176 Chroma Black
Cobalt Blue	Brilliant Blue Purple	True Blue	Pthalo Blue	137 Cobalt Blue
Colony Blue	Brilliant Blue + Burnt Umber (2:1)	Desert Turquoise	Avalon	142 Turquoise Blue
Dioxazine Purple	Dioxazine Purple	Dioxazine Purple	Purple	132 Dioxazine Purple
Fawn	Parchment	Mink Tan	Bambi	161 Burnt Umber
French Blue	Payne's Grey + Manganese Blue Hue + Ultramarine (2:2:1)	Navy Blue + Crim Tide	Nightfall	140 Manganese Blue
Gold Oxide	Raw Sienna + Scarlet + Unbleached Titanium (3:1:1)	Terracotta	Mexicana	165 Venetian Red
Green Oxide	Chromium Oxide Green	Mistletoe	Chrome Green Light	150 Chromium Green Oxide
Indian Red Oxide	Burgundy + Burnt Umber (1:1)	Rookwood	Candy Bar	166 Red Iron Oxide
Jade	Bright Aqua Green + Chromium Green Oxide (3:1)	Jade + Wedgewood Blue	Leprechaun	158 Olive Green Light
Moss Green	Green Gold	Olive GR + Sable Brown	Olive Yellow	177 Unbleached Titanium
Napthol Crimson	Napthol Crimson	Napthol Red	Tompte Red	120 Napthol Crimson
Napthol Red Light	Scarlet + Napthol Red Light (4:1)	Berry Red	Napthol Crimson	116 Cadmium Red Medium
Nimbus Grey	Unbleached Titanium + Manganese Blue Hue (1:1)	Slate Grey + Mink Tan	Lichen Grey	171 Warm Grey
Norwegian Orange	Red Oxide + Scarlet (1:1)	Burnt Orange + Calico	GA Clay + NAP RD LT	119 Chroma Red Deep
Opal		Flesh + Cashmere Beige	Dresden Flesh	168 Portrait
Pale Gold		Glorious Gold/M	Gold/M	
Payne's Grey	Payne's Grey	Uniform Blue	Midnight	173 Payne's Grey
Pine Green	Yellow Light Hansa + Manganese Blue Hue (5:1)	Avocado	Dark Jungle	147 Hooker's Green
Plum Pink	Viridian + Manganese Blue Hue (2:1)	Raspberry	Dusty Mauve	127 Magenta Deep
Provincial Beige		Sable Brown	Territorial Beige	162 Vandyke Brown
Prussian Blue	Ultramarine Blue + Burnt Umber (2:1)	Navy Blue	Prussian Blue	134 Prussian Blue
Pthalo Blue	Pthalo Cyanine Blue	True Blue	Manganese Blue	135 Pthalo Blue
Pthalo Green	Pthalo Cyanine Green	Viridian Green	Pthalo Green	145 Pthalo Green
Raw Sienna	Brilliant Yellow + Burnt Sienna (4:1)	T Cotta + Dark Choc	Raw Sienna	160 Raw Sienna
Raw Umber	Raw Umber	Dark Chocolate	Dark Chocolate	164 Raw Umber
Red Earth	Red Oxide	Brandywine	Red Iron Oxide	166 Red Iron Oxide
Rich Gold		Venetian Gold/M	Gold/M	
Rose Pink		Cad HD + Gooseberry	Crimson + Fiesta Pink	118 Chroma Red
Sapphire		Victorian Blue	Liberty Blue	134 Prussian Blue
Silver	Silver Met	Shimmering Silver/M	Silver/M	
Smoked Pearl		Antique White	Sandstone	178 Parchment
Storm Blue		Navy Blue + Black	Dark Night + Avalon	133 Indigo
Teal Green		Viridian Green	Black GR + Pthalo GR	146 Viridian
Titanium White	Titanium White	Snow White	White	179 Titanium White
Trans Magenta	Raspberry	Sizz Pink + Vic Blue	USA PK + SWHT Blush	124 Rose
Turner's Yellow	Turner's Yellow	Antique Gold + Cad Yellow	Empire Gold	109 Gamboge New
Ultra Blue Deep	Ultramarine Blue	Ultra Blue Deep	Ultra Blue	136 Ultramarine
Ultramarine	Brilliant Blue Purple	True Blue	Ultra Blue	136 Ultramarine
Vermilion	Scarlet + Brilliant Yellow (3:1)	Cad Orange + Tangerine	Tangerine	117 Vermilion
Warm White	Soft White	Buttermilk	Antique White	178 Parchment
Yellow Light	Brilliant Yellow	Lemon Yellow	Bright Yellow	103 Cadmium Yellow Light
Yellow Oxide	Yellow Oxide	Antique Gold	Antique Gold	159 Yellow Ochre

........ BRUSH

1

2

3

4

T he way you eventually decide to hold the brush is a matter of personal choice. Above all you must feel comfortable as you make the strokes; the following suggestions may help.

Holding the brush reasonably upright between the forefingers will provide optimum control. Avoid the pencil position in the crutch of your hand; movement here feels awkward.

Achieving balance as you make the strokes is important. The little finger fully extended enables gentle leverage whilst releasing and applying pressure, but some people find it gets in the way and prefer to tuck it under. Leverage is still possible by using an extension action across the top of the forefingers and knuckles. In this position the lower joint of the little finger also acts as a pivot.

The brush hairs are always pulled behind the handle. The handle is pulled by the arm from the shoulder in a free-flowing movement. As you progress into the stroke, the action accelerates slightly, but then should slow up as pressure is released, allowing the brush hairs to realign themselves. Slowing up ensures control as you complete the stroke.

PAINT CONSISTENCY AND LOADING (Figs 1–4)

As you practise holding the brush, it helps to have it fully loaded with paint. Only by seeing the results of how you hold the brush and how you move can you judge the method that works best for you. However, the brush must be **fully** loaded. This means getting the paint to the right consistency to be drawn up into the hairs.

Correct paint consistency will vary depending on the sort of stroke you want to make and the brush you want to make it with. The main concern is to load enough paint into the brush to

1 The brush is held in a reasonably upright position.

2 The handle pulls the hairs behind it.

3 Thicker paint consistency for a short stroke: thinner or cream-like for longer strokes or scrolls.

4 Examples of improper, inadequate loading.

........ CONTROL

complete your chosen stroke. The longer the stroke, the thinner the paint, so you will need to add varying amounts of thinner such as water, white spirit or flow medium. This is done by dipping the brush into thinner before applying it to the paint. Several dips may be needed before the right mix is achieved.

LOADING AND BLENDING

FULL LOADING (Fig 5)

Fully loading the brush will create a stroke of solid consistency from beginning to end. First dampen the brush slightly by dipping it in water and blotting the excess with paper towel. This encourages the paint to be drawn up into the hairs as loading ensues. Load the brush with a pressing, stroking motion at the edge of the paint puddle. Repeat this motion until the paint disperses evenly into the brush nearly up to the metal sleeve or ferrule. No blobs of paint should be visible.

SIDELOADING AND FLOATING (Figs 6, 7)

The effect of sideloading and floating is to create a graduated tonal range of strong to weak colour across the stroke. A flat brush is far better suited to this effect than a round one. The brush can be slightly damp or relatively wet. The wetter the brush, the more subtle the effect, hence the term 'floated' colour.

For normal sideloading, begin with a slightly dampened brush, stroking one side into the paint puddle. Now press and stroke the brush several times onto the palette going back and forth across a strip of approximately one inch. Walk the brush slightly to right and left but not more than half the width of the brush in either

5 *To load fully, stroke the brush through the edge of the paint puddle.*

6 *To sideload, load the paint onto one corner or side of the brush.*

7 *Blend the paint into the hairs by walking sideways.*

8 *Double loading two colours.*

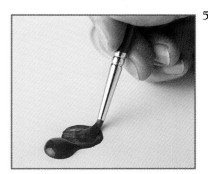

5

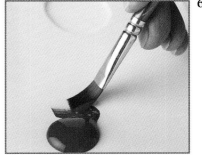

6

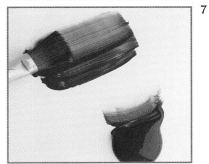

7

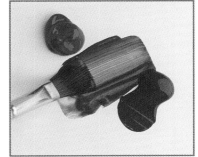

8

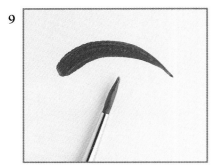

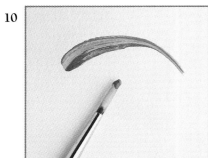

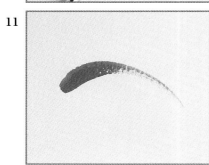

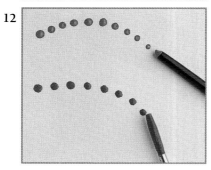

9 The fully loaded brush is tipped with another colour.

10 The fully loaded brush is tipped first with one colour, then another.

11 The brush is underloaded or some of the excess paint is removed.

12 To make a few dots, use the wooden end of the brush; to make many, fully load the brush.

direction. Blending will gradually be accomplished, but you may need to pick up more paint and repeat the action just described. Once the brush is fully loaded, replenishment with paint or thinnner is easily accomplished. After you have mastered this technique you will enjoy the results – the trick is to take care with the initial loading.

DOUBLE LOADING (Fig 8)

This type of loading creates the graduated effects of two colours which merge in the centre of the stroke. This technique also uses a flat brush and follows a similar procedure to sideloading, picking up another colour or value on the other half of the brush.

TIPPING (Figs 9, 10)

Tipping creates a textured effect to the stroke. Once the brush, flat or round, is fully loaded, simply dip the tip of the hairs into another colour or tone of paint. Remove any excess paint if necessary by lightly touching the palette once or twice, then produce your stroke. You can be as creative as you like, tipping a brush with more than one colour (multi-tipping).

DRY-BRUSHING (Fig 11)

Sometimes you may not want a stroke with a solid consistency from beginning to end. You may prefer a more wispy look where the paint peters out near the end of the stroke. Alternatively, you may want to create a fuzzy or worn look. Dry-brushing creates these effects. For the wispy effect, underload the brush (or load normally and blot away the excess) and then make your stroke. The fuzzy or worn look is best created with a worn brush. Pick up a little paint, then scrub the brush in a circular motion on the palette. This distributes the paint up into the hairs and deposits some of the excess. Now you can repeat this action on your surface.

DOTTING (Fig 12)

The wooden end of your brush dipped into paint is an excellent dotting implement if you need only a few dots. If your project entails a lot of dots (e.g. the Indian Chest project on page 110) you need to use a round brush, preferably a No. 3 or 4 with a slightly blunt end. The trick is to get the paint to a cream-like consistency and load the brush as fully as possible. The brush should behave almost like an eye-dropper, the merest touch onto a surface encouraging a droplet of paint to come away. If the paint consistency is right, as many as ten to fifteen droplets can be produced from a single loading.

BASIC STROKE FORMATION

COMMA STROKE (ROUND OR LINER BRUSH)

This is a basic stroke, and created almost as a natural response to the round brush shape as it is pressed onto the surface, drawn along and then released.

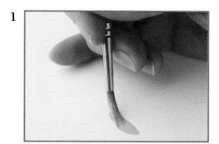

1 Hold the brush reasonably upright to the surface. Use your little finger for balance either fully extended or tucked under, in which case the lower joint becomes the balancing point. Decide which feels more comfortable.

2 Begin the stroke by a gentle pressing motion to make the brush hairs flatten into a rounded shape.

3 Now begin pulling the stroke into a gentle curve, releasing pressure as you pull. The motion is from the shoulder, not the index finger and thumb. Use your little finger as a lever to release and apply pressure.

4 Slow down as you make the tail so that the hairs can realign into the natural brush shape. Stop momentarily, then lift the brush off the surface cleanly.

CRESCENT STROKE (ROUND OR LINER BRUSH)

This stroke begins as it ends, on the tip. Control is needed to create the symmetrical shape.

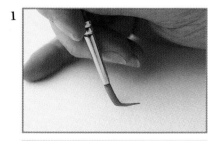

1 Begin with the brush fully loaded, the bristles coming to a point. Hold it upright to the surface.

2 Contact the surface with the point of the brush and slowly begin to pull the hairs round whilst gradually applying pressure.

3 In the middle section of the stroke, apply more pressure.

4 Just past the midpoint of the stroke, begin releasing pressure. Slide into the tail. Come to a halt and lift off cleanly.

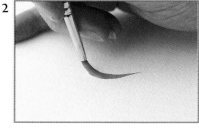

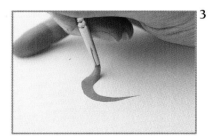

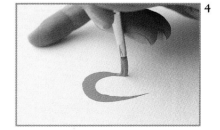

'S' STROKE (ROUND OR LINER BRUSH)

To strive towards a perfect 'S' shape is perhaps your goal, but shapes that are similar are no less appealing.

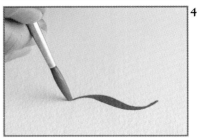

1 With the brush fully loaded and the bristles coming to a point, hold it upright and begin lightly skimming the surface in a gently curving motion.

2 Begin to change direction applying pressure as you do so.

3 At the midpoint of the stroke, change direction. Begin to release beyond the midpoint.

4 Nearing the end of the stroke, slow down and allow the brush hairs to realign into a point. Lift cleanly.

'S' STROKE (FLAT BRUSH)

Starting and finishing cleanly is the trick to master for this stroke.

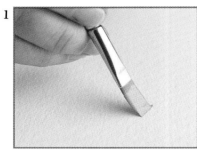

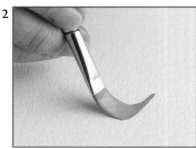

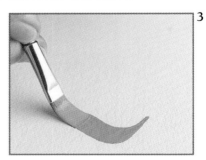

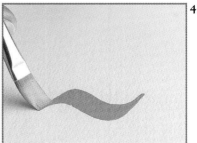

1 This stroke begins and ends on the chisel edge of the brush, so in order to paint clean tails at either end, the brush must be held reasonably upright. Begin by sliding the brush slowly on the chisel.

2 After a short slide on the chisel, begin to change direction. Apply pressure so that the broad part of the brush is now painting the surface. Switching between the chisel edge and the broad side automatically changes the direction of the stroke.

3 Beyond the midpoint, begin to slow up and release pressure. Change direction again as you swing back onto the chisel.

4 Finish upright and cleanly on the chisel. Lift off.

CRESCENT STROKE (FLAT BRUSH)

A clean start and finish as well as symmetry are both important. When you become proficient with the basic stroke, you can find some interesting variations.

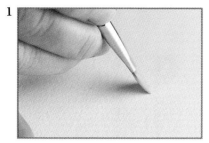

1

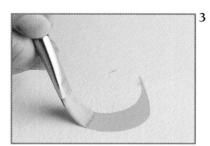

3

1 The stroke begins and ends on the chisel edge, so the brush must be held reasonably upright. Slide the brush along on the chisel as if you were going to paint an arch.

2 After a short slide on the chisel, apply pressure as you move into the curve of the arch. The brush pivots as you sweep onto the broad side.

3 Beyond the midpoint, begin to release pressure letting the brush rotate slightly as it reverts back onto the chisel.

4 With the brush reasonably upright, slide on the chisel. Stop and lift.

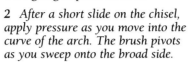

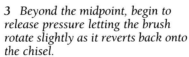

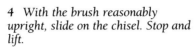

2

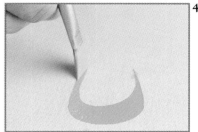

4

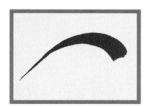

SCROLLS (FLAT BRUSH)

This stroke can begin at the tail end or the blunt end. Experiment to see which works best for you. If you are making a series of scrolls, each arising from a common source, it is better to begin with the tail.

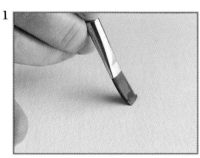

1

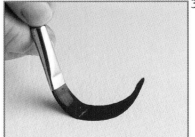

3

1 The stroke begins and ends on the chisel edge. Begin by holding the brush reasonably upright.

2 Slide the brush a short distance only on the chisel. Then begin to apply gradual pressure, thus thickening the stroke as it sweeps into a curve. The brush rotates very gradually as it sweeps onto the broad side.

3 Continue on the broad side for a short distance, maintaining pressure.

4 Once the stroke is the required length, slow down. Return the brush to the upright position and lift off cleanly.

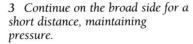

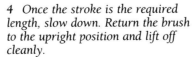

2

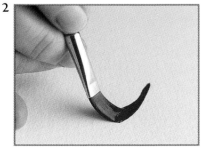

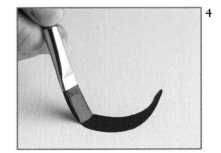

4

LEAF STROKE (FLAT BRUSH)

Mastery of the pivot and lifting off at the right moment is the key. Try the stroke from all directions and find what is most comfortable for you.

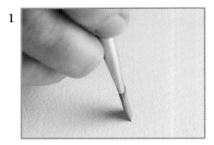

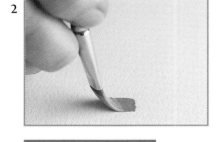

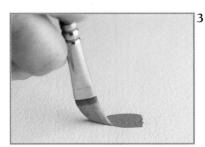

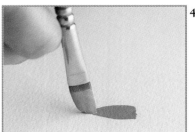

1 Begin with the brush in the upright position ready to apply pressure on the broad side.

2 Apply pressure pulling the brush towards you.

3 As you begin to release the pressure somewhat, pivot the brush in your fingers either clockwise or anticlockwise so that it rotates onto the chisel edge.

4 Slide a short distance on the chisel. Lift off cleanly.

CIRCLE STROKE (FLAT BRUSH)

Circles form the background for many motifs, so the ability to paint a perfect circle as one stroke is a useful skill. The brush pivots round its axis in a clockwise or anticlockwise direction depending which you find easier.

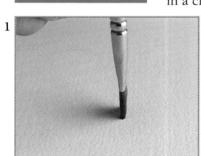

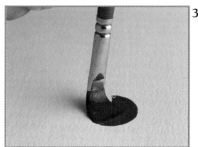

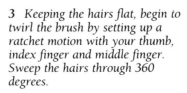

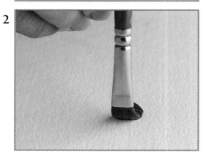

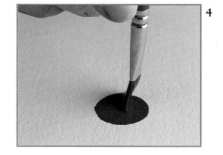

1 Hold the brush upright with your hand and arm angled upwards away from the surface. Bring the chisel down onto the surface with the outside edge at 12 o'clock.

2 Press the hairs down.

3 Keeping the hairs flat, begin to twirl the brush by setting up a ratchet motion with your thumb, index finger and middle finger. Sweep the hairs through 360 degrees.

4 Let the hairs fall back into place as you return to 12 o'clock and begin releasing pressure. Lift off.

TEARDROP (LINER BRUSH)

This stroke looks similar to the comma but is made from tail to head rather than vice versa. It also has a multitude of variations you can look forward to experimenting with.

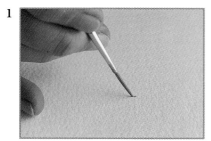

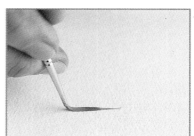

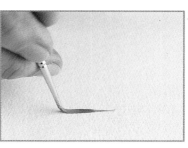

1 The brush should be loaded to a nice sharp point and held upright.

2 Glide down onto the tip. Slide along applying pressure to thicken out the stroke.

3 Slow down as you apply more pressure until the brush is sitting on the surface.

4 Having come to a complete stop, lift the brush off cleanly.

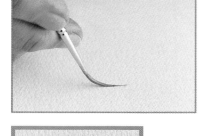

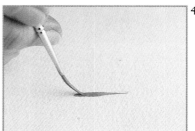

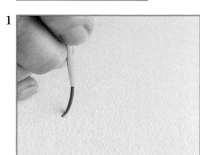

SCROLLS (LINER BRUSH)

These are lengthy, thinner, graceful strokes. Stay loose and free; there is no need to tense just because the strokes are longer.

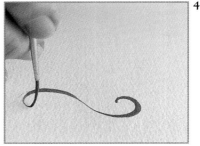

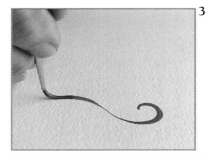

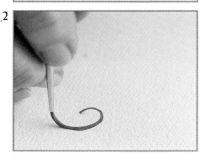

1 Load the brush with paint of a creamy consistency and hold it upright.

2 Pull the brush along, letting the hairs follow the handle.

3 Apply pressure as you go into the curve to thicken up the stroke, thus providing contrast against the thinner sections.

4 Release the pressure gradually as the curve is completed. Lift cleanly.

...BRUSH STROKE...

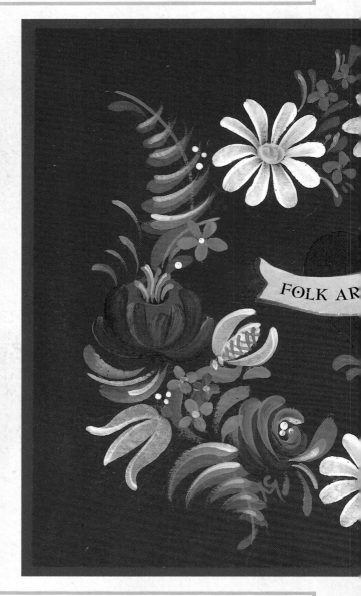

Just like arithmetic, folk art painting is elementary. (Many people will probably find it rather easier!) This is aptly illustrated by the four brush-stroke 'equations' shown here. The simple addition of these few basic strokes has created the beautiful sampler pictured in the main panel.

Don't be put off by the fact that making strokes is a freehand technique. In practice, mistakes are few since the shape of the stroke produced is almost an automatic response to the shape and contour of the brush used. For example, using a round brush, the action of pressing, pulling and gently lifting creates a teardrop stroke, whereas a press–bend–lift action creates a comma stroke, and so on. Indeed, these two strokes alone provide enormous scope.

If you look closely at the sampler (right), you will see that the majority of strokes are juxtaposed combinations of comma strokes. Some are lighter-toned commas which highlight darker strokes. Some are thick, some are thin, some long and some short. The effect is very lively, proving that the mastery of just one stroke can be very productive.

The 'S' stroke, another popular variant, is used sparingly in this example to provide contrast for the tulips. It is no more difficult than the comma stroke; it is simply a question of allowing the brush to make contact with the surface before applying pressure going into the 'S' bend. This is

TECHNIQUES

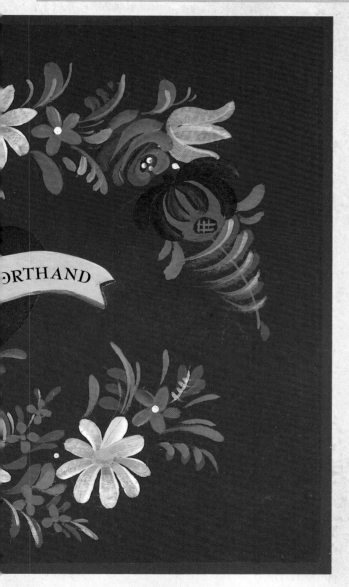

*This sampler is loosely
based on an 1870s design.*

followed by a release of pressure before and after the bend.

Once you feel confident making these strokes you will be ready to spread your wings. Perhaps you might like to try recreating the sampler.

This chapter provides in-depth coverage of technique, and once you have worked through these inspiring pages you will be accomplished in a wide variety of brush strokes. As you progress you may like to attempt one or more of the easier projects in chapter 10 such as the Tree of Life Tray on page 80 or the Pot of Tulips on page 84. Creating something pretty and useful will inspire you towards even greater achievement and enjoyment.

The techniques described in this chapter relate directly to all the projects illustrated in chapter 10, and each of these projects then goes on to provide further instruction. You will find this book a real companion at every stage of your development. The projects are all within your ability providing you adhere to the golden rule – practise! And remember, a result doesn't have to be perfect to be pleasing, so try not to spoil your fun by being too critical.

THE COMMA STROKE

The distinctive character of folk painting is beautiful stroke work. This is achieved by the way we load a brush and the pressures we exert on a brush as it is in motion. The comma is the most commonly used stroke. Three variations are shown below.

1 *Load round brush. When applying add pressure to spread hairs. Pull towards you slowly, then lift.*

2 *Load flat brush. Apply pressure. Draw towards you slowly lifting into the wedge to complete stroke.*

3 *The comma stroke is reversed for the teardrop. Fine, light pressure is used to start, continuing heavier and lifting off.*

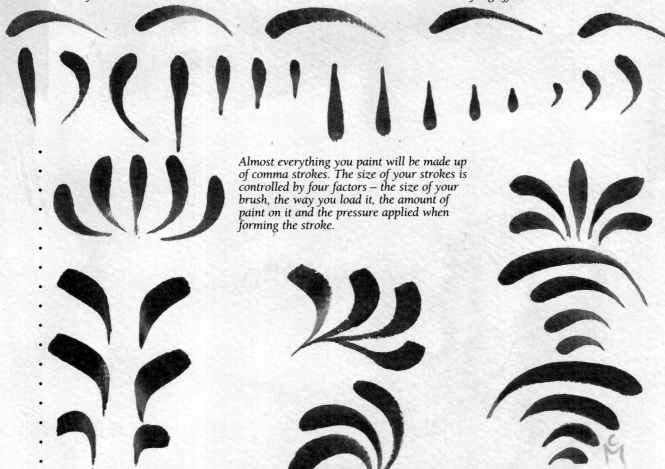

Almost everything you paint will be made up of comma strokes. The size of your strokes is controlled by four factors – the size of your brush, the way you load it, the amount of paint on it and the pressure applied when forming the stroke.

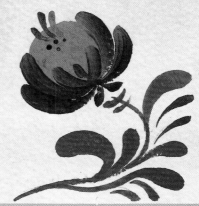

The Comma Stroke
THE CHRYSANTHEMUM

One of the easiest flowers to start painting is the chrysanthemum, a very simple style with a pleasing result. It uses only a circle and a comma stroke. As noted on page 22, the comma can be tip-loaded for further variation.

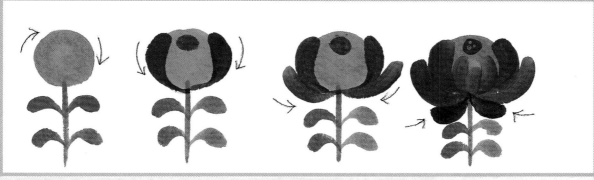

1 Using a round brush, paint circle, establish stem and paint comma leaves on stem.

2 Paint commas from the top, curving around the circle to meet at the stem.

3 Paint commas on outer edge in the position indicated, finishing at stem.

4 Paint inner petals, middle one shorter. Add commas underneath using darker tone.

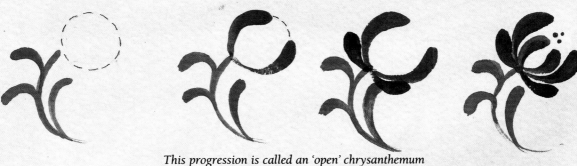

This progression is called an 'open' chrysanthemum because it is painted around an invisible circle.

The Comma Stroke
THE FAVOURITE DAISY

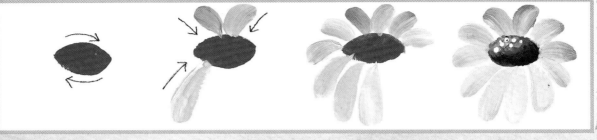

1 Paint centre using two comma strokes laid side by side.

2 Load brush and pull strokes towards the centre.

3 Turn flower as you work, pulling the lower petals towards you.

4 Make lower petals longer and lighter toned. Shade and highlight the centre.

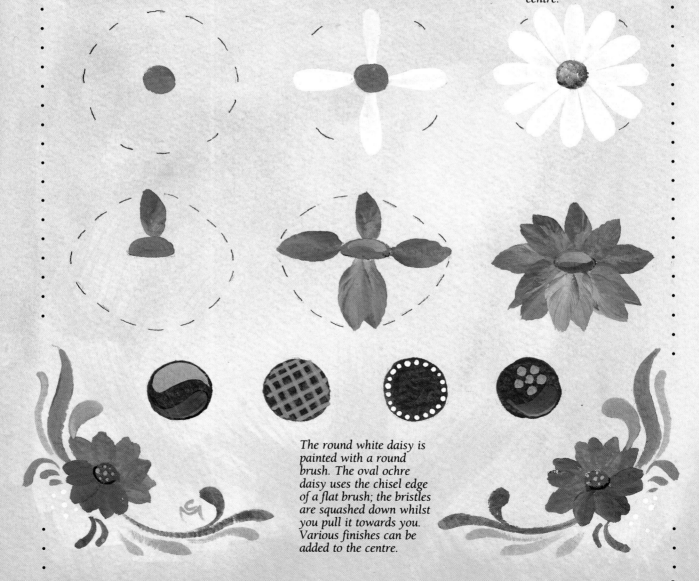

The round white daisy is painted with a round brush. The oval ochre daisy uses the chisel edge of a flat brush; the bristles are squashed down whilst you pull it towards you. Various finishes can be added to the centre.

The Comma Stroke
BORDER DESIGNS

*The possible variations of this stroke seem endless once you start
experimenting! Work along a lightly drawn pencil line for guidance.*

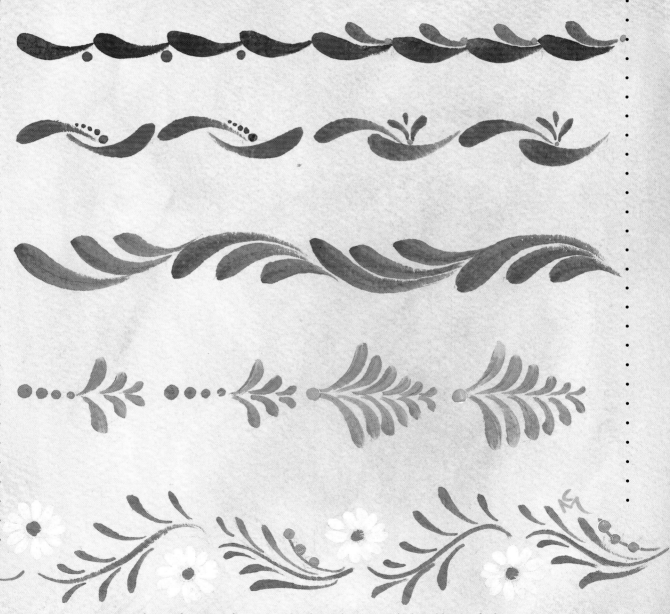

*Borders make pretty decorations by themselves, or with the addition of other
motifs such as the comma daisy.*

The Comma Stroke
THE BASIC ROSE

The progression shown in the panel is the basic rose from which others are developed. Those below are Bavarian styles, of which there are many variations. A skirting of few or many petals can be added and highlighted. Also, the bowl can be as plain or as detailed as you wish. Leaves can be added in a variety of strokes.

 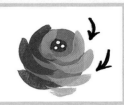

1 Paint circle with middle value of colour.

2 Paint 'throat' of rose in dark value.

3 Using commas in dark value pull two-thirds across the circle.

4 With high value, pull commas to scissor between dark commas.

 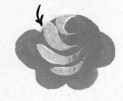 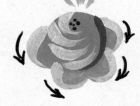

1 Paint circle using one stroke.

2 Add small crescent strokes for petals.

3 Using white, pull comma strokes two-thirds across the circle.

4 Add white commas to petal edge and in 'throat'. Dark value comma to edge of circle and dots.

 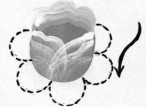

1 Paint basic circle.

2 Making a fluted crescent stroke, sideload two rows of white across the top.

3 With sideloaded brush, paint three 'S' strokes left; repeat right.

4 Paint crescent petals; outline with white commas.

The Comma Stroke
CLASSIC BLENDED ROSE

The beauty of this rose is captured with a flat brush double loaded (see page 22) with a light colour on one side and a dark colour on the other. As a placement guide for your petals, draw a circle. Take note of each stroke's precise position and where it is placed relative to the inside or outside of the circle. The edge of the circle becomes the bowl of the rose as you proceed through each step. Correct placement is the key to building the classic rose.

1 Place well-blended double loaded brush inside upper part of circle. Paint crescent stroke (see page 42), varying pressure to create ruffled edge. Repeat with another stroke below first.

2 Join bowl to back petals with two blended crescent strokes. Apply pressure as you curve the stroke.

3 This step is a double loaded, well-blended comma stroke placed just outside the bottom left edge of circle. Use a push–pull motion in the middle of the stroke.

4 Side petals are formed over part of last stroke. These are comma strokes starting on the chisel edge at right-angles to each side of the circle. Tails must cross.

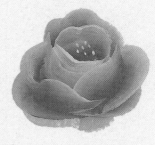

5 The strokes now begin to tuck between each other. With the chisel against the right-hand bowl, add a comma stroke which will overlap the comma made in step 4.

6 Stand the chisel edge along the middle lower edge of the bowl. Sweep the brush across the rose, ending on the chisel edge.

7 Starting with chisel edge on side of bowl make a half comma stroke; stop; now pivot the brush so that the stroke turns back on itself; complete with an 'S' stroke.

8 Follow steps 1 to 7 to complete this lovely free-hand rose. Add leaves (see page 37) and buds (two crescent strokes) to finish the design.

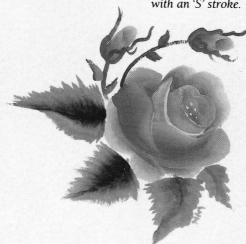

The Comma Stroke
TULIPS AND HEARTS

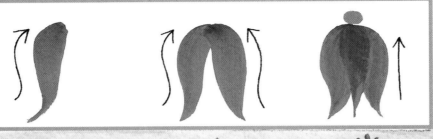

A simple tulip can be made, using a round brush, working upside down and pulling two or three comma strokes towards you, finishing with a dot.

The heart shape is symbolic of the heart of God, source of all love, hope and future life. Only after the Victorian period did it take on its sentimental meaning. This illustration shows how the Pennsylvanian Dutch heart is made, using a circle grid.

1 *Using a flat brush, paint comma stroke (pivot and pull) towards you, making a half circle. Gradually lift to release pressure and slide to a point on the chisel edge.*

2 *Repeat the stroke on the other side. Overlap the strokes slightly so there is no gap in the centre.*

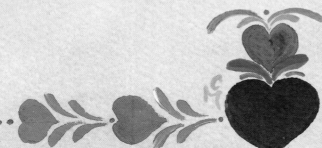

The Comma Stroke
LEAVES

Simple leaves can be made using the comma stroke.
Contrast is important: thick/thin, long/short, straight/
curly, light/dark, few/many. Interest can be added by
wriggling the commas or adding touches of the colour
of the flowers to which they might relate.

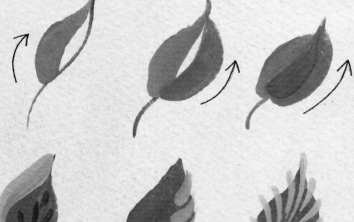

These leaves are created by only three
comma strokes using a round brush.
They should be painted with the work
upside down, always pulling the strokes
towards you. Begin with the stroke on the
outer leaf, working from stem to tip.
Highlights can also be painted as comma
strokes. Keep the shape of the whole leaf
in mind whilst painting each stroke.

Use a flat brush to make
these strokes. Place the
brush against the paper,
press, pivot and pull,
lifting gradually to
complete on the chisel
edge. Flat-based comma
leaves are ideal for
tucking up against
flowers so that they look
as though they are
underneath the flower.

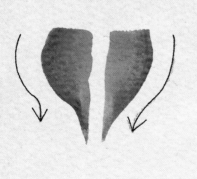

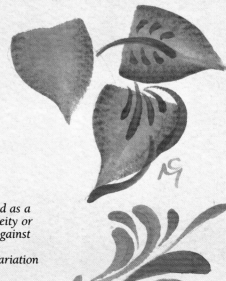

The comma stroke is ideally used as a
filler leaf for suggesting spontaneity or
breeziness. Butting the strokes against
each other or creating spacious
groupings provides interesting variation
to your work.

THE 'S' STROKE

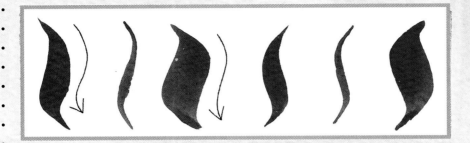

'S' strokes can be made with either a flat or round brush. The flat brush lends itself particularly well to the wider strokes.

Begin on the chisel edge. Gradually apply pressure, slowly sliding onto the broad side of the brush as you reverse direction coming into the 'S'. Pull down on the stroke. Reverse direction and gradually decrease pressure going out of the 'S'.

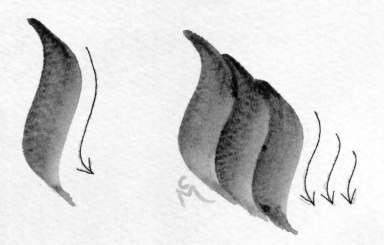

The 'S' stroke is also very useful for border decorations. As with the comma stroke, the variations seem limitless.

The 'S' Stroke
FLORALS

*'S' strokes can be used to create a wide variety of floral patterns simply by varying the
length and thickness of the stroke.*

1 Use a ½in liner to create delicate stems using long,
thin 'S' strokes.

2 The ½in liner is then used to produce the delicate
leaves and petals.

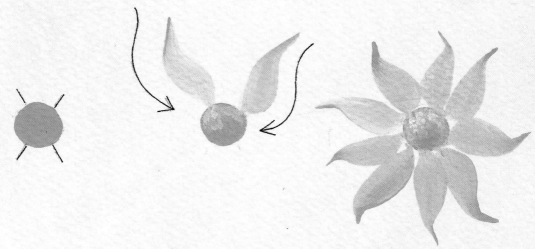

1 Using a round brush, paint
a circle. Add pencil markers to
indicate location of petals.

2 Paint 'S' strokes, pulling the
brush towards you and the circle,
with a brush tipped in a darker tone.

3 Fill in 'S' strokes around the
circle, rotating as you work.

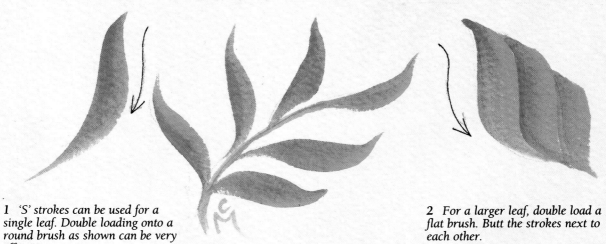

1 'S' strokes can be used for a
single leaf. Double loading onto a
round brush as shown can be very
effective.

2 For a larger leaf, double load a
flat brush. Butt the strokes next to
each other.

The 'S' Stroke
TULIPS

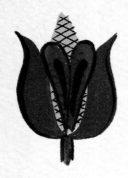

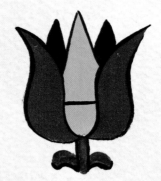

The tulip is one of the earliest motifs to appear in folk painting, possibly because of its powerful symbolic overtone as the flame of Christ. The tulip's shape, as well as the traditional flame colour, reflect its original symbolic meaning.

So consistently and widely has the tulip been used since the sixteenth century that the basic shape has yielded to numerous transformations and interpretations. All are easily recognizable as tulips. These two pages show only a few examples, using the primary colours in which they were most frequently represented.

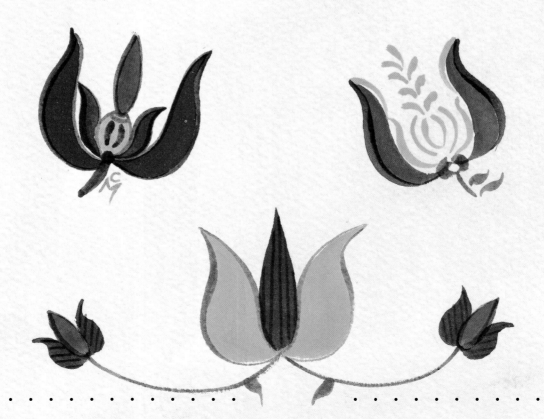

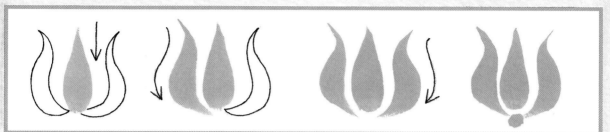

1 With a round brush, press down lightly. Gradually apply pressure whilst pulling towards you. Release and lift.

2 Begin at the top, pulling stroke towards the base of the tulip.

3 For the central petal pull the 'S' stroke away from the base.

4 Finish with a central dot, adding final decoration as suggested below.

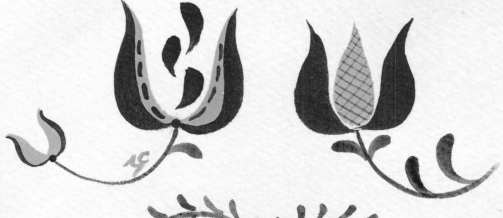

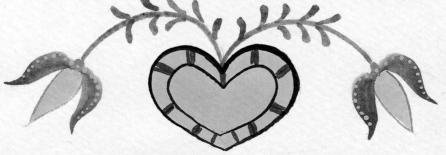

THE CRESCENT STROKE

A fine crescent can be formed using a liner brush (below left). Begin at the tip, apply pressure as you curve round and then gently release pressure and lift off.

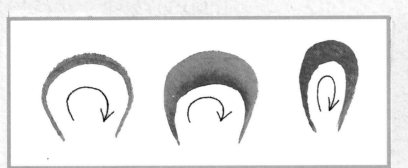

A crescent can also be painted with a flat brush (centre). Begin on the chisel end, gradually moving onto the broad side going into the curve. Release pressure and move back onto chisel before lifting off.

To form a crescent using a round brush (near left), apply the same technique as for a liner.

1 To paint a simple flower, first paint a circle. Pencil in a five-pointed star.

2 Paint in crescents, using points of the star as guides. A sideloaded flat brush creates a shaded effect on large or small petals.

3 This shows a flat crescent. Rather than sliding on the chisel edge as you begin, draw the whole chisel into the curve.

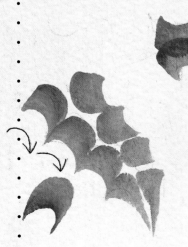

Flat crescents (see page 44) are used effectively for holly-style leaves. The 'elongated' crescent is used for heart-shaped leaves. These are formed on either side of the central vein: slide up on the chisel using only a slight broad-side motion, then slide down again so that the two chisel edges appear as one.

The Crescent Stroke
FLORALS

A flat brush, with pressure applied evenly or unevenly, creates crescents of all shapes and sizes. These can be used to paint a wide variety of florals.

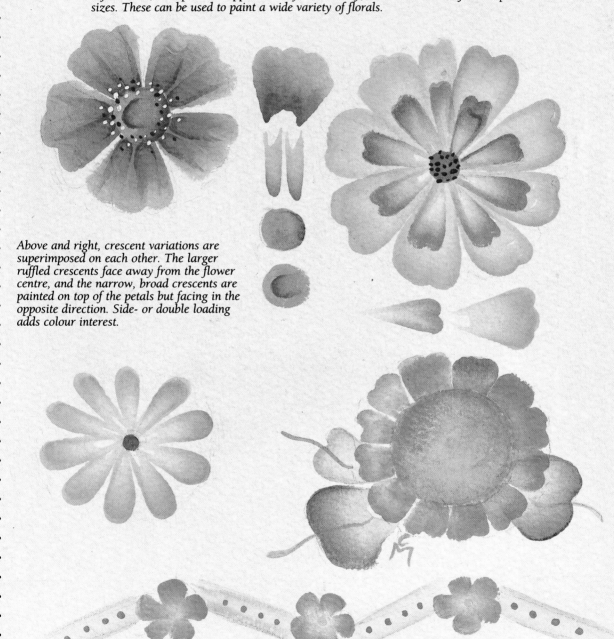

Above and right, crescent variations are superimposed on each other. The larger ruffled crescents face away from the flower centre, and the narrow, broad crescents are painted on top of the petals but facing in the opposite direction. Side- or double loading adds colour interest.

THE FLAT STROKE

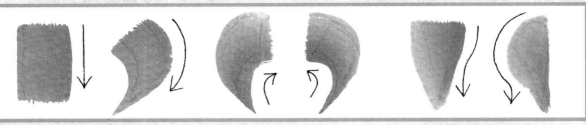

Flat crescent: using flat brush, even pressure applied from left to right.

Arched crescent: slide upwards on chisel, arch evenly to right and slide down.

Ruffled crescent: slide upwards on chisel, arch with uneven pressure from left to right and slide down.

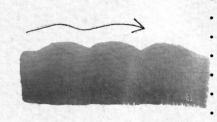

Tooth-shaped crescent: as for the arched crescent, but with a dip in the middle.

Elongated crescent: slide upwards on chisel, arch round and then immediately slide down on the chisel.

Scalloped crescent: apply uneven pressure at regular intervals on the top edge of the brush.

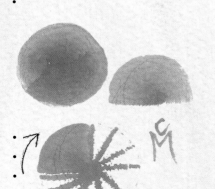

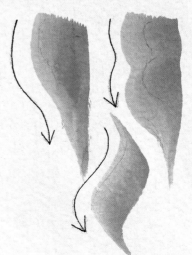

◄ *Circle: pivot flat brush around its axis point.*

► *Flat drop: pull broad side of brush towards you, allowing it to pivot on its axis as you tail off.*

The Flat Stroke
LEAVES

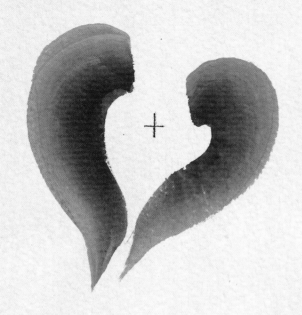

Using two pivoting strokes, sideloaded for tonal variation, paint a heart-shaped leaf.

With brush flat on paper, begin with a pivot and then apply uneven pressure to create outside bumps. Pivot to a tail as you finish off.

Sideload a flat brush and paint four overlapping crescent strokes. Shadows are added with small commas. Vary each leaf's veins to add individuality.

COMBINING STROKES

Combine the basic strokes to create a limitless variety of images. The following pages show just some of the possibilities.

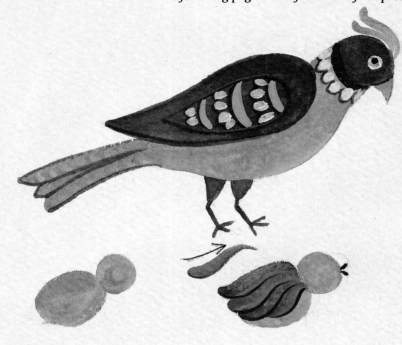

BIRDS

Birds are historically a popular theme in folk art, and were frequently used to decorate certificates. Like the tulip, they have evolved into many fantastic and colourful variations.

1 Paint and fill a circle and oval with Yellow Oxide.

2 To create wings, load red into brush and tip with Yellow Oxide. Line each stroke.

3 Add three commas for plumage. Line.

Birds can be decorated in many ways. Use commas, tip-loaded in white, for wings and tails. Paint small commas in darker tones for chest. Add liner strokes for patterns. Paint small commas and detail for smaller filler birds.

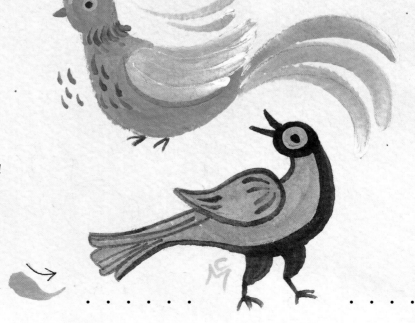

Combining Strokes
TREE OF LIFE

Birds in pairs form an interesting focal point in decoration – either beak to beak or tail to tail, or alternating on branches. The latter were used extensively on nineteenth-century birth certificates.

The tree of life is a universal motif symbolizing renewal, growth and vitality. Birds in pairs, or small animals, often appear in conjunction with the tree of life.

The tree of life is an organic design, where different kinds of flowers grow out of a single stem.

The small creatures shown under the tree above were painted using two commas as below.

Using a flat brush double loaded with two tones of green pigment, 'S'-stroke leaves are made with one pull. Clusters can also be created.

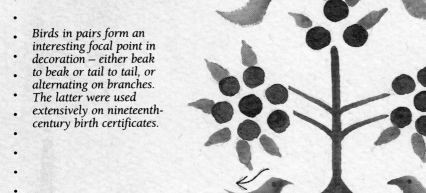

Combining Strokes
ANIMAL FORMS

Using the circles and comma strokes shown in the panel, and a little imagination,
simple animal forms can be painted.

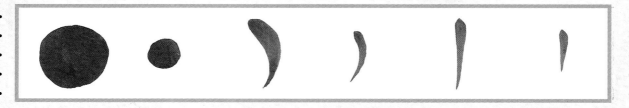

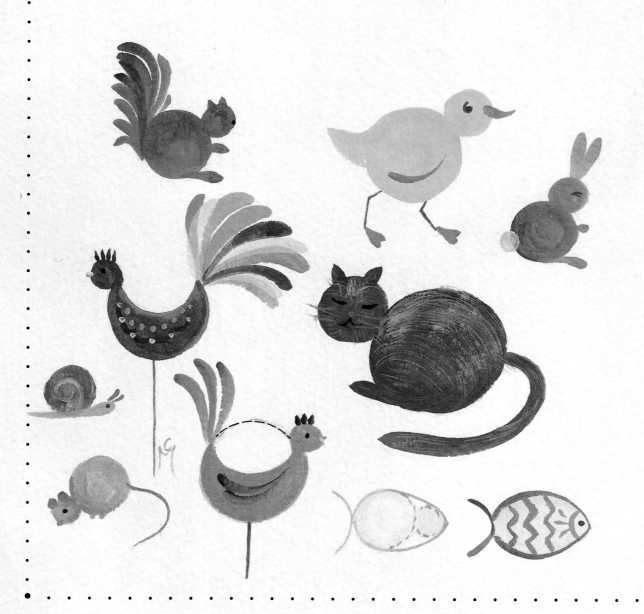

Combining Strokes
PRIMITIVE ANIMALS

Primitive-looking animals play an important part in folk art decoration. These have been painted using the strokes shown left. Here a flat, float loaded brush is used to outline the body form. Crescent strokes are painted on the sheep. Garlands add a festive note.

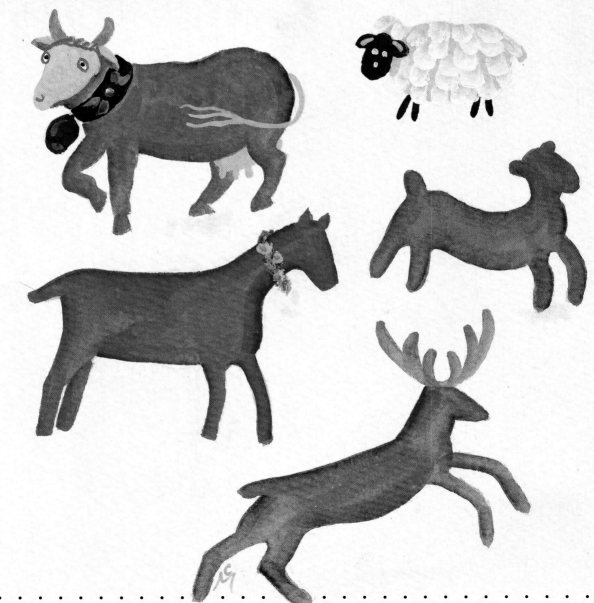

Combining Strokes
HERALDIC ANIMALS

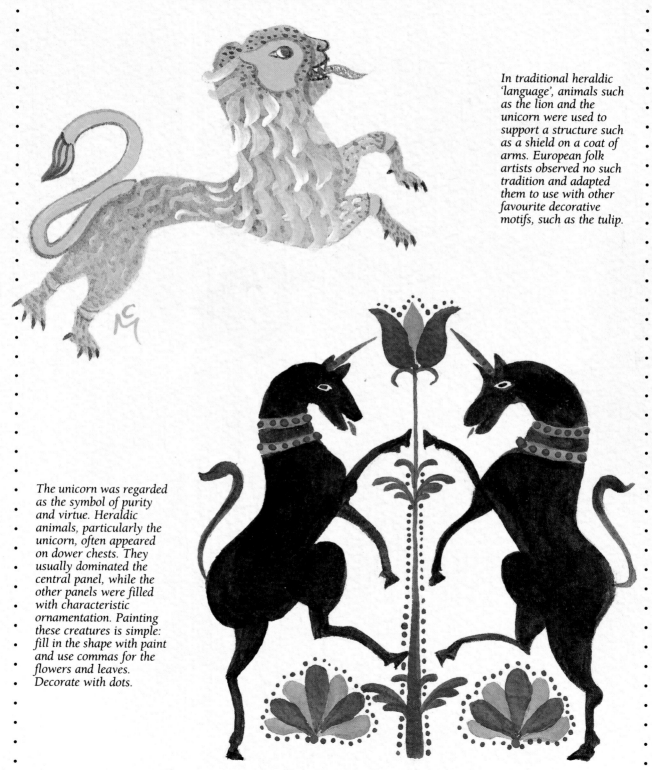

In traditional heraldic 'language', animals such as the lion and the unicorn were used to support a structure such as a shield on a coat of arms. European folk artists observed no such tradition and adapted them to use with other favourite decorative motifs, such as the tulip.

The unicorn was regarded as the symbol of purity and virtue. Heraldic animals, particularly the unicorn, often appeared on dower chests. They usually dominated the central panel, while the other panels were filled with characteristic ornamentation. Painting these creatures is simple: fill in the shape with paint and use commas for the flowers and leaves. Decorate with dots.

Combining Strokes
INSECTS

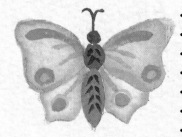

1 Paint body using two pairs of crescent strokes with flat brush. Add a dot for the head.

2 With float loaded brush, paint outline of wings. Fill centre with wet brush.

3 Decorate with imaginative colours and shapes.

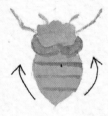

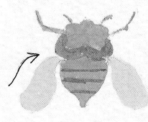

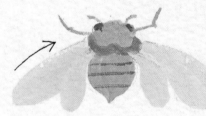

1 Fill in body and head. Add detail.

2 For wings, use soft comma strokes pulled towards body.

3 Paint larger wings with same colour commas, sideloading with pink.

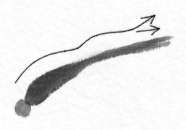

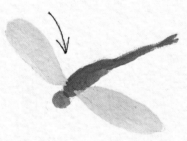

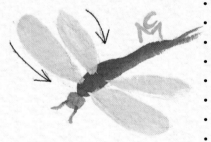

1 With a round sideloaded brush pull stroke away from head, lifting at fork of tail.

2 Pull comma wings towards body, sideloaded with yellow/blue.

3 Add second wings in blue. Add detail.

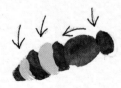

1 Dab on head with round brush. Use crescents for body and tail.

2 Use liner to add legs and antennae.

3 Using two butting commas, spread brush and pull-lift to body to form wings. Add eyes.

Combining Strokes
SIMPLE STROKE-WORK PEOPLE

Figures were usually beyond the ability of folk artists, as they had no formal art training. Attempts were often grotesque and amusing. Such figures were used on birth and baptismal certificates as decorative elements, together with hearts, birds, and tulips. Over the centuries the same figures were retraced and hence costumes remained the same from century to century.

The basic steps for painting a man, using simple strokes, are illustrated here. The woman is the same except with a skirt instead of breeches. Try elongating them. They can be elaborated and embellished at will.

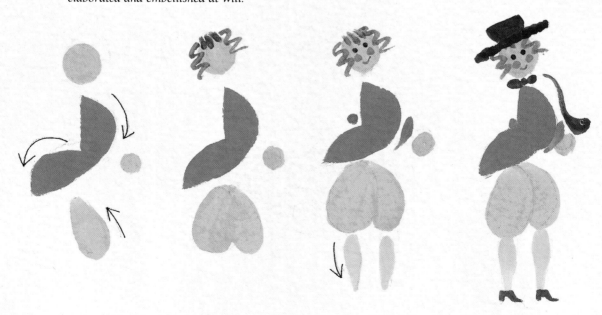

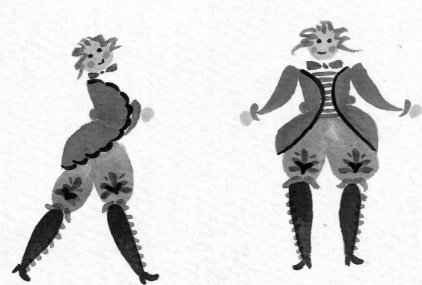

Figures can also be painted in action, or face-on. The right and left halves of the coats use the same basic strokes as the side view, with additional comma strokes for arms. Decorate the clothes in your own designs.

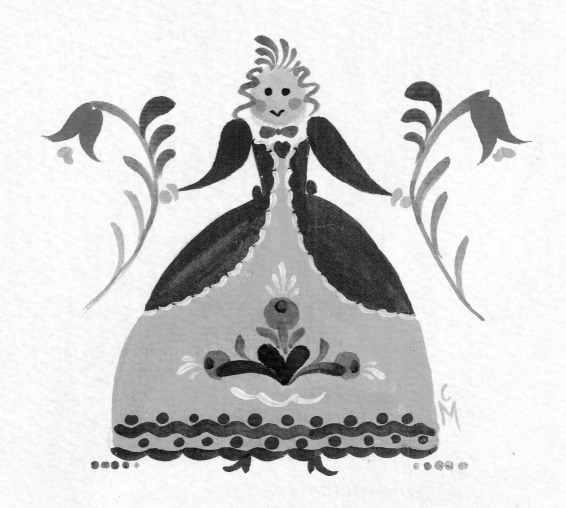

Combining Strokes
BERRIES

Blackberries
1 Paint imperfect circles in medium-tone colours. The edges need not be even.

2 Dip a round pencil eraser into darker colours; press on each segment.

3 Shade berry undersides with flat brush floated with a dark colour (crescent stroke).

4 Add highlight with flat brush loaded with a lighter colour.

Raspberries
1 Paint violet comma stroke with round brush.

2 Paint darker value comma stroke, then blend in the centre using brush double loaded with both colours.

3 Push away strokes in a lighter colour for raspberry seeds.

4 Add comma leaves.

Strawberries
1 Paint red strawberry shape.

2 Paint sideloaded dark and light strokes on top of red shapes.

3 Add seeds by sideloading round brush with yellow and green.

4 Add leaves using sideloaded 'S' strokes.

Blueberries and Cherries
Use steps similar to those above. Shade with float loaded darker tone. Highlight with float loaded lighter tone. Finish with white accents.

Combining Strokes

MUSHROOMS AND FRUIT

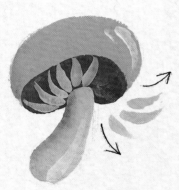

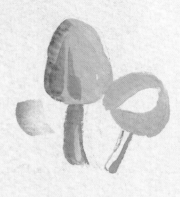

Mushrooms
1 Use comma strokes for the underside of gills.

2 Use different colours and strokes to alter the mushroom variety.

3 Sideloading creates shading and highlighting.

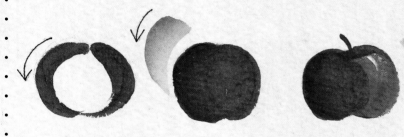

Apples
Follow the steps for the raspberry. Paint and fill shape, shade and highlight, finish with accents.

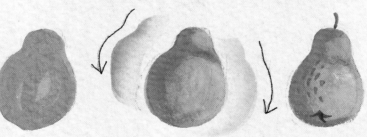

Pears
Use the same technique as apples. Main colours are Yellow Oxide and Burnt Sienna.

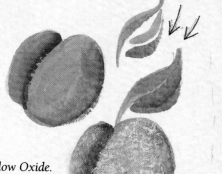

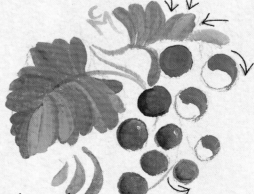

Peaches
Base in Yellow Oxide. Paint shadows with Cadmium Scarlet.

Leaves can be painted using comma strokes.

Combining Strokes
MORE FLORALS

Flowers painted from various angles take on a romantic quality. There are really no rules as to how an effect is created. The brush, the way it is loaded, or the stroke you choose is up to you. See if you can analyse what has been done here. You may even try to copy it, but if you do, don't expect an exact replica. Allow yourself the liberty of your own creative expression!

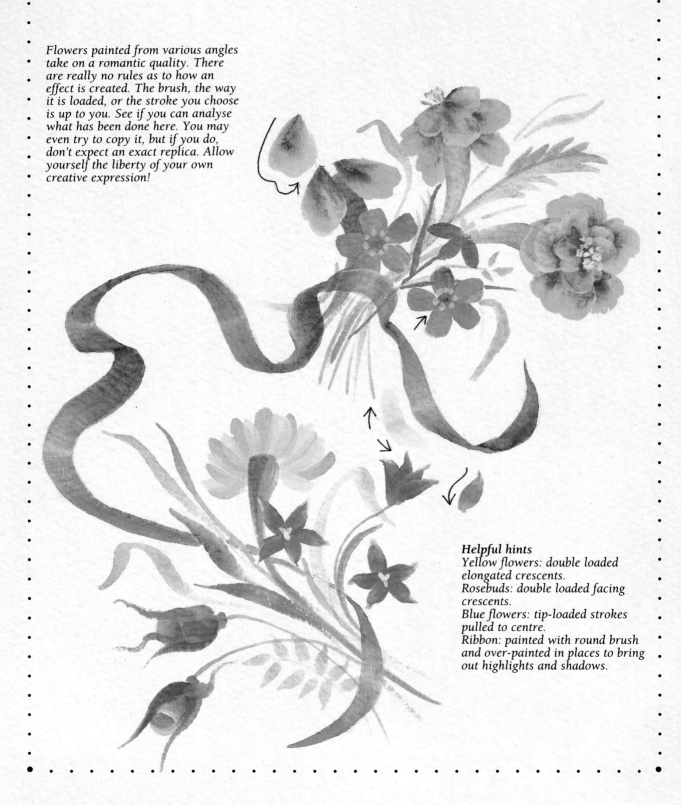

Helpful hints
Yellow flowers: double loaded elongated crescents.
Rosebuds: double loaded facing crescents.
Blue flowers: tip-loaded strokes pulled to centre.
Ribbon: painted with round brush and over-painted in places to bring out highlights and shadows.

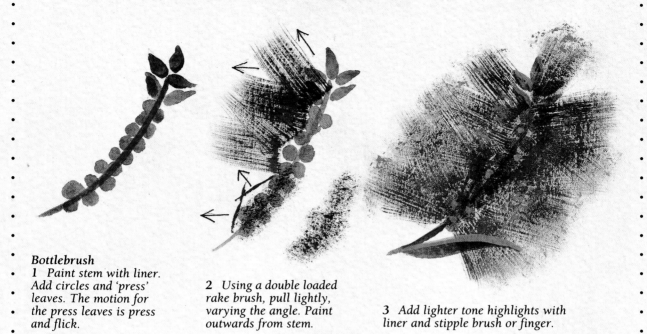

Bottlebrush
1 Paint stem with liner. Add circles and 'press' leaves. The motion for the press leaves is press and flick.

2 Using a double loaded rake brush, pull lightly, varying the angle. Paint outwards from stem.

3 Add lighter tone highlights with liner and stipple brush or finger.

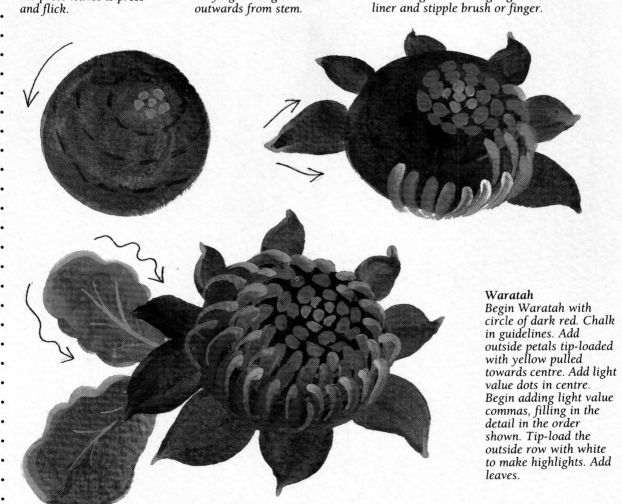

Waratah
Begin Waratah with circle of dark red. Chalk in guidelines. Add outside petals tip-loaded with yellow pulled towards centre. Add light value dots in centre. Begin adding light value commas, filling in the detail in the order shown. Tip-load the outside row with white to make highlights. Add leaves.

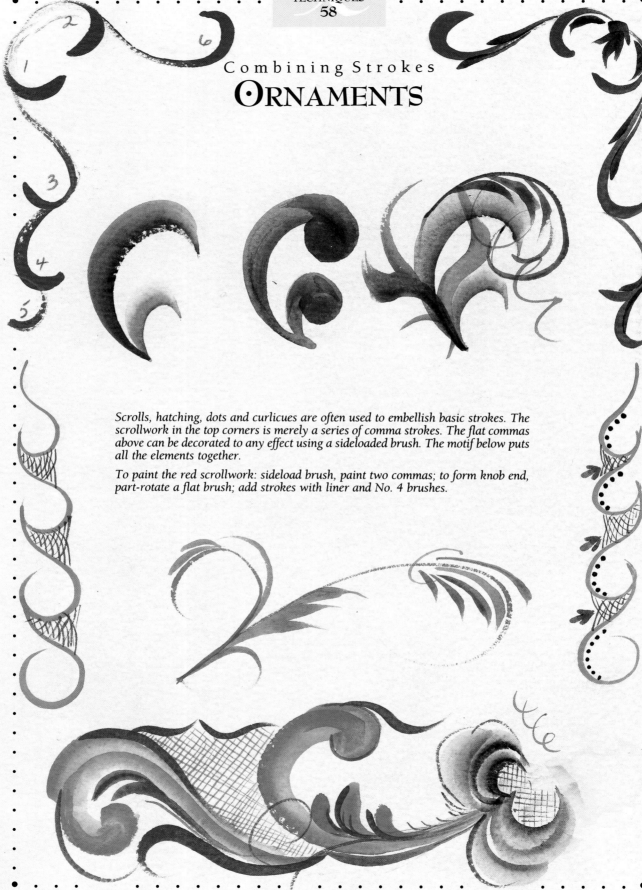

Combining Strokes
ORNAMENTS

Scrolls, hatching, dots and curlicues are often used to embellish basic strokes. The scrollwork in the top corners is merely a series of comma strokes. The flat commas above can be decorated to any effect using a sideloaded brush. The motif below puts all the elements together.

To paint the red scrollwork: sideload brush, paint two commas; to form knob end, part-rotate a flat brush; add strokes with liner and No. 4 brushes.

Combining Strokes
BASKETS AND VASES

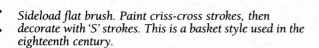

Under-paint basket shape with dark brown. Double load flat brush with lighter tones. Paint flat crescents and 'S' strokes.

Sideload flat brush. Paint criss-cross strokes, then decorate with 'S' strokes. This is a basket style used in the eighteenth century.

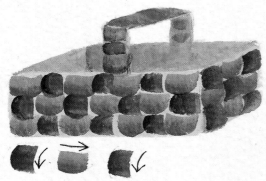

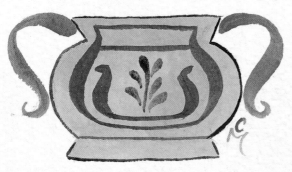

A loosely constructed basket is created using a flat brush sideloaded with two tones of brown.

Urns appeared in folk art in many varieties. Earlier examples resembled chamber pots.

Combining Strokes
Classic Motifs

Classic motifs were not generally used in rustic European folk art traditions. However, if the fashion for painted furniture had persisted beyond 1850, these motifs might well have been adapted. Folk art tended to lag behind fashion. Here we pick up the threads and show how the stroke technique adapts to reproducing these familiar and well-loved motifs, which have migrated through various ancient cultures – Assyrian, Egyptian, Greek – to the present day.

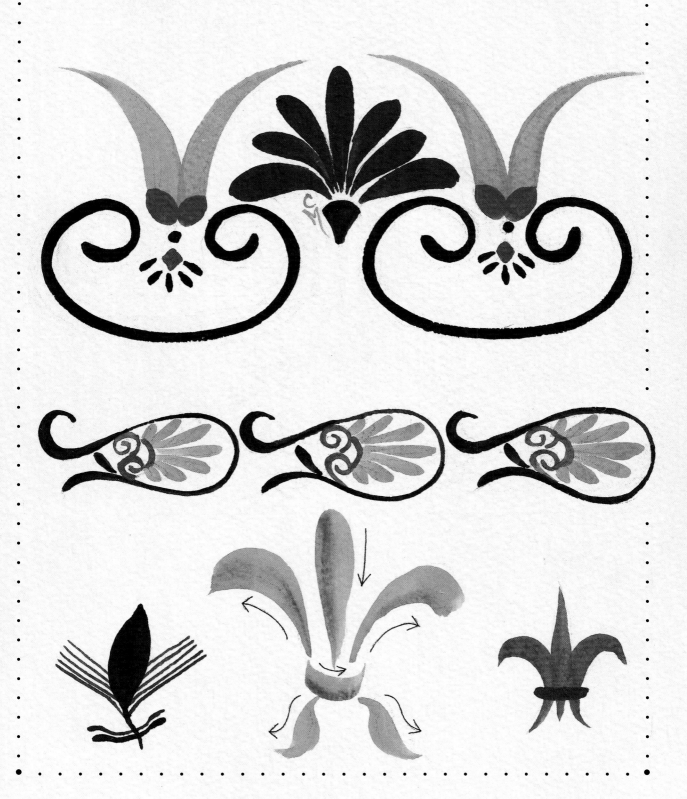

...PREPARING AND...

Aproperly prepared surface enhances both the decoration and the finished object. A beautifully painted design will not hide a poorly prepared surface, so a little effort at the preparation stage is essential. Sanding, sealing, and preparing the painted surface with care will pay dividends.

All surfaces need to be sealed to provide a barrier between the object and its painted decoration. This barrier prevents moisture, pitch and other volatile products within the object reacting with the applied paint.

The sealer also gives the surface a 'tooth' or 'key', enabling the paint to adhere. Different sealers are available for different surfaces.

Traditionally, sealers are supplied as a single step in the preparatory process. The base coat is then traditionally applied as the next step, although advances in technology have enabled manufacturers to combine these two steps into one by mixing pigment into the sealer. Most of the projects in chapter 10 follow this procedure using Jo Sonja's All-Purpose Sealer along with compatible water-based pigments in a ratio of 1:1, but other brands of sealer are available.

Another technological advance is the production of multi-purpose sealers that can be used on a variety of surfaces such as wood, metal and ceramics. This is a useful economy for the folk artist working on a variety of smaller items.

BARE WOOD

First use a commercial wood filler to fill any holes or gouges in the wood. When the filler is completely dry, sand lightly with a medium grit sandpaper following the grain. Wipe with a damp cloth. Apply a coat of sealer.

Choose either a petroleum- or water-based sealer depending on your choice of pigment. Use a water-based product with acrylics and a petroleum-based one with oil paints or alkyds. The chapter 10 projects use water-based products almost exclusively because they are quick-drying, easy to use, and non-toxic.

All sealers will raise the grain

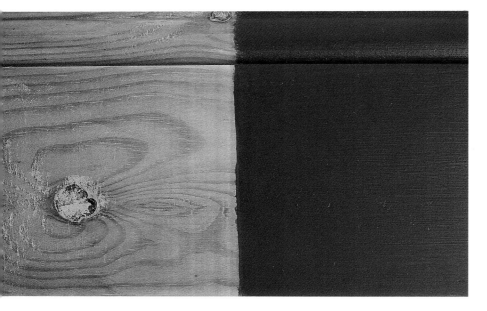

On the left, holes have been filled in then sanded when completely dry; on the right is the finished result, which has been painted with Cobalt Blue and Jo Sonja's All-Purpose Sealer mixed 1:1.

.... BASE COATING

of the wood, so when your piece is completely dry, buff the surface with a fine grade of sandpaper, or an unprinted brown paper bag. Wipe with a damp cloth, and your piece is now ready for your imagination!

PAINTED WOOD

Painted wood may have to be stripped if the finish is cracked or chipped. This can be done at a commercial dippers, or you can purchase a commercial wood stripper and follow the instructions on the package. You may need to use several applications. Once all the paint has been removed, rub down with a cloth soaked in mineral spirits (white spirit) to neutralize the effect of the stripper.

WAXED AND OILED WOOD

Old wood may have several layers of wax, oil, and/or grease protecting the surface. These will have to be removed using mineral spirits (white spirit) and a fine grade of steel (wire) wool. You may need to make several applications. As the wax etc. begins to dissolve, continue rubbing with a soft cloth soaked in spirits. Then rinse well with water. To complete the preparation, follow the instructions for bare wood.

SHELLACKED AND VARNISHED WOODS

If the surface is in good condition, simply wash it down with warm soapy water and a little disinfectant. When it is dry, rub the surface with some medium grade wet-and-dry sandpaper to key the surface. You will need to use oil-based paints when decorating a varnished surface; shellac is suitable for either oil- or water-based treatment.

Distinguishing shellac from varnish may not be easy. Shellac has a smoother wax-like finish, but the best test is to apply a few strokes of water-based paint to the cleaned surface. The paint will congeal or curdle on varnish but will go smoothly onto shellac. Wipe off the test paint immediately.

BASE COATS

The following examples use a combination of water-based products which are compatible with the acrylic pigments so widely used by decorative artists.

Opaque Base Coat Once you have completed the basic steps above, apply two or three coats of acrylic colour. If the object is small, use pigment straight from the tube. If the paint needs thinning, use a small amount of water-based all-purpose sealer rather than water for better binding. For large objects, buy pre-mixed emulsion (latex). Alternatively, add a touch of pigment to white emulsion (latex) and apply.

Allow each coat to dry and sand lightly with fine grade paper or a brown paper bag. Wipe the surface with a damp cloth. As a further step, you may wish to seal the surface with a light misting of clear acrylic spray. This will allow you to correct mistakes without damaging the prepared surface (see page 75).

Acrylic Stains Acrylic wood stains are made using earth colours such as Raw Sienna (oak), Burnt Sienna (maple), Burnt Sienna/Burnt Umber/ Burgundy (mahogany), etc. They are easy to make and to apply. You could, for example, stain a piece with a background colour to match your existing decor. To make the stain, squeeze a little of your chosen acrylic colour into a container. Add enough water to give a fluid consistency. Add one tablespoon of water-based varnish for every half-cup of coloured fluid. The varnish acts as both binder and sealer, so no initial sealing of the wood is necessary. Stir the mixture thoroughly. Apply with a sponge or bristle brush, covering the surface evenly. If you should need to even out the colour, wipe the whole area gently with a cloth moistened with water. Let it dry overnight and buff lightly with fine sandpaper or a brown paper bag.

Acrylic Pickling The pickling effect is created with pale colours to impart a white haze to the object, so producing a hazy wash of colour over the wood. For large objects, pre-mixed emulsion (latex) paint thinned with water to the required degree of transparency can be used. Similarly, you can tint white emulsion (latex) paint with a small amount of acrylic pigment for the same effect. One part of paint to 8–20 parts of water will provide an effective mixture for colour washing. For smaller objects, combine water-based varnish and gesso 2:1 (the chalk powder in the gesso smooths the surface and fills in the grain). To this mixture add a small amount of your chosen acrylic pigment. Blend the ingredients well and test the colour on the underside of your piece. Finally, apply with a damp rag or sponge brush wiping off any excess. Work quickly or in sections as the water-based varnish dries quickly. Dry overnight, then sand lightly or buff with a brown paper bag.

Glazing Glazing is the same as pickling but does not create the white hazy effect. Use the same recipe of one part pigment to 8–20 parts of water depending on the desired intensity of the colour. Gesso is omitted, thus the colour of the glaze is clear rather than hazy or milky. Add the varnish as for pickling. Apply in the same way.

NEW TIN

New tin can be bought with a number of finishes: ready primed but not base coated, primed and base coated (black or grey colour), or unprimed with a shiny metal surface.

Wash unprimed tinware in warm soapy water that is not lemon or lime scented as the citric acid in such detergents causes the metal to rust. Rinse well and dry thoroughly using a warm oven or hairdryer. Wash a second time in a 1:1 solution of vinegar and water. Wash again in a non-citric detergent, rinse well and dry thoroughly in an oven preheated to 200°F, turning it off once the tinware is inserted.

If the surface is shiny, rub very lightly with the finest grade of steel wool taking care not to go through the thin tin plating. Prime with either a spray or brush-on primer using several light coats. Allow each application to dry thoroughly.

Your piece is now ready for sealing. Some decorative arts manufacturers offer an all-purpose sealer for use on any surface including metal. Apply a thin coat of undiluted sealer using random, criss-cross strokes. Work in small areas to avoid producing ridges. Continue in this manner, over-lapping the previous section, until the entire surface is covered. Allow to dry and cure for at least twenty-four hours.

Finally, apply a base coat as instructed on page 66. If you are using acrylic from the tube which needs thinning, use water-based varnish as a thinner as this will promote better binding. The piece is now ready to decorate. Varnish when completely dry with several coats of water-based varnish. Alternatively, finish with clear acrylic spray (see chapter 9 for more finishing techniques).

A wire brush removed rust. The surface was sanded using sandpaper and steel wool, then brushed with rust inhibitor. It is then brushed with Norwegian Orange and Jo Sonja's All-Purpose Sealer mixed 1:1.

OLD TIN

Rust is the main problem with old tin. Remove it using a wire brush, then sand with a fine grade of sandpaper. If there are any scratches, use a fine grade of steel wool for final sanding.

If your piece is heavily rusted you may need to use one of the special heavy-duty products available. Other alternatives are sand blasting or having it 'dipped' at a car body shop. This method is recommended for larger objects.

To remove paint, use a commercial paint stripper following the instructions on the tin. Once the paint has been removed, rub down with a cloth soaked in white spirit to neutralize the effect of the stripper. Brush the surface with a commercial rust inhibitor and then proceed as for new tin.

UNGLAZED POTTERY AND EARTHENWARE

Terracotta flower pots are easily transformed into decorative pieces by first making sure they are dry and clean, then sealing the pot inside and out using one or two coats of a white PVA glue (available from most art supplies stockists) diluted with a little water. This will prevent the moisture in the soil destroying the painted surface. Alternatively, you can use one of the all-purpose sealers commercially available.

A coloured base coat can be applied by mixing acrylic pigment with the sealer in equal proportions before decorating. The durability of sealer also makes it an ideal alternative to varnish for the finishing coat (see chapter 9).

CERAMICS, PORCELAIN, STONEWARE, AND GLASS

Ceramic studios sometimes sell unfinished items which are ideal for decoration, but it is very difficult to key such a smooth hard surface. Some commercial sealants (for example Jo Sonja's All-Purpose Sealer) are effective for this purpose.

Sand the surface lightly with fine sandpaper and remove dust with a damp cloth. Apply an even coat of all-purpose sealer brushing on with a random action to avoid producing ridges. Dry thoroughly before transferring the design (see chapter 8).

With porcelain you may paint directly onto the sanded surface, although a light coat of acrylic matt spray coating before you begin to paint will make corrections easier.

CANVAS

First sponge with soap and water to remove any sizing. Rinse well and dry completely before painting. Stuff canvas shoes with tissue paper or paper towels to make a firm painting surface. Transfer the design (see chapter 8). Paint as desired using a textile medium with your pigment (e.g. Jo Sonja's Textile Medium). When the paint is completely dry, heat set in a clothes dryer for twenty to thirty minutes on a medium setting.

·····BACKGROUND·····

After preparing your surface according to the instructions in chapter 6, the next step is to apply a background. This background forms the base for the decoration or stroke work.

The variety of backgrounds illustrated in the following pages can be produced with either water-based or oil-based paints. The choice depends on which decorative pigments you intend using: if you are using acrylics the background must be a water-based paint; you can, however, place oils over acrylics.

Whether you choose to paint your decoration on a plain base-coated background or some other background of special effects with a faux (false) finish is a matter of personal taste. Plain or less fussy backgrounds tend to be better for showing off stroke work, whereas the richer backgrounds

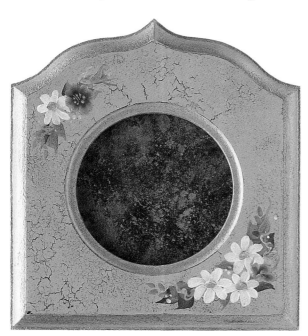

are best reserved for panels or relief work as an overall design complement.

Basic base-coating methods were described in chapter 6. We now show you how to create some unusual effects using more advanced techniques.

BASE COATING AND SEALING IN ONE OPERATION

In chapter 6, you were instructed to apply sealer as part of the preparation procedure. As a short cut, you can apply the sealer and base coat as one step. If the object is small, mix equal amounts of pigment and sealer well with a palette knife and apply. If the object is large, use emulsion (latex) as explained on page 63 but add a teaspoon of sealer for every half-cup for better binding.

Allow each coat to dry and sand lightly with fine grade sandpaper or a brown paper bag. Wipe the surface with a damp cloth. As a further step, you may wish to seal the surface with a light misting of clear acrylic spray. This will allow you to correct mistakes without damaging the background (see page 75).

METHODS FOR CREATING SPECIAL EFFECTS BACKGROUNDS AND FAUX FINISHES

Finishes and backgrounds either can be inventive or can imitate something such as wood, marble or inlay. They can also imitate the look of age. This section outlines some of the more popular and easier techniques (see also chapter 9 for more on finishing). Water-based products have been used in the demonstrations illustrated here.

EFFECTS

EASY EFFECTS

The following effects are grouped together because they are relatively quick and easy to achieve:

- Sponging
- Rag Rolling
- Stippling
- Ragging
- Aged Plaster
- Dragging

Two preparatory stages are common to all:

Stage 1 Apply one layer of base coat in your chosen colour and allow it to dry.

Stage 2 Apply a second base coat in a contrasting tone or colour. Lay it on with a brush, painting in average-length, random strokes. Then 'lay off' the paint by pulling the brush over the surface in one direction only. While this paint surface is still wet, apply the required finishing technique (see below). Water-based paints dry quickly and are thus suited to smaller areas. Large projects are more suited to slower-drying oil-based paints.

Sponging Off/Sponging On While the final layer of base coat remains wet, take a dampened sea sponge and begin lightly dabbing the surface. Twist your wrist as you work to create a random mottled effect. Alternatively, you may use the 'sponging on' method to create an attractive stippled effect.

Instead of brushing paint onto the surface, apply it with the sponge, using the same wrist motion described above. When this is dry, you can add another colour following the same procedure. Use as many colours as you like, but allow each to dry before adding the next.

SPONGING OFF

SPONGING ON

RAG ROLLING OFF/RAG ROLLING ON

Rag Rolling Off/Rag Rolling On Fold the rough edges of an absorbent cloth inwards, then roll it up into a cylindrical shape. Retain some of the interesting wrinkles for textural effects. Roll the rag over the freshly painted surface (stage 2), taking off the overcoat. Overlap each row slightly. Alternatively, you can use the 'rag rolling on' method, applying contrasting paint to your surface by rolling the paint-loaded rag over the initial dry base coat.

Stippling Use a stiff-bristled stippling or jamb brush. Holding the brush upright, begin tapping it onto your wet base coat. Work in strips and avoid bending the bristles.

Ragging Use a stockinette or alternatively some ragging purchased from an automotive shop to create a swept look. Make a soft pad with the fabric and dab at the wet base coat in a sideways movement. Skid in different directions.

STIPPLING

RAGGING

Aged Plaster Lay newspaper over the wet base coat. Rub the surface to remove air bubbles. Then lift off the paper, taking care not to slide it. This technique is only suitable for flat surfaces and provides the texture of old plaster.

Dragging Holding a jamb brush at an acute angle, pull it over the surface of the wet base coat. Work in strips, overlapping each one.

ARTIFICIAL AGEING

There are several ways to make your background look authentically old. You can create the look of old plaster (see page 69), while a *Spirit Rub* will give your work an antiqued appearance. For an old and worn look use the *Wax Resist* method, or if you want a crazed and lined look try *Crackling*.

Spirit Rub This is a very quick and easy method for achieving the antiqued look. However, it does

AGED PLASTER

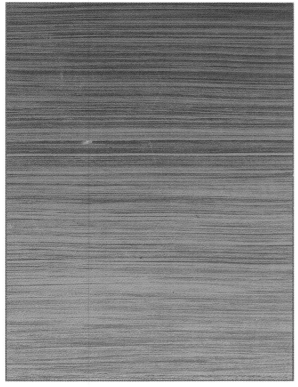

DRAGGING

SPIRIT RUB

employ methylated spirit, so work in a well-ventilated room or outdoors. Apply three layers of base coat allowing each coat to dry. Mix a solution of water and Burnt Umber (10:1). Paint this solution over the object and allow it to dry. This will look very messy! Dampen a kitchen towel with methylated spirit and wipe it over the object. Then wipe gently with a dry towel. If the object is large, work in sections.

Wax Resist Once three layers of base coat have completely dried, take a white candle and rub it onto your object in random drifts, particularly on edges and places which would be prone to wearing. Be generous with the wax. Now apply another coat of paint in a contrasting colour and allow it to dry. With medium grained sandpaper, sand the surface lightly. The paint applied on the wax drifts will come away readily. (This technique is demonstrated in the Georgian Cupboard project on page 131.)

WAX RESIST

CRACKLING

BLACK MARBLE

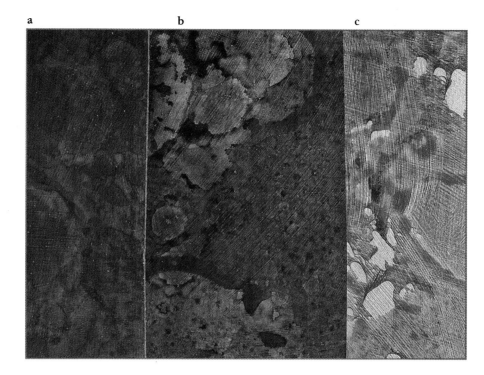

a Provincial Beige (first colour); Norwegian Red (second colour).

b Pthalo Blue (first colour); Teal Green (second colour).

c Provincial Beige (first colour); Brown Earth (second colour).

SEMI-PRECIOUS STONES

Crackling There are several crackle products available which are very easy to use. Some are applied under the base coat and some over – follow the manufacturer's instructions carefully. Once the crackles have appeared, paint over with Burnt Umber, wiping it off immediately with a dry cloth. The pigment goes into the cracks and produces an authentic aged look.

IMITATION BACKGROUNDS

These can look very effective either in panels or as a border to a plain panel rather than as straightforward backgrounds onto which decorative painting is superimposed. Two examples are demonstrated here, but you can experiment to produce many more.

Black Marble Apply three coats of black base coat and allow to dry. Then apply random blobs of black and white pigment straight from the tube onto the black surface. Loosely cover with plastic foodwrap, crumpling and mixing with both hands. Tones of grey should appear alongside the black and white areas. Remove the plastic, then draw a dampened feather across the painted surface in a diagonal direction to create a negative, veined effect. Twist and fidget to blend with the watery paint. Dip the feather into white pigment and repeat.

Semi-Precious Stones Apply two or three layers of base coat using Pale Gold mixed with sealer 1:1. When this is dry, apply a coat of Pale Gold without sealer. Allow to dry. Use varnish to thin your first choice of colour (see examples above) to a milk-like consistency. Brush this evenly over the surface, then immediately spatter the wet paint with any alcohol such as surgical spirit or isopropynol. (Alternatively, you may use methylated spirit, but beware of the fumes.) This is done by pointing the bristles of a wetted toothbrush face-down towards the work and quickly pulling your finger towards you across the bristles. Allow to dry. Brush another colour of your choice, similarly thinned with water-based varnish, over the surface. Again quickly spatter with alcohol. Some spatters should be large, others small, so that the layers of paint show through.

PATTERN

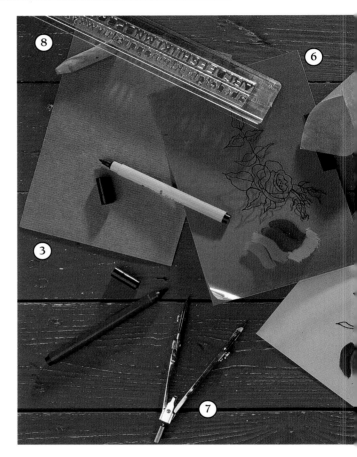

A s a beginner you are likely to follow instructions to the letter, but as you become more experienced, you'll be looking for short cuts: simplified methods of transferring a pattern onto your object as well as easier ways to approach the painting and application of borders etc. This chapter provides some useful tips.

PATTERN APPLICATION

SIMPLE TRANSFER WITH GRAPHITE PAPER

Trace the pattern onto tracing paper. Position it onto your object with graphite paper which is placed face down, underneath the tracing. Using masking tape to hold in place, trace around the pattern with a soft leaded pencil, pressing lightly so as not to leave dent marks. (Carbon paper is a poor substitute for graphite paper because it leaves permanent marks.) Use light graphite paper on dark surfaces.

SIMPLE TRANSFER USING A CHALK PENCIL

This method can be used as a substitute for graphite paper. Trace the pattern onto tracing paper. Now turn the tracing paper over and go over the lines with a chalk pencil pressing quite hard. Turn it face upwards and fix in position on the object with masking tape. Go over the pattern with a soft pencil as above. Remove the tracing paper. These lines are easily covered by paint but erase with water.

FREEHAND APPLICATION

Use a chalk pencil to draw on patterns of your own design. The lines can be erased easily if you make a mistake.

CONVERTING PATTERNS TO SIMPLIFIED GUIDELINES

Too many tracing lines can be more confusing than helpful, so we recommend sticking to basic outlines as you transfer a pattern.

There are also ways of simplifying the transfer process by using a system of guide marks. For example there is no need to trace every petal of every flower. Flowers with individual petals are easily simplified. Nor is there any need to trace leaves; the stem or trellis is enough.

TRANSFER

For many varieties of flowers, simply make a small circle at the centre and a broken line to indicate the outer margin. Paint up to the guideline.

For simple flowers such as these, a small dot or circle will be a sufficient guideline. This method is used in the Indian Chest project on page 110.

For a six-petalled flower, superimpose one isosceles triangle on another. Paint from point to point.

For a five-petalled flower, draw a five-pointed star. Paint from point to point.

For the flower stem, simply draw in the main trellis, add smaller marks to indicate placement of leaves, and paint.

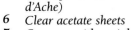

PLACEMENT OF A REPEATED
DESIGN (without using measurement)

AROUND A CIRCLE OR CYLINDER

If you wish to paint a border with a repeated pattern around a flower pot, for example, a chalk pencil is all you need. Place a random chalk mark anywhere along the rim. Now place another directly opposite. Do the same to make quarter segments, repeating as necessary.

1 Make a random chalk mark. *2 Make another directly opposite.*

3 Divide into quarters. *4 Repeat as required.*

ALONG A LONG STRAIGHT LINE

Take some brown paper or newspaper and cut a strip the same length as the patterned area you wish to cover. Fold it in half. Fold each half into halves, each quarter into halves and so on. Unfold the paper and lay it along the length to which the pattern will be applied. With a chalk pencil, make marks on the object to correspond with the folds on the paper. Apply the pattern at each point. (This is less awkward than using a ruler.)

OVER A GIVEN AREA

Cut a sheet of brown paper or newspaper to the size of the area you wish to cover. Fold it as above as many times as you wish. Then fold it at right angles the other way as many times as you wish. Lay the sheet of paper flat. Points where the folds intersect can now be marked with a piece of chalk depending on how dense you wish to make your pattern. In the example illustrated alternate

intersections are chalked. Press hard with the chalk to leave a good deposit of chalk dust. Press the chalked side of the paper onto the object, thus leaving behind the chalk deposits as indicators for pattern placement. This method is used in the Indian Chest project on page 110.

FINDING CENTRE POINTS

SQUARE/RECTANGLE

1 Fold from corner to corner.
2 Repeat in opposite direction.
3 Intersection point is the centre.

CIRCLE

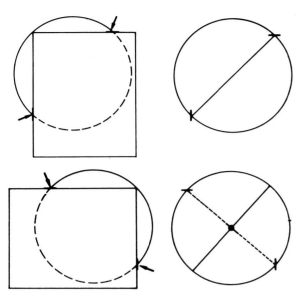

1 *Place an A4 sheet of paper on the circle with the corner touching the edge. Mark the points where the paper crosses the circle (arrowed).*

2 *Remove paper and connect the two marked points.*
3 *Repeat in the opposite direction.*
4 *The lines cross at the centre of the circle.*

DESIGN AND COLOUR TRIALS

If you are undecided or hesitant about your choice of pattern or which colour scheme to use on an object, you can easily experiment.

Take a sheet of clear acetate, and use a non-permanent felt-tip pen to trace on the pattern. Now lay this in position on your object and you can judge for yourself whether the design is suitable. If you feel the pattern needs some additions or deletions, you can make adjustments and test them by this method. The non-permanent pen marks will wipe off afterwards.

If you have already base coated your object and wish to do some colour scheme trials before going any further, you can also use this method. Water-based paints adhere effectively to the acetate. Paint on a variety of colour schemes and choose the one that appeals most. The paint will easily wash off when you are finished.

ENLARGEMENTS AND REDUCTIONS

PHOTOCOPY METHOD
The easiest way to enlarge or reduce a pattern is by the photocopy method. Modern copiers can do the job at the press of a couple of buttons.

PANTOGRAPH METHOD
Pantographs can be purchased at any drafting or art supplies shop.

PROPORTIONAL GRID METHOD
Without access to a copier or pantograph, size adjustments can be made with proportional grids. These will enable you to redraw the pattern on an easy segment-by-segment basis.

PAINTING STRAIGHT AND CIRCULAR BORDERS

It takes a steady hand to paint a straight border. If you are not ready for this challenge, here is the solution. You will need a compass with an ink attachment (inker), and a ruler with an angled edge. (It must have an angled edge otherwise the paint will smudge as the ruler is removed.) The flat edge should face upwards thus creating a hollow between the inker, the straight edge, and the surface. Alternatively, use an ordinary ruler raised off the surface by inserting some small coins underneath it. Circular border lines can be made using the inker. You needn't worry about it blotching. It is a very efficient implement. Practise first on paper to raise your confidence.

CORRECTING ERRORS

In chapter 6 on surface preparation, we advised applying a coat of varnish (by either spray or brush) before resuming the decorative work. This precaution is very helpful when faced with a mistake or something you don't like.

To remove a mistake from a varnished surface, quickly dip your brush in water and run it over the error several times. Blot the area with a paper towel. Repeat if necessary.

FINISHING

With the decorative stroke work completed and thoroughly dry, your piece is ready for the final stage or stages.

The very final stage is the application of several coats of varnish and/or wax to protect your work, but there are other optional interim stages you might consider. For example, you may feel the decoration looks rather brash, pristine, or new, and needs toning down a little. If so, you can give it an aged look by antiquing and/or fly-specking. The effect is similar to a beauty spot on the face – blemished perfection!

INTERIM FINISHES

ANTIQUING

The best pigment to use to create an authentic antiqued look is Raw Umber. Other appropriate pigments are Burnt Umber, Prussian Blue, Raw Sienna, and Burnt Sienna.

Before proceeding, apply a couple of coats of varnish to your object, so that if your result disappoints you it can be wiped off with a thinner.

If your object is small or if the surface is vertical, or if you only want to tone down certain areas of your work (for example a brash gold border), you can use the pigment straight from the tube. In paste form, it won't run. Pick up a small amount of pigment onto a soft cloth and begin to rub it onto your object. Give the surface a light glazing and then polish it off until the right effect is achieved. Work quickly if using acrylics because they are fast-drying. For larger projects, mix up an antiquing glaze. You will need either a water-based antiquing medium for acrylics or an oil glazing medium for oil-based paints. Both mediums are available commercially. Medium is added to a small amount of Raw Umber pigment to make a sloppy paste which is the antiquing glaze. When you paint this onto your object the covering will look like a brown sludge, but don't worry! Begin to remove the excess with a soft cloth. Rub more where you feel there should be a highlight and less where you think the antiqued effect should be strongest. Try to achieve a blending effect from darker to lighter areas.

FLY-SPECKING

The effect of fly-specking on top of antiquing is a moot point. Some think the spattered effect enhances an object and makes it look more natural while others think it looks amateurish and careless. The way to create the effect is to take a toothbrush and dip the bristles lightly into the antique glazing mixture, perhaps slightly thinned. With the bristles face down towards the object, run your thumb over the bristles in a flicking motion. Be careful not to overdo it.

THE 'VERY' FINAL OPTIONS

The objective when applying the very final finish or finishes is not only to protect your work, but also to give it the desired sheen. If you want

TOUCHES

something quick, easy, and modern, simply apply varnish. If, on the other hand, you want a more traditional look, you may need a special varnished effect. Alternatively, a waxed sheen might be more to your liking.

VARNISHING

Two or three coats of varnish are needed to provide adequate protection to your work. Use a water-based varnish if you are using acrylics and an oil-based varnish if using oils or alkyds. Depending on the quality of the sheen you require, a range of choices is available from glossy to matt finishes. Each coat should be applied in thin layers for even coverage and drying. Sand between coats with a very fine grade of sandpaper or a brown paper bag.

Water-based varnishes look milky in the tin, but dry clear. They have a short drying time so will not pick up moisture and dust from the atmosphere as readily as polyurethane varnish. They are not as protective in terms of wear and tear, but for small decorative items are ideal.

Some tips for successful varnishing are to ensure your working area is as dust free as possible, that your piece is absolutely dry, and that there are no draughts coming through doors or windows. Avoid excessively humid conditions as this can cause a milky bloom to appear on your work. Always follow the manufacturer's instructions as these do vary by brand.

USING SHELLAC AS AN ALTERNATIVE TO VARNISH

Shellac produces a very smooth authentic 'yellowed with age' look and is used in French polishing. It can be used over both oils and acrylics. Shellac is available in various grades from standard brown to fine-grade orange, and is sold under a variety of brand names.

It requires thinning with methylated spirits, and because of this is quick drying when used on wooden objects. Be prepared to ruin a brush unless you buy a cellulose brush cleaner. Work quickly and wear a protective mask against the fumes.

WAXING

The patina of a waxed finish requires a little more elbow grease but is worthwhile if you like to maximize the authentic look. Any commercial brand of hard wax (not spray) is suitable, preferably a brand containing beeswax to give the most authentic patina.

Wax can be a protective coat on its own if used directly over oil-based paints. With acrylics, you should apply one or two coats of matt water-based varnish before waxing. The main dis-advantage of wax is that it reacts to direct moisture and heat. Coffee cup blooms, for example, are an all too familiar sight on unprotected waxed surfaces.

Using a soft cloth, apply the wax to your object sparingly. Allow it to dry and then polish off with another clean soft cloth. Repeat this procedure three or four times and a lovely satin sheen begins to appear. An occasional fresh coat of polish will keep your piece in good condition.

······ 20 PROJECTS ·······

INTRODUCTION

The following notes apply to all the projects in this chapter:

• • • •

• Most projects in this chapter use water-based rather than oil-based products; actual materials used are specified in each case.

• A number of manufacturers produce an integrated range of products for the decorative art market. These include pigments, sealer, mediums, and varnish. For the purposes of this book, the Jo Sonja's integrated range has been used; if you are using another manufacturer's pigments, please refer to the colour conversion chart on page 19 to help you select your colours. Suppliers and stockists are listed on page 166.

• Bear in mind that where mixes of paint are recommended, the proportions are approximate only.

• Flow medium may be used as a water substitute for thinning paint. As well as extending the paint flow it eradicates brush marks.

• Ideal brush sizes are given for each project — substitute a similar brush from your own collection if you do not have the exact size to hand.

• Many projects contain instructions to 'base in' an area. This means you should paint in a background or base colour using no particular stroke unless specified. This base forms the foundation for the stroke work.

• Patterns may be enlarged or reduced as appropriate (see page 75).

• Chalk pencils and graphite paper are recommended for pattern transfer as the lines can later be washed or rubbed off (see page 72).

• Remember to erase all visible pattern lines before varnishing. Chalk or graphite tracing lines are easily erased with a damp brush after the paintwork is dry.

• • • •

This chapter draws the contents of the book together in twenty exciting and diverse projects. Everything you have learned in these pages can now be put to practical use. The stroke-work painting skills you have practised are combined with background painting and finishes to produce objects which will enliven your home or can be given to friends as gifts.

EVERY STEP IS ILLUSTRATED
Detailed instruction is given on how to produce the finished designs from the initial patterns provided. Each step of the painting process is methodically demonstrated in a stage-by-stage approach which leaves nothing to guesswork.

A WIDE VARIETY OF PROJECTS
The projects have been carefully selected to provide a representative range of the many

·····STEP-BY-STEP·····

applications of folk art technique. You will find traditional European examples, from which began the folk art movement as it is known in the West today, together with less familiar but just as inspiring examples from non-European cultures who have also developed characteristic folk-painting styles and themes. The selection goes even further, borrowing familiar decorative themes from antiquity and illustrating how these too can be expressed using folk painting techniques. We even show you how an Art Nouveau design can be adapted. Finally, for the more adventurous, in project 20 we show that almost any design can be adapted to the folk-painting technique.

CHOICE OF ARTISTS' COLOURS AND MATERIALS

There is a wide choice of products on the market which can be used for decorative art. As regards artists' colours, the choice is between oil-based and water-based types. If you already have oil colours to hand, then try a project with them by all means; but if you are starting from scratch, you should buy water-based products.

As we saw in chapter 2, water-based products are non-toxic and do not require white spirit as a thinning agent, thus are safer to use. They also dry much more quickly, which is a great help whilst you are learning, and means quick results can be achieved. However, not all water-based

colours are suitable. Poster paints are unsuitable because they are non-durable, and fine-art water-colour pigments are not appropriate because their colour density is too low.

Ordinary water-based acrylic paints satisfy the quick-drying criterion, but their paint density, and hence their ability to cover an object or pattern, is less than satisfactory. Best results are achieved by using acrylic gouache water-based paints, which satisfy both these important criteria. The projects in this book use Jo Sonja's Acrylic Gouache.

OBJECTS TO PAINT

As mentioned in chapter 6, gouache acrylic paint can be used on a variety of surfaces, including wood, metal, ceramics, and fabric. Small-scale items, especially of wood, are available at reasonable prices from a variety of suppliers, such as kitchen shops or second-hand shops. In some areas, specialist folk art shops supply just about anything you care to name, either on the premises or by mail order (see page 166).

PIGMENT AND PAINT COMPATIBILITY

You must always use compatible base coats and finishing coats. For example, oil-based and water-based products don't mix, so you need to decide which system you are going to use. If you simply must mix the two, for example if you wish to apply water-based decoration to an oil-based base coat (or vice versa), you must first apply an interfacing coat of shellac over the base coat.

Shellac can also be used to avoid stripping an object before proceeding with the decoration, particularly useful if you wish to decorate large items of pre-painted furniture.

TRADITIONAL FOLK ART

Most countries, if not all, seem to have developed their own folk painting traditions. It was not a grand art form, but it gained in currency with the rise of the middle classes. Within affordable limits, they commissioned and bought painted artefacts according to fashion and tradition. Much of the subject matter was copied and adapted from a variety of sources. Indeed, there were favourite themes that cropped up in a multitude of variations, depending on the penchant of the artists and the materials and pigments available to them.

For folk art hobbyists worldwide, European subjects are the most familiar. In fact, many examples were carried over to the American continent, where the hobby now has the strongest following. This section introduces seven very representative European examples of painting styles.

TREE OF LIFE TRAY

No one can fail to recognize the tree of life motif, which has many variations internationally. It signifies renewal, growth and vitality, and is often combined with birds, thus reminding us of its water-giving properties as well. This particular example, although not directly European, was probably adapted from a European example which found its way to Pennsylvania – perhaps by way of a German settler.

In this example the stroke-work leaves are accented with shade and highlight colours, while the birds are base coated in a solid colour with and decorated stroke-work.

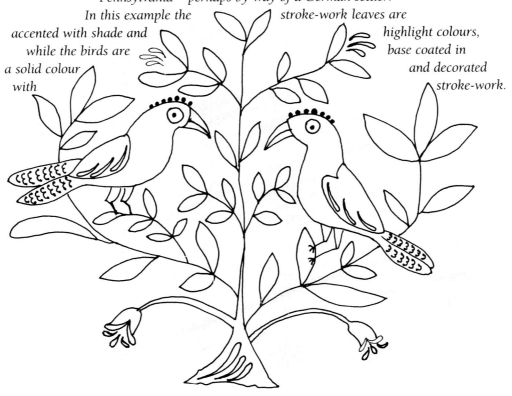

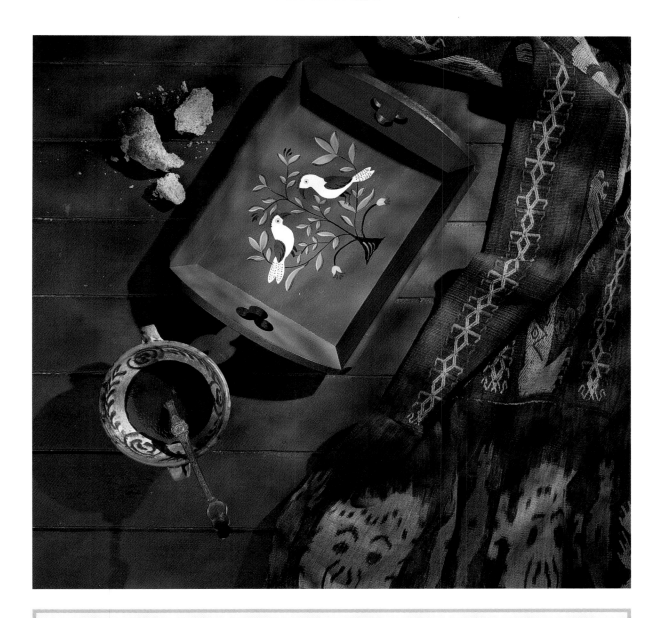

MATERIALS

• Wooden tray of any size or shape.

BASE COAT

• French Blue. Red Earth for trim (Jo Sonja's colours or similar substitutes).

FINISH

• Water-based varnish.

PALETTE

• Jo Sonja's colours or similar substitutes: Prussian Blue, Brown Earth, Red Earth, Fawn, Moss Green, Pine Green, Yellow Oxide, Yellow Light, Warm White.

BRUSHES

• No. 4 round, flat ¼in (6mm), liner, large flat brush for base coating.

OTHER SUPPLIES

• Tracing paper, graphite paper, soft lead pencil, chalk pencil, brown paper bag, palette knife.

INSTRUCTIONS

BACKGROUND PREPARATION

1 Sand and seal the wood as in the general instructions (pages 62–3). When dry, re-sand lightly with a brown paper bag.

2 Using the flat brush apply a coat of French Blue for the main colour and a coat of Red Earth for the trim.

3 When dry, apply a second coat of each colour. Once this is dry, transfer the pattern (see page 72 for instructions on how to do this).

TREE

1 Mix Prussian Blue with a touch of Brown Earth using a palette knife.

2 Base coat the tree trunk and branches. Use the No. 4 round brush for the base of the tree and the liner for the rest.

3 Mix Moss Green and Pine Green in the proportions 2:1 and with the liner paint commas on trunk.

LEAVES

1 Mix Moss Green and Pine Green 2:1.

2 Using the round brush, base in the leaves using comma strokes. The larger leaves require two strokes.

3 When dry, line the lower sides of the leaves with Pine Green and the upper sides with Yellow Oxide.

4 As indicated on the pattern, add decorative comma strokes with Pine Green between the upper leaves.

FLOWERS

1 Mix Yellow Light and Fawn 2:1 and base in the flowers with two comma strokes.

2 When dry, add decorative comma strokes with Red Earth.

BIRDS

1 Using the round brush, load with Warm White and base in the bird. You may need three coats to create an even finish.

2 When dry, base in the wing and beak with Red Earth, using the round brush.

3 When these are dry, add Black comma strokes to the wing. Separate the beak with Pine Green using the liner brush.

4 Base in the iris of the eye using Yellow Oxide. When dry, add a dot of Pine Green for the pupil. Base in the beak with Red Earth. When dry make a separating line with Pine Green and liner brush.

5 Base paint the legs and feet with Pine Green.

6 Add dots for the comb on bird's head using the wooden end of your paint brush. Dip it into Red Earth and then carefully apply each dot.

7 Add the tail details: make a very thin ink-like solution of Pine Green then use a liner to make the pattern, which is a series of 'W's with tiny dots at either end.

FINISHING

When completely dry, erase tracing lines and apply three or four coats of varnish, sanding lightly between each coat once dry.

KEY		
1 French Blue	*4 Yellow Oxide*	*8 Prussian Blue*
2 Moss Green	*5 Red Earth*	*9 Warm White*
3 Pine Green	*6 Fawn*	*10 Brown Earth*
	7 Yellow Light	

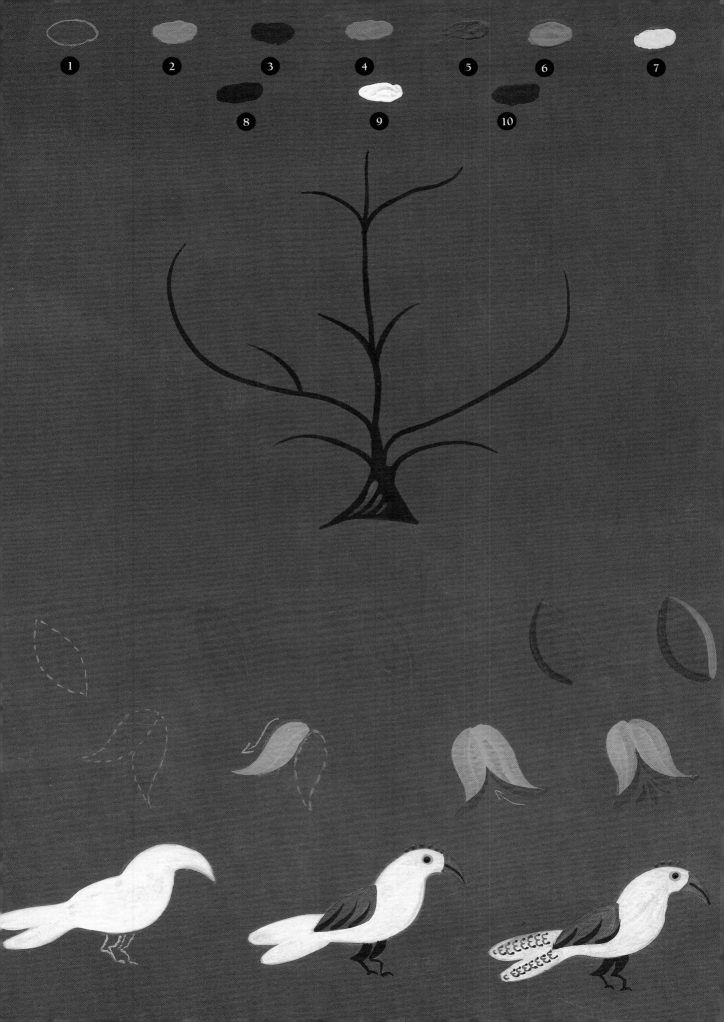

POT OF TULIPS PATTERN

This design is a variation on the previous project's theme, the Tree of Life. Here, the elongated stems and outsized flowers have grown to tree-like proportions. Such interpretations allowed the folk artist to satisfy his imagination without forfeiting the symbolic significance of the various elements, tulips symbolizing the flame of Christ while the vessel represents the water of life.

It is also of interest to note that this historically recent design illustrates the trend towards stylization which has become almost a trademark of the folk art motif. (Compare this with the earlier, more natural design used in the Romanian project on page 92.) Variations on this theme are widespread. This popular and symbolic folk motif looks well when mounted in a frame for wall display or as a cupboard door.

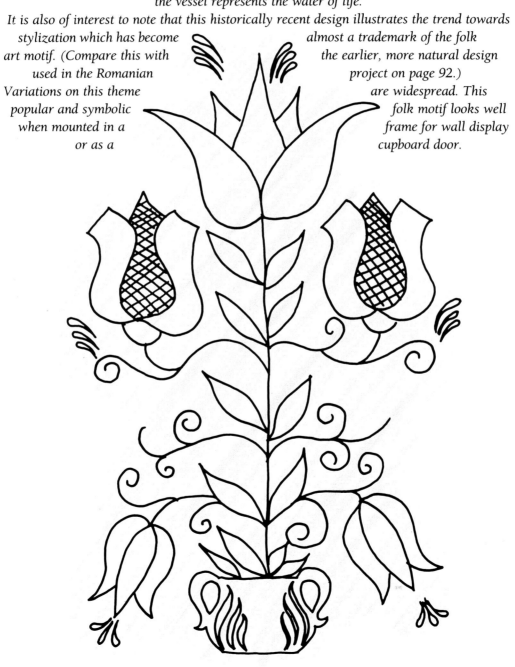

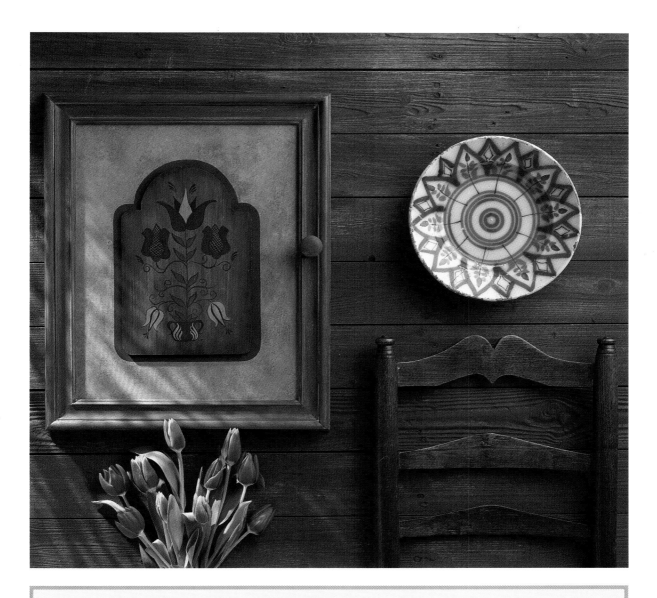

MATERIALS

• The design is painted on to a shaped wooden board.

BASE COAT

• Warm White, Yellow Oxide, Red Earth (Jo Sonja's colours or similar substitutes), Kleister medium (optional), all-purpose sealer.

FINISH

• Water-based varnish.

PALETTE

• Jo Sonja's colours or similar substitutes:

Green Oxide, Indian Red Oxide, Napthol Red Light, Red Earth, Sapphire, Storm Blue, Ultramarine, Warm White, Yellow Oxide.

BRUSHES

• Old stiff-bristled brush, large brush for base coating, ¼in (6mm) flat, No. 4 round, liner.

OTHER SUPPLIES

• Tracing paper, graphite paper, soft lead pencil, chalk pencil, fine grained sandpaper or brown paper bag.

INSTRUCTIONS

BACKGROUND PREPARATION

1 Sand and seal the wood as in the general instructions (pages 62–3). When dry, re-sand lightly with a brown paper bag.

2 Base coat with two coats of pale yellow, using Warm White and Yellow Oxide in the proportions 12:1.

3 To create the wood grain effect, measure approximately one teaspoon of Kleister medium onto your palette. Add a small amount of Red Earth and mix well. Then with a large brush apply an even coat over the base colour. Quickly take a dry, stiff-bristled brush and drag it through the wet paint until the desired effect is achieved. An alternative method is to add the Red Earth colour to sealer or varnish, dragging the mixture with a stiff brush.

4 When thoroughly dry, transfer the pattern using graphite paper or a chalk pencil (page 72).

STEM AND BRANCHES

1 Mix Green Oxide and Napthol Red Light 2:1.

2 Thin the paint mixture with flow medium or water and begin painting the stem and branches.

LOWER TULIPS

1 Load No. 4 brush with the Yellow Oxide mix and paint in 'S' stroke outer petals and teardrop inner petal.

2 When dry, outline central petal with bright red mix, and the outer petals with Green Oxide.

SIDE TULIPS

1 Using the same blue mix as above, with a flat brush paint the side petals.

2 Use the red mix as above and paint in the central section.

3 When dry, cross-hatch with the yellow mix used above. The hatching should run parallel with the outside of the middle petal.

4 Paint the calyx with Red Oxide.

POT

1 Base the pot with the blue mix.

2 When dry, add 'S' strokes with liner loaded with Yellow Oxide mix.

LEAVES

1 Base with Green Oxide.

2 Outline with the Green Oxide and Napthol Red Light mix.

TOP TULIP

1 Mix Ultramarine with Sapphire and Storm Blue 4:1:1.

2 Load a round brush and paint the blue petals using an 'S' stroke.

3 Base in the middle petal with a mix of Yellow Oxide and Warm White 1:2.

4 Paint in the red petals with a mix of Napthol Red Light and Indian Red Oxide in the proportions 4:1.

FINISHING DETAILS

1 Add decorative red comma strokes as shown on finished object.

2 When the object is completely dry erase tracing lines and varnish with two or three coats of water-based varnish, sanding lightly between each coat once dry.

KEY	
1 *Green Oxide*	5 *Indian Red Oxide*
2 *Yellow Oxide*	6 *Napthol Red Light*
3 *Warm White*	7 *Storm Blue*
4 *Red Earth*	8 *Ultramarine*
	9 *Sapphire Blue*

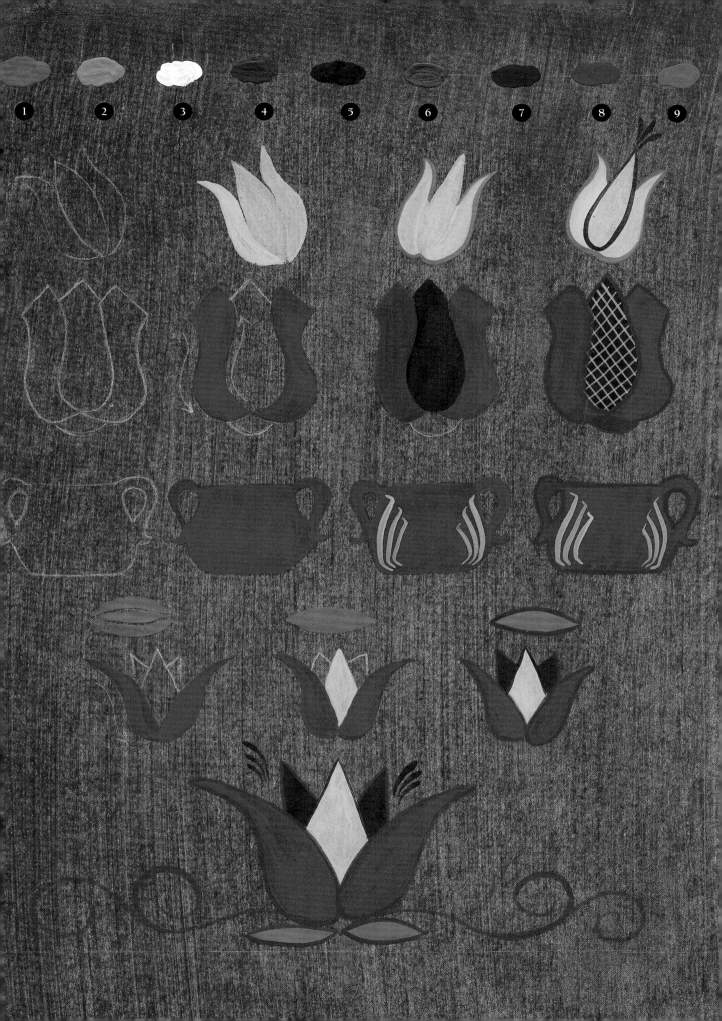

BAVARIAN BOX

In the Middle Ages the craft of making curved wooden boxes, fashioned from thin strips of wood by a special axe, was introduced in Bavaria. These boxes are commonly known as 'shaker boxes' today.
Traditionally, the boxes were used to store a wide variety of items both in the home and commercially. Families used them to store documents, or heirlooms such as christening gowns or bridal head-dresses. Decoration was added to mark the special nature of the contents: many of those in daily use or for more mundane items were plain.
The strikingly delicate visual impact of the design on this fairly easy project is achieved by combining plenty of small strokes, dainty white lines and amusing little curlicues.

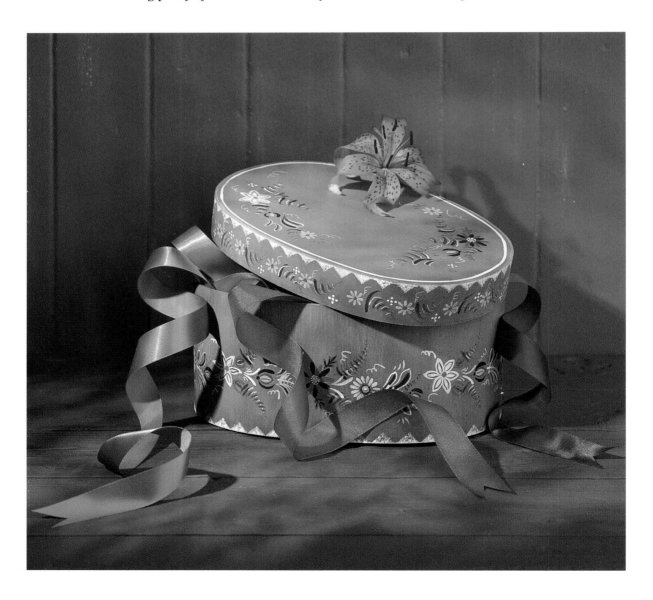

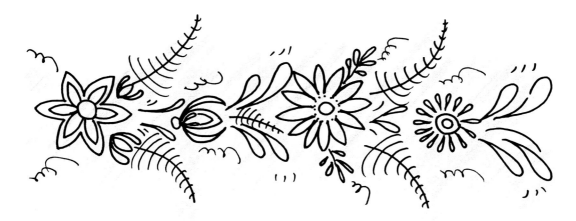

MATERIALS
• • • • • • • • • •

• Shaker box 10 × 7in (25 × 18cm), or any
similar box.

BASE COAT

• All-purpose sealer, Norwegian Orange,
Turner's Yellow, Raw Sienna (Jo Sonja's
colours or similar substitutes).

FINISH

• Water-based varnish.

PALETTE

• Jo Sonja's colours or similar substitutes:
Warm White, Sapphire, Storm Blue, Turner's
Yellow, Burgundy, Green Oxide, Pine Green,
Teal Green.

BRUSHES

• Large brush for base coating, No. 4 round, liner.

OTHER SUPPLIES

• Tracing paper, graphite paper, soft lead
pencil, chalk pencil, small square piece of
sponge, masking tape, brown paper bag.

INSTRUCTIONS
• • • • • • • • • • •

BACKGROUND PREPARATION

Mix Norwegian Orange, Turner's Yellow, and
Raw Sienna in the proportions 2:2:1. Add an
equal quantity of all-purpose sealer. Mix well.
Base coat the box with two coats, painting the

inside as well as the outside. Allow each coat to
dry, sanding lightly between each.

ZIG-ZAG BORDER

1 Apply masking tape ½in (12mm) from the

top edge of the lid and the bottom edge of the base. Dampen the square sponge.

2 Using a brush, paint Warm White onto one of the corners of the sponge.

3 Position the corner of the sponge on the exposed border area and begin dabbing along the edge to create a zig-zag pattern. After five or six dabs, paint some more white paint onto the sponge and continue dabbing. Allow to dry.

BOX BASE

Using graphite paper, trace on the design outline (see page 72). There is no need to trace on the detail, as this is painted on later.

SMALLER FLORAL DETAILS

Paint the small floral details – the buds and tulip-shaped flowers. Use a liner brush when painting the dark pink and white details.

LARGE PINK FLOWER

1 Mix Warm White with a touch of Burgundy.

2 Base in petals with No. 4 brush. The brush stroke should be pulled away from the centre.

3 Add more Burgundy to a small amount of this paint mixture to make a darker tone.

4 Load liner brush and paint around petals.

5 Thin the paint. Dip the wooden end of the brush into the paint and make a dot for the centre of the flower.

LARGER TULIP

1 For the tulip flower, use Turner's Yellow for the central petals, Storm Blue for the outer petals, Warm White and a dark-toned pink mix to line the inner petals, as shown opposite.

2 Load a liner brush with Green Oxide and paint in the stem.

FERN FRONDS

Mix Green Oxide with water or flow medium. Load liner. Paint frond as shown – first the stem, then the cross-pieces.

LARGE BLUE FLOWER

Petals are painted with alternating strokes of Storm Blue and Sapphire. Base in each petal in these alternating colours using the teardrop stroke with a No. 4 brush.

MULTI-PETALLED PINK FLOWER

1 Using same light pink tone as for the large pink flower, base in all the petals.

2 Add a pink centre using the No. 4 round brush, followed by yellow, then white.

3 Paint yellow flowers around the side of the lid in the same way, adding a Sapphire centre.

LARGE COMMA LEAVES

Load the No. 4 brush with Green Oxide and paint comma leaves. Shade with Teal Green and Pine Green mixed 1:1. Add Warm White highlights as shown opposite.

CURLICUES AND DETAIL

Thin a little Warm White. Load liner brush and add the curlicues using a light-wristed, circular motion. With wooden end of brush, add Warm White dots.

LID

1 Trace on pattern. Paint on design as above, adding the blue-centred yellow daisies.

2 Take a chalk pencil and make a guideline ¼in (6mm) all the way round the lid.

3 Load liner with Warm White and paint a narrow border around the lid.

FINISHING

1 Erase any tracing lines.

2 Apply two or three coats of varnish, sanding lightly between each coat once dry.

KEY

1	Raw Sienna	6	Storm Blue
2	Norwegian Orange	7	Burgundy
3	Turner's Yellow	8	Green Oxide
4	Warm White	9	Pine Green
5	Sapphire	10	Teal Green

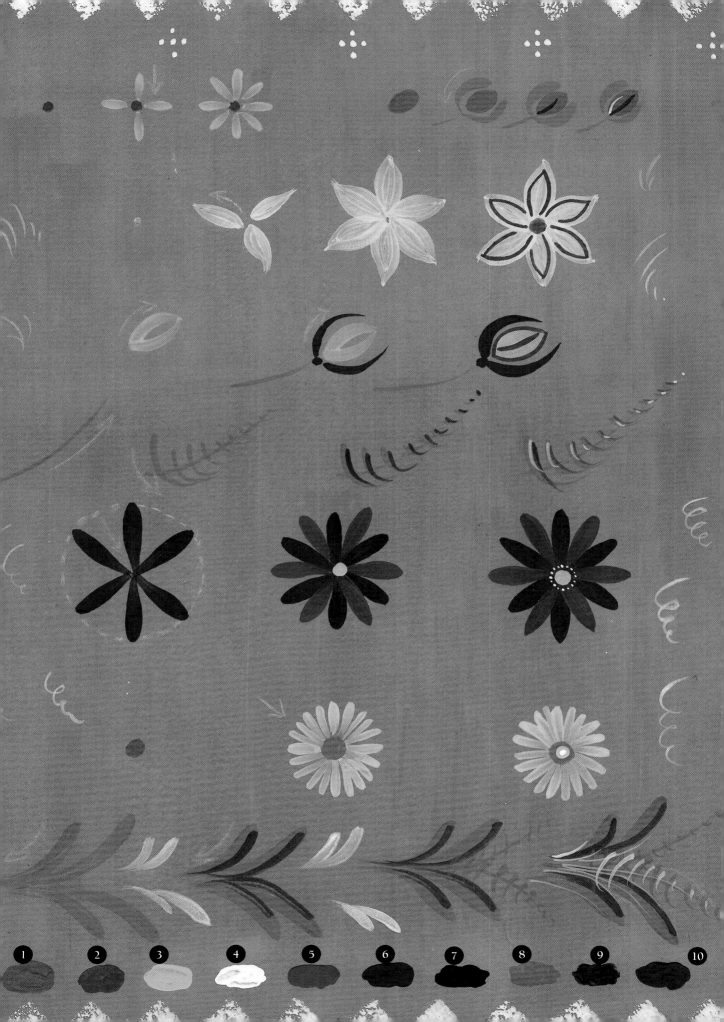

SEWING TABLE WITH ROMANIAN DESIGN

Traditional folk painting is usually associated with rather stylized decorative forms, so this lively example is quite a contrast. Instead of straight stalks with oversized flower heads firmly fixed on top, here you almost feel that these tulips are gently swaying in a breeze. This looser style was the result of Renaissance influence, which pre-dated the trend towards stylization.

The detail illustrated in this project is taken from a Romanian chest dated 1768, which appears in the Ethnographic Museum of Budapest. Instead of adhering rigidly to stroke work, the motifs are simply washed in with colour and then over-stroked. The cover illustration shows the same design used on a tin box.

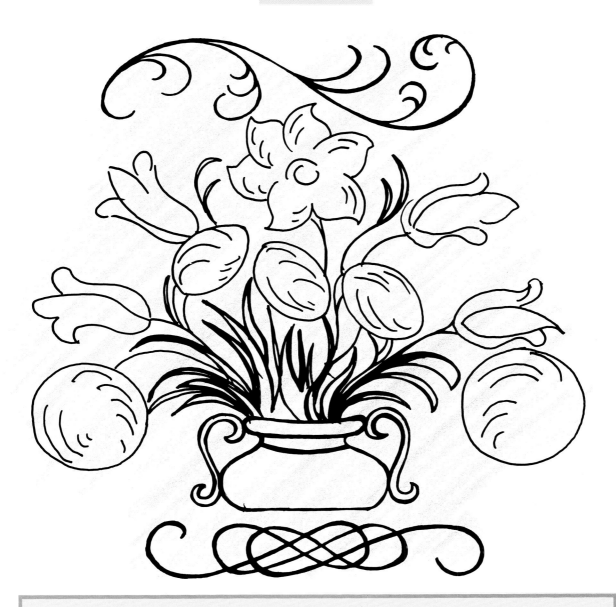

MATERIALS

• • • • • • • • • •

• A small wooden sewing table is used here but any box-shaped object could be utilized.

BASE COAT

• All-purpose sealer, Sapphire, Warm White, Storm Blue, Teal Green (Jo Sonja's colours or similar substitutes).

FINISH

• Water-based varnish.

PALETTE

• Jo Sonja's colours or similar substitutes:

Smoked Pearl, Raw Sienna, Vermilion, Warm White, Pthalo Blue, Teal Green, Payne's Grey, Carbon Black.

BRUSHES

• Large base coating brush, ⅜in (9mm) flat, No. 4 round, liner.

OTHER SUPPLIES

• Tracing paper, graphite paper, soft lead pencil, chalk pencil, natural sponge or towelling, two jam jars with lids, brown paper bag.

INSTRUCTIONS

BACKGROUND PREPARATION

1 Mix a small amount of Warm White with Sapphire in the proportions 1:5 to make a slightly lighter tone, then mix it in equal parts with all-purpose sealer. Apply one coat of paint all over, allow to dry then sand. Apply a second coat. Allow to dry. You will need approximately ½ cup of paint for a table such as this. **(a)**

2 Brush on Storm Blue wash using random strokes. (Making a wash is very easy: simply mix a very weak solution of Storm Blue and water in a jar. Give the jar a good shake. Four or five chocolate-chip sized drops of pigment with ⅛ cup of water will be sufficient. Test the density of the wash on paper and add pigment or water to suit.) Avoid overloading the brush. The paint should have a swept-on look. **(b)**

3 Before it dries, sweep over it again in one direction to blend the wash into the base. Allow to dry. **(c)**

4 Wash with Teal Green, using the same method as above. Mix the wash with all-purpose sealer 4:1 and brush on. Allow to dry. **(d)**

OFF-WHITE CENTRAL PANEL (see below centre)

Mark out a central square panel leaving a 2½in (60mm) blue border.

1 Mix seven chocolate-chip sized drops of Smoked Pearl with an equal amount of all-purpose sealer. Apply two coats using the large brush, allowing each to dry before applying the next. **(e)**

2 Wash with Raw Sienna, painting in one direction only. **(f)**

3 Before the wash dries, dab with a dampened sponge or paper towel to create a mottled effect. Avoid overdoing the sponged effect. When dry, trace on the motif (page 72) **(g)**

POT

1 Base in pot with Pthalo Blue.

2 Using the liner, outline with Payne's Grey.

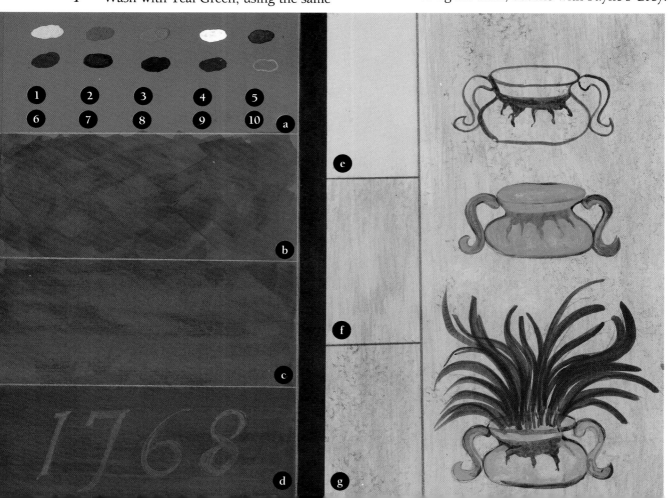

Shade the neck of the pot.

3 Mix Pthalo Blue with a small amount of Warm White and paint over the outlines.

4 Before the paint dries completely, dab with a damp sponge or cloth.

FLOWERS

1 Using the No. 4 brush, load with a watery Vermilion and paint in the base coat.

2 Load the No. 4 brush with a less-watery Vermilion and add strokes of stronger colour to each petal.

3 Using a liner loaded with Payne's Grey, paint in floral outlines.

LEAVES

1 Using the liner brush loaded with Payne's Grey, paint some freehand leaf strokes. Allow to dry.

2 Mix Teal Green with a small amount of Payne's Grey. Load the No. 4 round brush and over-paint the leaves.

BLACK BORDERS (see below right)

1 Rule in all the borders around the central panel. You will see that for the box on the cover the lid, base and corners were also ruled.

2 Using the ⅜in flat brush, paint in all the black borders using Carbon Black. Allow to dry.

3 Paint in the wavy line with a liner loaded with Smoked Pearl.

SCROLLS

Load the liner with Smoked Pearl and paint scrolls. Highlight with Vermilion.

FINISHING

Erase all tracing lines. Apply two or three coats of varnish. Sand lightly with a brown paper bag between each coat once dry.

KEY			
1	*Smoked Pearl*	4 *Warm White*	8 *Carbon Black*
2	*Raw Sienna*	5 *Pthalo Blue*	9 *Storm Blue*
3	*Vermilion*	6 *Teal Green*	10 *Sapphire*
		7 *Payne's Grey*	

ROSEMALING IN ROGALAND STYLE

Rosemaling, or 'rose painting' was a flourishing decorative art form in Norway during the eighteenth century. A number of distinctive styles arose, one of them Rogaland, whose chief characteristic is symmetry. This contrasts with the similar but asymmetric Telemark style.

Despite the name, roses are ... *not always the outstanding feature of rosemalled pieces.* ... *In this example, tulips dominate, although the* ... *central stylized flower and smaller white* ... *flowers are rose variations.* ... *Rosemaling is now often* ... *used as a general term* ... *for Scandinavian decorative* ... *art.*

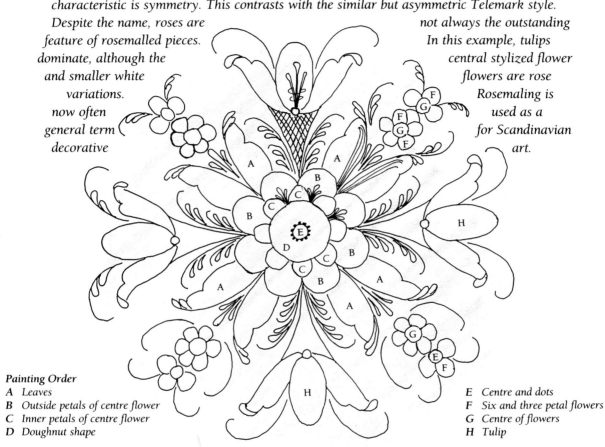

Painting Order
A Leaves
B Outside petals of centre flower
C Inner petals of centre flower
D Doughnut shape
E Centre and dots
F Six and three petal flowers
G Centre of flowers
H Tulip

MATERIALS
· · · · · · · · · ·

• Round plate (the one pictured has a 14in (35cm) diameter with an 8in (20cm) centre).
FINISH
• Water-based varnish.
PALETTE
• Jo Sonja's colours or similar substitutes: Warm White, Yellow Oxide, Pine Green, Burnt Umber, Norwegian Orange, Teal Green, Napthol Red Light, Moss Green, Raw Sienna, Smoked Pearl, Carbon Black, Prussian Blue.

BRUSHES
• Large brush for base coating, ⅛in (3mm) flat, ¼in (6mm) flat, ½in (12mm), No. 5 round, liner, teardrop.
OTHER SUPPLIES
• Tracing paper, white graphite paper, chalk pencil, stylus or toothpick, all-purpose sealer, Jo Sonja's Kleister medium (or thick-cream consistency wallpaper paste), aluminium foil, fine grade sandpaper.

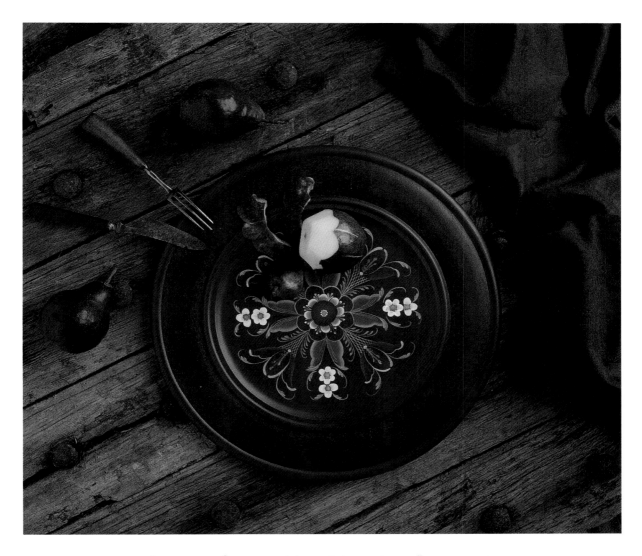

INSTRUCTIONS

BACKGROUND PREPARATION

1 Page 99 is divided into four sections to show how the paint work has been developed, but tackle the painting by following the lettering order A to H on the black-and-white pattern.

2 Mix Napthol Red Light and all-purpose sealer in the proportions 1:1 and base coat the border. Two or three coats may be needed. Mix Teal Green and sealer 1:1 and base coat the centre, outside rim, and back. Allow both to dry.

RIM

Mix Kleister medium and Burnt Umber 4:1.

Apply with the large brush. While wet, take a crumpled piece of aluminium foil and dab it round the rim. Apply a coat of varnish to the whole plate when dry. This will allow paint spills or mistakes to be wiped off easily.

LEAVES (A)

1 With a ½in flat brush base coat the leaves with a mix of Pine Green and Yellow Oxide 2:1.

2 Sideload with a mix of Teal Green with a touch of Carbon Black. Shade the leaves on the straight side. Sideload with Moss Green and highlight scalloped side.

3 Thin Moss Green with water. Add three thin vein lines curving at the top. Finish with two tear-drop strokes or two comma strokes in Moss Green.

4 Mix Napthol Red Light and Norwegian Orange 4:1. Add decorative commas between the leaves.

CENTRE FLOWER – OUTER PETALS (B)

1 Mix Napthol Red Light and Norwegian Orange 4:1 and undercoat these petals using a ¼in flat brush. Two coats may be necessary.

2 Add a touch of Prussian Blue to Napthol Red Light mix above. Sideload brush and shade the bottom sections of the petals.

3 Mix Yellow Oxide and Smoked Pearl 1:2. Use a liner to outline each petal.

CENTRE FLOWER – INNER PETALS (C)

1 Using a chalk pencil, draw in or retrace these petals as indicated in section 1 opposite.

2 Base in petals with Yellow Oxide.

3 Sideload ¼in brush with Raw Sienna and shade towards the inside of each petal.

4 Sideload ¼in brush with Warm White and highlight the outside of each petal.

5 Load a liner with the Napthol Red Light/ Norwegian Orange mix. Tip with Warm White. Add three teardrops between each petal.

FLOWER CENTRE (D, E)

1 Base in with Pine Green and Yellow Oxide mixed 2:1 using the ½in flat brush.

2 Sideload ¼in flat brush and shade with Teal Green and Carbon Black mix leaving a portion of the Pine Green and Yellow Oxide centre exposed. Shade around the outside edge.

3 Paint the centre with Yellow Oxide using the ⅛in flat brush. Using toothpick or stylus add dots in Warm White.

WHITE FLOWERS (F, G)

1 Mix Warm White and a touch of Moss Green. Using a ¼in flat brush, paint in the petals using a crescent stroke.

2 Sideload brush with Moss Green and shade each petal towards inside edge. Sideload ¼in brush with Warm White and highlight each petal using a crescent stroke towards the outside edge.

3 For flower centres double load a ⅛in brush with Yellow Oxide and Raw Sienna. With the Raw Sienna on the outside of the circle, hold the brush upright and dab it lightly around the floral centres to produce a blurred effect.

4 To finish off, add dots of Napthol Red Light and Norwegian Orange mixed 4:1.

TULIPS (H)

1 Undercoat with Napthol Red Light and Norwegian Orange 4:1. Sideload ½in brush with Napthol Red Light touched with Prussian Blue. Shade the bottom of the central petal and the inside edge of the side petals.

2 Sideload brush with Napthol Red Light and Yellow Oxide 2:1 and highlight the top of the middle petal and outside edge of side petals.

3 Using Yellow Oxide and Smoked Pearl 1:2 apply teardrops on petal edges as indicated.

4 Add a dot at the base and three decorative teardrops onto the central petal using Yellow Oxide tipped in the Napthol Red Light/ Norwegian Orange mix.

FINISHING DETAILS

1 Load liner with Moss Green. Add crosshatching as indicated, first painting the two outside stem lines. The cross-hatching contours with these lines.

2 Add the rest of the detailed liner work and stroke work to complete the project as indicated.

3 Allow paint to dry and cure overnight. Erase all visible lines before applying varnish. Apply at least two coats of varnish, sanding lightly between each coat once dry.

KEY	
1 Teal Green	6 Prussian Blue
2 Pine Green	7 Norwegian Orange
3 Moss Green	8 Napthol Red Light
4 Yellow Oxide	9 Burnt Umber
5 Raw Sienna	10 Smoked Pearl
	11 Warm White

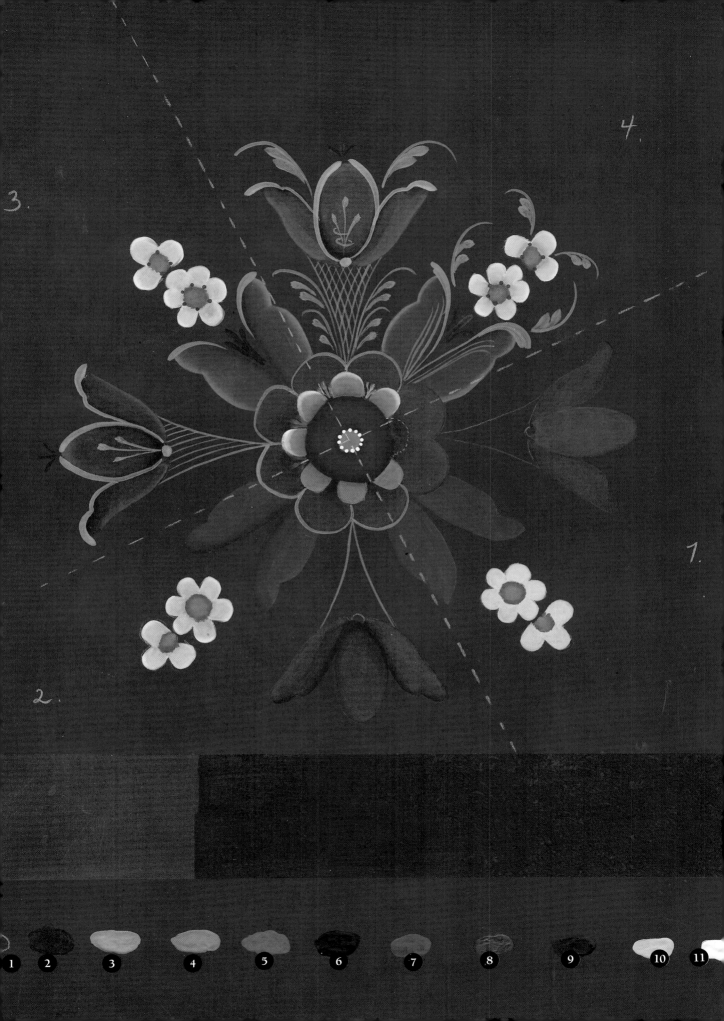

BRIDES' BOXES *c.*1778

(This project has been kindly donated by Jo Sonja Jansen,
the world renowned folk artist.)

*In the eighteenth century, boxes made of 'shavings' of wood, usually oval in shape, were
often given as wedding presents or love gifts. There were many centres for the painting of
these boxes, but it is generally believed most of them came from central and
lower Germany, particularly the area of the Thuringian Forest, and that the artists were
exceptionally well trained.*

*While examples of decorated boxes can be traced back to the Middle Ages, the style shown
here represents a type of box very popular in the late 1700s to early 1800s. The graphic
presentation of the design forms and the skilful calligraphy-like lines attest to the skills
of the artists who mass-produced these boxes for the giftware market of their time.
The old boxes may be viewed in most museums with a folk art section in Germany,
Switzerland and Austria.*

*Bentwood boxes are available from many sources. Prices vary greatly, depending on the
workmanship and the production methods.*

*To paint this project, a very simple dry-brush technique is used at various points. This
simply means loading your brush with less paint, or paint of a slightly thicker consistency.
Blot any excess paint off using a paper towel, and then with gentle pressure begin slowly to
move the brush back and forth over the surface of your object with a light sweeping action.
Aim for patchy adherence of the paint rather than a full-cover treatment.*

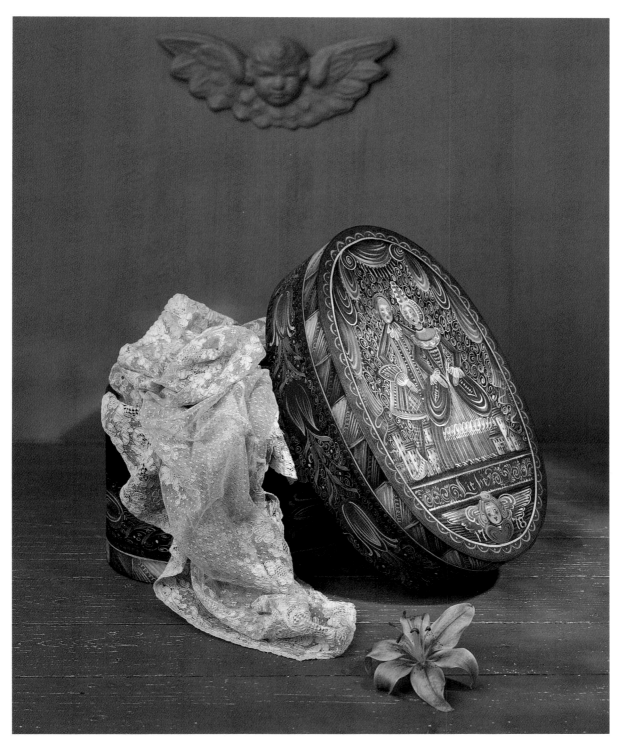

*Part of the pleasure of folk art painting lies in
personal interpretation of designs. The finished box
above is slightly different from the artwork on the
following pages, and your box will be different again.*

MATERIALS

• • • • • • • • • •

• Shaker-style box (see page 88).

BASE COAT

• Carbon Black (Jo Sonja's colour or similar substitute).

FINISH

• Glaze medium, wax polish.

PALETTE

• Jo Sonja's colours or similar substitutes: Red Earth, Yellow Oxide, Gold Oxide, Green

Oxide, Smoked Pearl, Warm White, Carbon Black.

BRUSHES

• Large base coating brush, ¼in (6mm) flat, No. 4 round, No. 8 flat or filbert.

OTHER SUPPLIES

• Tracing paper, graphite paper, chalk pencil, fine sandpaper, adhesive tape (e.g. Sellotape/ Scotch Magic tape).

INSTRUCTIONS

• • • • • • • • • • • •

BASE COAT

1 Sand the box.

2 Base coat the lid and sides with a thin coat of Carbon Black diluted with a little water or glaze medium.

3 Lightly sand when dry and apply another coat.

4 Dry and sand allowing the wood to show through in places.

5 Lightly stain the inside of the box with Yellow Oxide mixed with glaze medium in proportions 1:4.

6 Trace the 'couple' design onto the box lid (page 72) drawing only the major lines. Now add the sectional motif to the lid's sides, fastening the graphite paper with adhesive tape.

7 Trace the floral motif onto the sides of the box in the middle position.

8 Add the sectional motif to the bottom edge ensuring that it runs the opposite way to the same motif on the lid.

THE SIDES – BORDER

1 With a ½in flat brush, apply a light coat of Red Earth around the top edge of the lid and bottom edge of the box. Underload the brush so that the black undercoat shows through in places. This 'dry-brush' technique is used throughout this project.

2 Now dry-brush alternate sections of the

border with Red Earth. Dry-brush remaining sections with Smoked Pearl.

3 Dry-brush triangles onto the border: Yellow Oxide onto Red Earth sections: Warm White onto Smoked Pearl sections.

4 Load a liner with Smoked Pearl and paint a narrow line where the sectional pattern meets the Red Earth stripe.

5 Add the detail: curlicues and accents as shown on each section.

THE SIDES – FLORAL MOTIF

1 Dry-brush in the base colour for the flowers using the No. 8 flat brush, alternating Smoked Pearl and Red Earth.

2 Add the leaves, dry-brushing with Green Oxide.

3 Highlight red flowers as shown with Yellow Oxide. Highlight light flowers with Warm White as shown.

4 Highlight the leaves with Yellow Oxide and add the stems.

5 Finger-paint on the red berry circles. Highlight with a Warm White dot.

6 Using a liner loaded with thin Warm White, infill the black spaces of this floral panel with irregular spiral shapes.

THE BRIDAL COUPLE

1 Mix a flesh colour with Smoked Pearl and a

touch of Red Earth and Yellow Oxide. Base in all the flesh areas using a No. 4 round brush.

2 Base in the green portions of the drapery and dress with Green Oxide mixed with water or glaze medium, to create a transparent effect.

3 Base in red portions of drapery, groom's stocking, bride's gown (pelmets, bodice and sleeves), roof tops and heart using Red Earth, creating the same transparent effect. Base in the red band with a less watery mixture.

4 Base in yellow portions of groom's coat and hair, angel's hair, lettering and numerals with Yellow Oxide, creating the same effect.

5 Base in bride's head dress, collar, underskirt, lace portion of sleeves, groom's cravat, sleeve ruffle, shoe, and angel's wings with a very transparent mix of Smoked Pearl. Paint houses with a semi-transparent mix of Smoked Pearl.

FACES

1 With a large base-coating brush, moisten the faces before adding the detail. This facilitates the application of colour.

2 Using a No. 8 brush, shade the flesh areas with a small amount of diluted Red Earth.

3 Dab on the cheeks with Red Earth. Stroke on the lips, add the neck ribbon, paint the finger lines and dimples on the hand with a liner.

4 Base in the house doors with Red Earth.

5 Softly brush Smoked Pearl across the forehead and down the nose with a No. 4 brush; dab for the nostril bumps and the chin. Dab in the whole eye area.

6 Mix a touch of Carbon Black and Red Earth for the iris, lid line and eyebrows. Also add a touch onto the central lip area. Use dots of Smoked Pearl to highlight eyes and cheeks.

DECORATIVE DETAILS

1 Add a touch of Carbon Black to Red Earth to make a dark red colour. Using a No. 4 brush, 'shadow' stroke all the areas based in red.

2 Decorate red stripes on groom's jacket with

same mixture. Add more Carbon Black to Red Earth until almost black, and paint in the windows on houses.

3 Decorate green areas with Yellow Oxide using a liner. Highlight groom's coat, hair, stocking, the roof tops and the angel's hair with strokes of Yellow Oxide using a liner.

4 Apply the scrolls on the red band and the scallops to the border with Yellow Oxide.

5 Decorate the background around the angel with Green Oxide strokes.

6 Decorate all red and transparent white areas with strokes of Smoked Pearl. Decorate the underskirt with a variety of long, short and 'S' strokes using the same colour. Paint stroke detail on angel's wings, cravat, bride's collar, bodice, pelmet, and wrist ruffles.

7 Apply liner 'sworls' to the background.

8 Lettering may be highlighted with Smoked Pearl and shaded with dark red mix.

FINISHING DETAILS

1 Use tiny touches of Warm White to provide contrast on the windows and along the border of the red band, and on the neck ribbon.

2 Take a 1in flat brush and dry-brush over the entire box very lightly and freely with Carbon Black, Smoked Pearl, and Yellow Oxide, one at a time. Use random strokes. This will give the box an aged quality.

3 Glaze with Jo Sonja's Glazing Medium or similar; sand and glaze once more.

4 Finish with paste wax rather than varnish, in order to give a more authentic aged quality.

LETTERING

Long scripts as well as short ones were applied to boxes. A longer one is illustrated opposite to show you how to form letters with a flat ¼in brush. It translates 'I share my heart with you'.

KEY

| 1 Smoked Pearl | 3 Gold Oxide | 5 Yellow Oxide |
| 2 Red Earth | 4 Warm White | 6 Green Oxide |

1 4

2 3 5 6

Mein herz in mir,
theilich mit Dir

COMMON LOON DECOY

The use of decoys to trap wildfowl is an ancient technique. In Egypt, pictorial evidence of the use of live tethered decoys exists on ancient monuments. It was in America, however, that decoy hunting really took off. European lands and hunting rights were controlled by powerful landowners, but settlers in America were free to hunt at will, and hunters soon began to make wooden decoys. Early decoy painting was often crude, but in recent years this folk painting tradition has developed into a highly refined decorative art form.
The Common Loon is a favourite throughout Canada and the United States. Known best for its hauntingly delirious laughter echoing around inland waterways, its physical appearance is also striking. Its distinctive black and white plumage makes it a pleasing project.

MATERIALS

• Wooden loon decoy (see suppliers list on page 166).
FINISH
• Water-based varnish.
PALETTE
• Jo Sonja's colours or similar substitutes: Payne's Grey, Burnt Umber, Prussian Blue, Warm White.

BRUSHES
• ¾in (18mm) flat for base coating, ½in (12mm) flat, ¼in (6mm) and ⅛in (3mm) filberts, ¼in (6mm) and ⅛in (3mm) filberts, liner.
OTHER SUPPLIES
• Wood glue if decoy is unassembled, fine sandpaper, block of wood, double-sided tape, paper towel, soft lead pencil.

INSTRUCTIONS

BACKGROUND PREPARATION
1 If the decoy is supplied unassembled, glue the head slightly to the left or right for a natural appearance. Remove excess glue and allow to cure overnight.
2 Sand and remove dust with a damp cloth, then mount the decoy on a small block of wood with double-sided tape for easier handling.

3 With a soft lead pencil sketch in the details as shown in figures 1 and 2 making sure the design is symmetrical.

SIDES AND BREAST
Mix Warm White and all-purpose sealer in the proportions 1:1. Paint the breast, sides, and neck patches with this colour.

Fig 1

Fig 2

HEAD, BACK, AND NECK

1 These are a rich black/green colour made by mixing Prussian Blue and Burnt Umber. Check that the colour is dark green by adding water to the colour in the brush and blending it on the palette. Add more Prussian Blue if it looks too grey, or Burnt Umber if too blue.

2 Add all-purpose sealer to this mix 1:1 to seal and base coat the wood in one step.

3 Thin a small amount of this mixture with water, load a flat brush and blot on paper towel to remove excess water. Begin to paint the head area. The colour will be black/green.

4 Now paint the neck, back, and tail using the

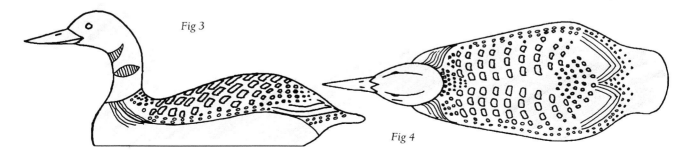

Fig 3

Fig 4

same paint mixture, this time just thinning the paint enough to make it flow easily. Less thinning makes it look almost black as you paint it on.

5 Care needs to be taken to blend the colours under the tail where the black/green paint mix meets the white (see dotted line in figure 1). This is done by loading a ¼in filbert or an old, worn flat brush with paint. Blot the excess on a paper towel until the brush is almost dry, then lightly paint wispy 'feathers' as shown in the colour illustration. Paint from the black area to the white area.

BILL

1 Mix Payne's Grey and all-purpose sealer 1:1 and paint the loon's lower bill using ½in flat brush.
2 Mix a lighter tone of grey by adding a touch of Warm White to the Payne's Grey/all-purpose sealer mix and paint the upper bill.
3 Add nostrils with black/green mix from previous section.

FEATHER DETAILS

Use chalk to mark in the placement for the feather details. Do this freehand using figures 3 and 4 as your guide. Decoys will vary in size, so the number of feathers required to fill the space will be different for each, but the method will be the same. First chalk in the primary feathers, then chalk in the wing area plus a triangle at the base of the neck for the spots between the wings. Next chalk a triangle above the primaries. Your markings should be roughly symmetrical.

PRIMARIES (large tail feathers)

1 Load a ½in flat brush with Warm White. The brush should have a nice sharp edge. Blot on a paper towel to remove excess paint.
2 Refer to the colour illustration to see how the strokes should look. The brush is held upright with the chisel edge of the brush at the edge of the feather. Use a flick and lift motion towards the head to achieve the soft feathered effect. Use this stroke for all the primaries.

WINGS

With the brush perpendicular, press down and lift straight off. Stroke direction is toward head. For the larger feathers use a larger brush and vice versa. The feathery look is best achieved by using a filbert rake, although an ordinary filbert is a good substitute.

Load a ⅛in filbert with Warm White and paint two or three rows of feather strokes. Then change to a ¼in filbert and paint two rows, decreasing in size towards the shoulder (refer to figures 3 and 4 as well as the coloured illustration).

BACK

Use a ⅛in filbert, paint feathers as before in the triangle from the neck area towards the tail. Then, with the same brush, add the same small strokes just above the primary feathers.

SIDES

Load again with Warm White and make more small spots all around the extremity of the decoy where the white and black areas meet (see figure 4).

NECK AND SHOULDER STRIPES

1 Load a liner brush with the Prussian Blue/Burnt Umber mix used for the head and apply the stripes on the neck patches.
2 Reload brush and pull stripes from the base of the neck towards the shoulders.

FINISHING

1 Carefully scrape away any paint that may have got onto the decoy's eyes.
2 When the decoy is completely dry, apply four or five coats of varnish, sanding lightly between the coats once dry.
3 For a nice smooth finish, apply a paste wax and buff with a soft cloth.

KEY		2 *Prussian Blue*	4 *Warm White*
1 *Payne's Grey*		3 *Burnt Umber*	

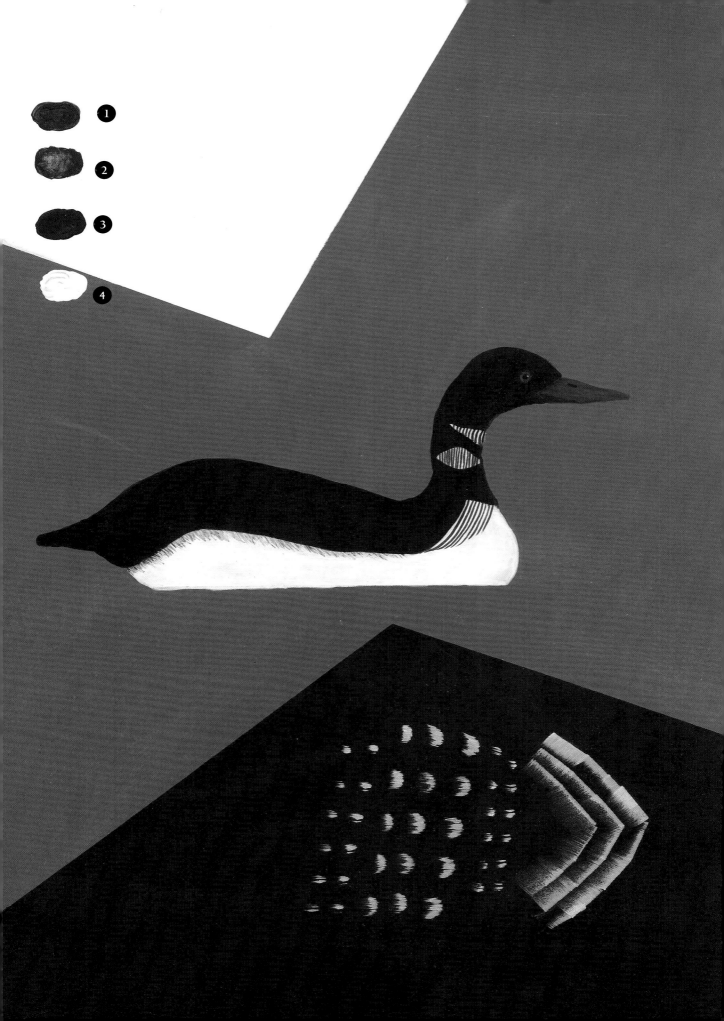

INTERNATIONAL FOLK ART

International folk art enjoys immense popularity, each culture having created a unique painting tradition and style. When folk or ethnic painting traditions are compared, the similarities in technique immediately become apparent. The basic brush strokes are used the world over, enabling us to extend our field of interest beyond the familiar European traditions.

Our Indian Chest project below follows a very old painting tradition, whereas the Mexican example on page 118 is much more recent, responding mainly to the popular tourist market. The Russian Table (page 122), whilst barely a century old, has an elaborate and beautifully executed style. Indeed, Russian folk art is gaining recognition as one of the best-crafted painting traditions. Australia's folk art movement has been particularly active in recent years. Founded on European traditions, the trend now is to develop a floral language that is uniquely Australian using basic folk-painting techniques. Our Tin Tub project on page 126 follows this theme. Japan's foray into folk art is also of particular interest because it represents a departure from the ancient Japanese brush-painting tradition to a new variation of a similar theme as illustrated by the Place Mat project on page 114.

INDIAN FLORAL CHEST

The diminutive 'what-not' chest that inspired this project came from Rajastan in India, an area renowned for its decorative folk art. The chest illustrates a charming example of a traditional Mogul motif. The daintiness of the pattern is almost wallpaper-like, and highly novel as furniture decoration. Such dainty patterns are common in this part of the world, as is a more restrained and harmonious approach to design. This is in contrast to the European practice of using interconnecting devices and embellishments such as lines, scrolls, chains, and curlicues to enhance the basic motif.
This project is really quite easy. The floral motif uses only two strokes, and although the line work requires a steady hand, the odd few wobbles will easily pass unnoticed.

MATERIALS
· · · · · · · · · ·

• Chest of drawers (or any suitable piece of wooden furniture).

BASE COAT
• Matt black emulsion (latex).

FINISH
• Water-based varnish.

PALETTE
• Jo Sonja's colours or similar substitutes: Warm White, Pale Gold, Norwegian Orange, Burgundy, Green Oxide, Turner's Yellow, Cadmium Yellow.

BRUSHES
• No. 4 round, No. 00 round, ⅜in (9mm) flat, ³⁄₁₆in (5mm) flat, liner.

OTHER SUPPLIES
• Tracing paper, graphite paper, soft lead pencil, chalk, chalk pencil, brown paper bag, handle knobs.

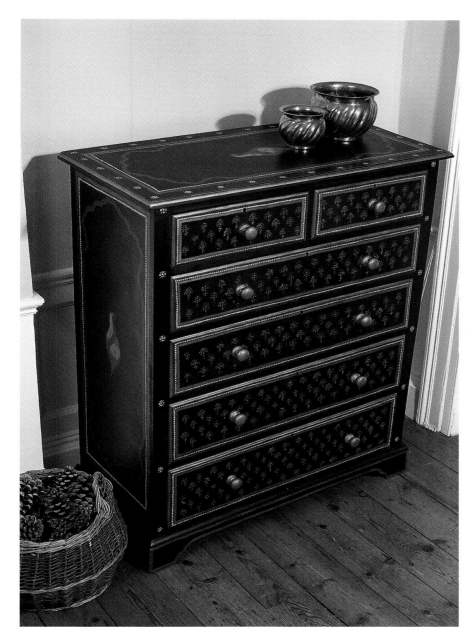

INSTRUCTIONS

BACKGROUND PREPARATION

First remove handles, fill holes and sand. Apply two or three coats of matt black emulsion, allowing to dry between coats.

BORDER

1 Load a ⅜in flat brush with Pale Gold and paint all the wide gold borders round each drawer as well as the features at the base of the chest. (In the absence of any easy-to-follow indentations, mark out the ¾in (18mm) borders with a chalk pencil.) Allow to dry.

2 Using a liner, paint a line along the inside edge of the gold border in Norwegian Orange.

3 Mix Warm White to a thin, creamy consistency. Load the No. 4 round brush well. If mixed correctly (with water or flow medium), the brush will shed circular droplets of paint much like an eye dropper as it makes contact with the object. One brush load will make several circles. Make a border of circles next to the orange line.

4 Load a ¼in flat brush with Pale Gold and paint an inner border alongside the circle border.

5 Using a liner loaded with Norwegian Orange, paint lines on both edges of the inner gold border.

6 Using a No. 00 round brush, load with warm white and make two small dots on either side of each of the small circles.

FLORAL MOTIF

As the motif is so easily painted there is no need to use a pattern, but you will need to mark out the placement position for each flower. This is explained below.

1 Cut paper to fit size of panel.
2 Fold paper as often as required.

3 Fold evenly the other way.

4 Place chalk marks at required intersections.

Panelled areas are to be painted with repeat patterns.

1 Mix Warm White and Norwegian Orange in the proportions 4:1 to eye-dropper consistency by adding water or flow medium. Load a No. 4 round brush and deposit a drop of paint on each of the chalk marks. Allow to dry.

2 With the same brush, colour, and paint

consistency, deposit four droplets around each of the original droplets. Allow to dry.

3 Mix Burgundy to the same eye-dropper consistency, and superimpose smaller droplets of these onto the original petals.

4 Mix Green Oxide and Cadmium Yellow 1:1. Using a liner, add the stems and leaves.

FURLED PALM LEAF

1 Trace on the pattern (see page 72).

2 Load Turner's Yellow onto a No. 4 round brush and fill in the yellow area.

3 Load brush with Green Oxide and fill in.

4 Outline the divisions with Pale Gold using a liner.

5 Shade in Norwegian Orange with a No. 4 round brush by pulling out several strokes from the points.

6 Add the floral motifs as in the previous section.

PANEL BORDER

1 Make a paper template of the shape to fit panelled areas.

2 Lay the template onto each panel and go round it with a chalk pencil.

3 Load a ⅜in flat brush with Norwegian Orange and paint in the border.

FINISHING

1 To add contrast at various points on your object, include the floral detail as illustrated. Colours used are Warm White and Norwegian Orange using the 'eye-dropper' technique detailed above.

2 Antique the gold areas if you prefer a toned down effect (page 70).

3 Apply two coats of water-based varnish, sanding between each coat once dry.

4 Finish handle and knobs with Pale Gold and sealer mixed 1:1. Affix to each drawer in pairs.

KEY	
1 *Burgundy*	4 *Warm White*
2 *Green Oxide*	5 *Norwegian Orange*
3 *Turner's Yellow*	6 *Cadmium Yellow*
	7 *Pale Gold*

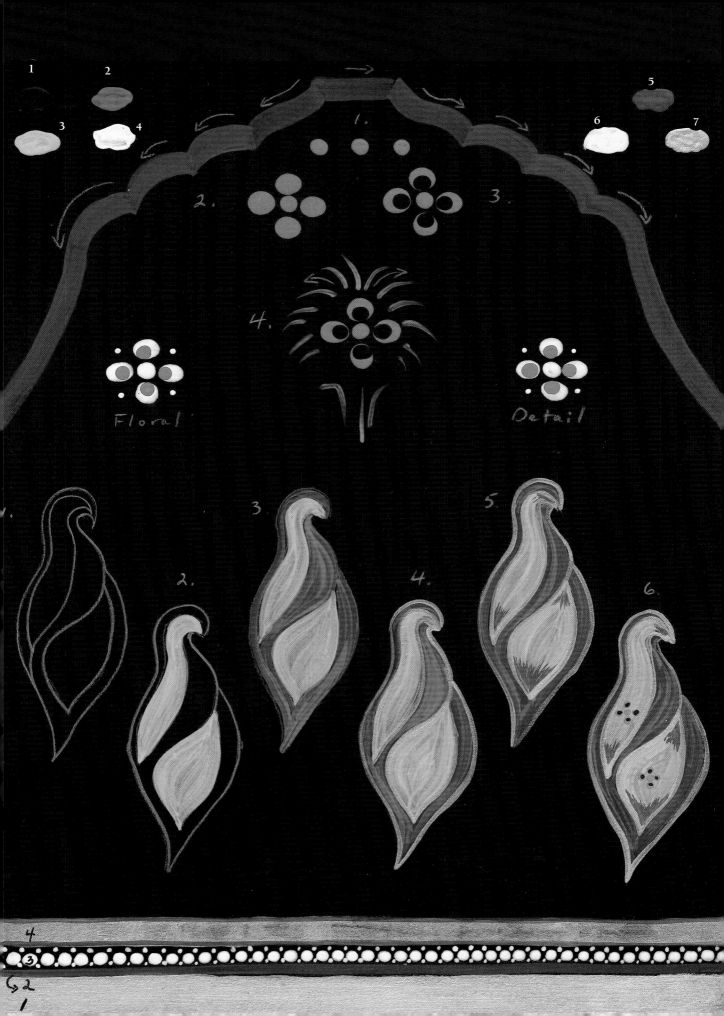

1

2

3 4

5

6 7

1.

2. 3.

4.

Floral Detail

3 5

2. 4. 6.

4

3

2

1

JAPANESE CHERRY BLOSSOM PLACE MAT

Brush painting is an ancient Oriental tradition utilizing such curious items as an inkstone, rice paper and special paints and brushes. In Japan, the name given to this art form is Sumi-e. It requires a mastery of brush control and stroke work much the same as folk painting. Sumi-e and folk painting differ in that Sumi-e uses watery inks instead of paint and is a more disciplined stroke technique. They do not use the same thematic material, nor is paint consistency or brush-loading technique the same, but the interest now being shown by Japan and the West in each other's painting techniques is an encouraging development of cross-cultural links. This project has been selected because it illustrates a typical Japanese theme, the cherry blossom, yet painted in the folk style rather than the Sumi-e method. It achieves a completely different but equally charming effect.

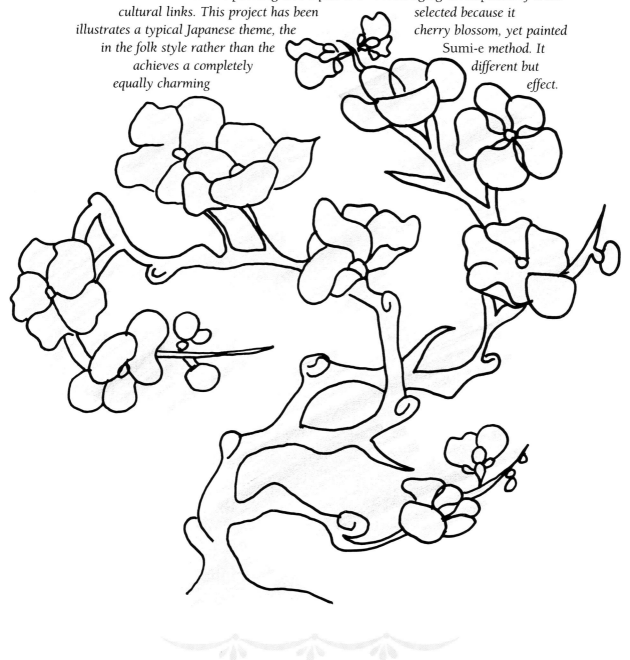

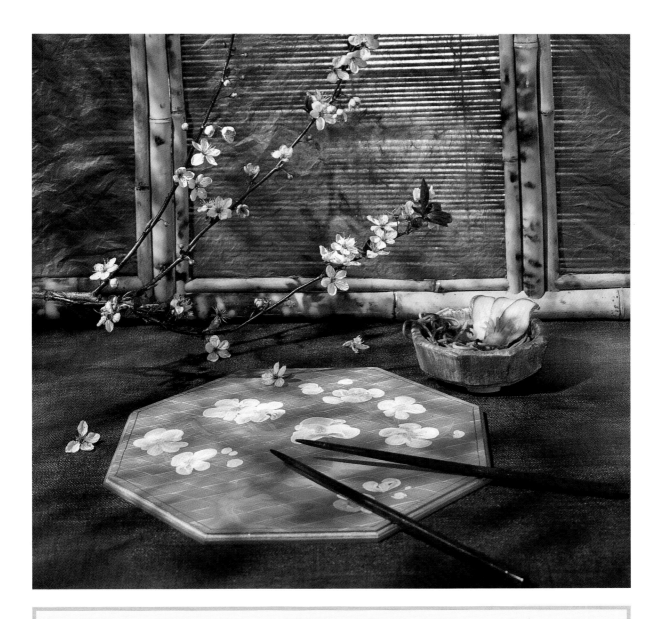

MATERIALS

• Wooden place mat of any shape.
BASE COAT
• Sapphire (Jo Sonja's colour or similar substitute) and water-based all-purpose sealer.
FINISH
• Water-based varnish.
PALETTE
• Jo Sonja's colours or similar substitutes: Sapphire, Provincial Beige, Yellow Light, Turner's Yellow, Carbon Black, Warm White, Burgundy, Pale Gold.
BRUSHES
• No. 4 round, ¼in (6mm) flat, ⅜in (9mm) flat, liner.
OTHER SUPPLIES
• Tracing paper, graphite paper, chalk pencil, soft lead pencil, masking tape, graph paper.

INSTRUCTIONS

BASE COAT AND DIAMOND GRID

1 Seal the mat using a 1:1 mixture of Sapphire and all-purpose sealer. Allow to dry.

2 Prepare a diamond-shaped grid either by ruling out lines on a sheet of graph paper or by marking measured lines on plain paper.

3 Trace the grid onto the object.

4 Mix a light value (page 18) of Sapphire and Warm White, then load a liner brush and begin filling in each diamond segment with a series of lines. The lines should run parallel but need not be precisely uniform. Begin painting from the top, loading your brush only once. Allow to dry.

5 Apply a coat of varnish and allow to dry.

6 Trace on the cherry blossom branch and outline the blossoms. There is no need to trace on each flower petal.

FLOWERS

The brush loading technique for each petal is as follows:

 (a) load brush with Warm White. Use a slightly thinner consistency to create a translucent delicate look;

 (b) mix a touch of Burgundy with Warm White to make a light pink value. Pick up a very small amount on one corner of the brush;

 (c) always begin the petals with the pink towards the outside edge.

As you begin to paint each petal don't try to follow the lines faithfully. Remember, every petal should look different. Practise on paper before you begin. When you finally commence painting the object, a few false starts won't matter. They can easily be rubbed off the varnished surface without affecting the grid. The petal strokes involve a combination of two or three movements (use a ⅜in flat brush for the larger flowers and a ¼in flat for the smaller ones):

 (i) standing the brush on the chisel edge and rocking back and forth on the chisel plane;

 (ii) pivoting or sweeping the broad face of the brush keeping the inner edge stationary while the outer edge pivots;

 (iii) interrupting the pivot motion and swivelling the chisel back on itself.

Vary each action to ensure that each petal is slightly different.

FACE-ON FLORAL VIEW

Load the brush and make petals in the order indicated above. Use the motion described at (i) and (ii) for all five petals, reloading brush fully.

SIDE FLORAL VIEW

1 Load the brush and make the three large petals using the motions described at (i), (ii) and (iii) for all three petals. Add two small irregular strokes as indicated.

2 With your finger, lightly rub a little Turner's Yellow into the middle of each flower.

3 Stipple a few specks of Yellow Light on top of the hazy yellow for the stamens.

BRANCHES

1 Mix Provincial Beige and Pale Gold in equal proportions. To create a slightly green cast, mix and add a tiny amount of Yellow Light and Carbon Black to make olive green.

2 Paint in the branches and twigs using a No. 4 round brush. Load Provincial Beige onto the same brush and add a few comma shadows.

3 Load Pale Gold and finish with some comma highlights. When dry, add a coat of varnish.

GOLD RIM

1 Using a liner brush, edge the mat with a Pale Gold line (see page 75).

2 Finish with two or three coats of varnish.

KEY		
	5	*Provincial Beige*
1 *Warm White*	6	*Pale Gold*
2 *Burgundy*	7	*Carbon Black*
3 *Yellow Light*	8	*Sapphire and White 1:1*
4 *Turner's Yellow*	9	*Burgundy and White 1:1*

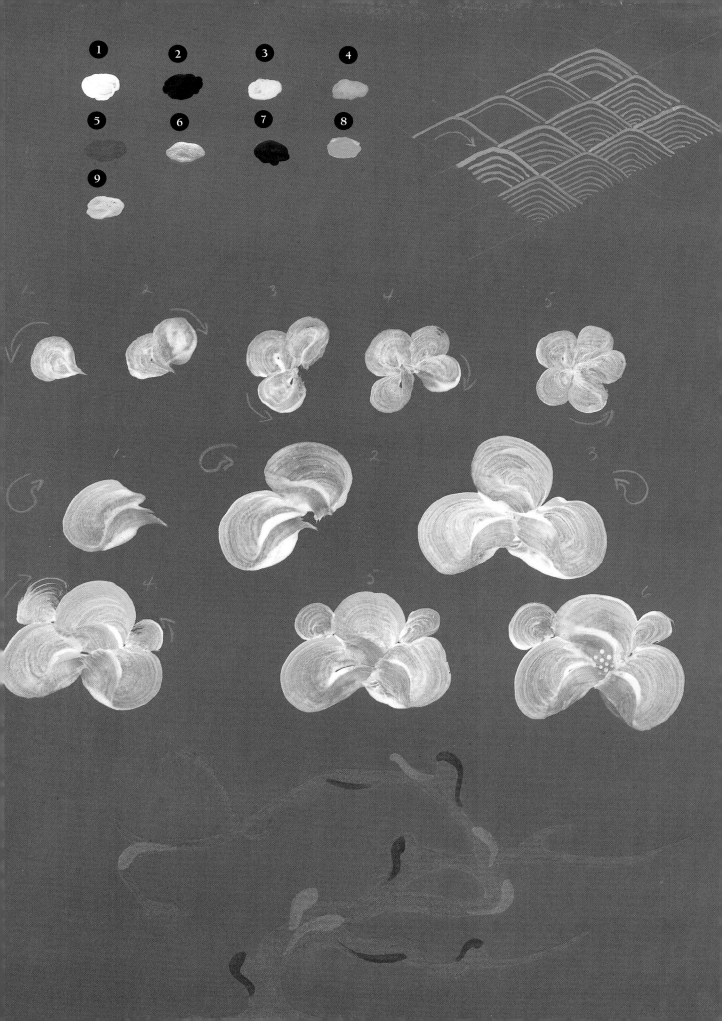

MEXICAN MARIGOLDS

Mexico has a very lively tradition of gourd painting which this project mimics. This colourful busy pattern on a brightly coloured background is a typical example of the Mexican style. The quantity of stroke work makes it look far more complicated than it is. The succession of strokes on the fronds and seed pods, for example, are quick rhythmic commas and teardrops produced with a liner brush.

MATERIALS

• Wooden towel rail.

BASE COAT
• Cobalt Blue Hue (Jo Sonja's colour or similar substitute) and all-purpose sealer mixed equally.

FINISH
• Water-based varnish.

PALETTE
• Jo Sonja's colours or similar substitutes: Brown Earth, Cadmium Yellow, Vermilion, Brilliant Green, Green Oxide, Burgundy, Warm White.

BRUSHES
• ¼in (6mm) flat, ½in (12mm) flat, No. 4 round, liner. (A rake could be used as an option to the flat brush to give a ragged edge to the petals.)

OTHER SUPPLIES
• Tracing paper, graphite paper, soft lead pencil, chalk pencil, fine grain sandpaper.

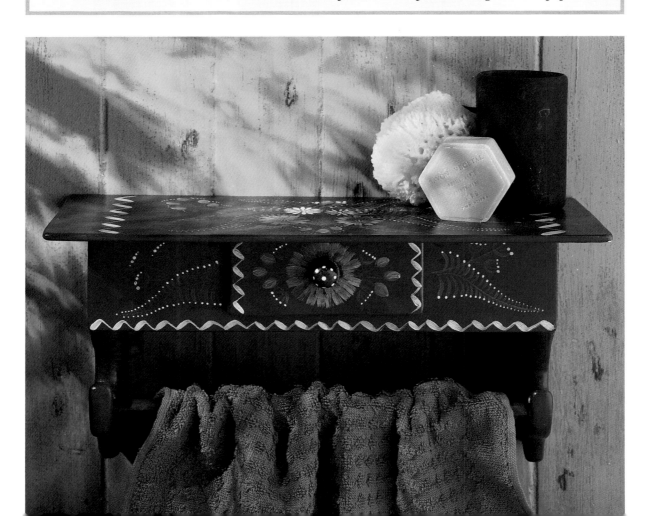

INSTRUCTIONS

BACKGROUND PREPARATION

1 Enlarge or decrease pattern to suit object.

2 Mix Cobalt Blue and all-purpose sealer in the proportions 1:1. Paint towel rail with 2–3 coats. Allow each to dry. Sand each lightly.

3 Trace on the pattern (see page 72).

MARIGOLDS

1 Load Brown Earth onto ¼in flat brush or rake and paint marigold circles. Begin applying the petals before the paint dries.

2 Mix Cadmium Yellow with Vermilion 2:1, but leave it streaky rather than fully blended.

3 Load a flat or rake brush. Paint in the petals in the order indicated beginning on the outside edge pulling each stroke towards the centre. Fill in the centre petals. Load Warm White and add centre dots.

BRACKEN LEAVES

1 Mix Brilliant Green and a touch of Green Oxide. Paint in the spine with a liner.

2 Load flat brush with green mix. Begin from the base of each leaf painting up the spine. The strokes should be at 90°, decreasing in size as you approach the tip.

FLOWER BUDS

1 Paint the stems using the green mix and No. 4 round brush. Add a touch of Burgundy to Warm White to make a pink mix.

2 Load a No. 4 round brush with pink mix, then tip it lightly in Warm White.

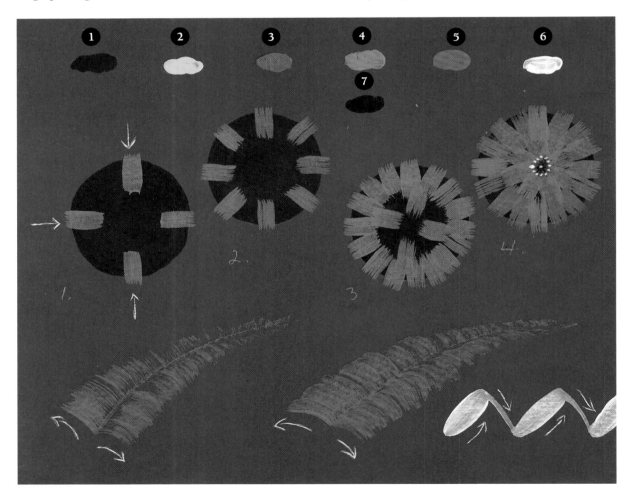

3 Paint in the buds with comma strokes.

4 Load brush with green mix and paint in the calyx with comma strokes.

DAISIES
Load a No. 4 round brush with Warm White. Make teardrop strokes. Add yellow centres.

FERN FRONDS
Mix Brilliant Green, Cadmium Yellow, and Green Oxide 3:2:1. Using a liner, paint the central spine, then add the fronds. Finish by tipping each vein with Warm White.

SEED PODS
Using the green mix, use liner to paint the stem, then add four or five comma strokes to make the seed pods. Work from the stem upwards. Tip each stroke with Warm White.

BORDER
Using a round brush, work in a straight line moving from left to right: press down then release to make the tail, repeating until the border is completed.

FINISHING
Apply two or three coats of varnish, sanding lightly between each coat once dry.

KEY		
1 Brown Earth	*4*	Brilliant Green
2 Cadmium Yellow	*5*	Green Oxide
3 Vermilion	*6*	Warm White
	7	Burgundy

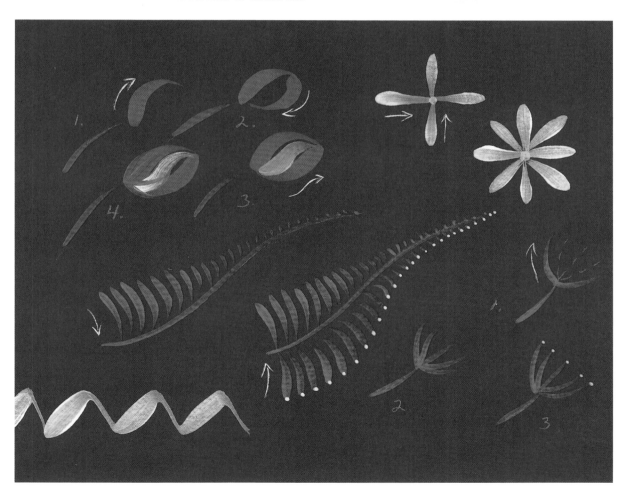

RUSSIAN TABLE

Throughout Russia there are many folk painting traditions representing a number of ethnic groups. Some are quite simplistic whilst others are very highly developed in terms of both paintwork and finish. Russian floral trays from Zhostova are highly prized for their very realistic and delicate flower paintings, whereas Khokhloma designs are renowned for their bright reds, golds, and highly polished fired finish.
The project illustrated here is an adaptation of a Khokhloma design from around 1900. The scale and gusto of the pattern suggests a rather daunting painting exercise, but in fact most of the strokes are commas.

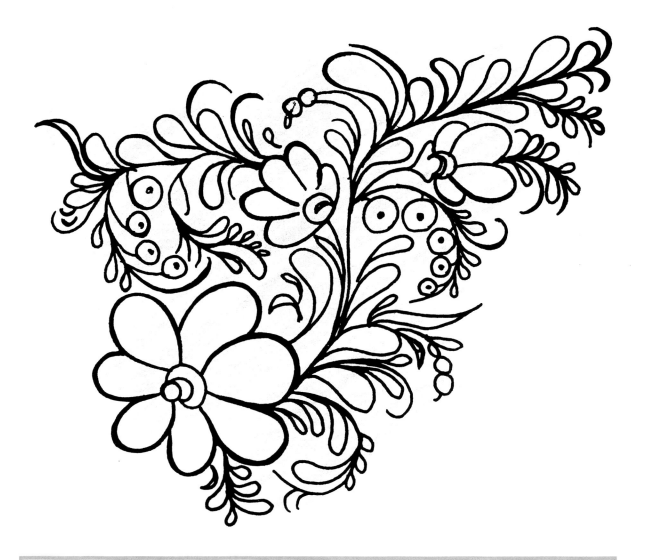

MATERIALS

• • • • • • • • • •

• Wooden occasional table.

BASE COAT

• All-purpose sealer, Carbon Black (Jo Sonja's colour or similar substitute).

FINISH

• Water-based satin-finish varnish or substitute.

PALETTE

• Jo Sonja's colours or similar substitutes: Carbon Black, Rich Gold, Yellow Oxide, Turner's Yellow, Norwegian Orange, Napthol Red Light, Napthol Crimson, Cadmium Scarlet, Green Oxide, Teal Green.

BRUSHES

• No. 3 round, No. 8 round, liner, large brush or sponge for base coating.

OTHER SUPPLIES

• Graphite paper, tracing paper, kneadable eraser, adhesive tape (e.g. Sellotape/Scotch Magic tape), soft lead pencil, chalk pencil, brown paper bag.

INSTRUCTIONS

BACKGROUND PREPARATION

1 Sand and apply base coat using a mix of Carbon Black and all-purpose sealer in the proportions 1:1.

2 Trace on the pattern (page 72). You will note that the pattern on the table is a repeat. Section the table top into quarters (page 74) and trace the pattern into each quarter.

3 Make the following paint mixes:
Yellow Oxide, Turner's Yellow and Norwegian Orange 1:3:1 (Orange Mix);
Napthol Red Light, Napthol Crimson and Cadmium Scarlet 2:2:1 (Red Mix);
Green Oxide and Teal Green 1:2 (Green Mix).

ORANGE FLOWERS

1 Load No. 8 brush with Orange Mix and paint the flowers using comma strokes. Start with the outside flowers so as not to rub out the pattern lines. When the outside is dry, paint the middle section.

2 Use a No. 3 brush to paint the smaller flowers.

3 Using a liner, paint all the lines which join the large flowers (see photo) using the same paint mix as above.

4 Load a No. 3 brush with the Red Mix and paint each petal using an arched movement for each stroke. Note that on the larger flowers, an orange 'corridor' is retained on each petal.

5 Paint in the red crescents and circles in the flower centres.

6 Dot the flower centres with Carbon Black as shown.

LEAVES

1 Begin filling in all the red comma-stroke leaves using the Red Mix as above with a No. 3 round brush. Simply follow the pattern working your way round methodically.

2 Fill in the stem lines with same Red Mix. Some of the stems are an 'S' shape. Not all of these are marked on the pattern but you can fill in lines where you feel they are needed.

3 Load brush with Orange Mix. Base in all the main comma leaves.

4 Load a No. 3 brush with Green Mix to paint the over-stroked commas on the green leaves.

BERRIES

1 Using a No. 3 round brush, paint all the red berries using commas as illustrated.

2 Add an orange dot in the centre of each.

3 Dot with Carbon Black.

4 Paint all the orange berries with same Orange Mix as above.

5 Over-paint the orange berries with the Red Mix leaving side crescents as shown.

6 Dot the centre of each berry in black.

7 Allow to dry completely.

FINISHING

1 Take a soft cloth and rub Rich Gold around the edge of the table allowing some of the background to show through.

2 Erase tracing lines before applying a coat of varnish.

3 Sand lightly with a brown paper bag.

4 Apply additional coats of varnish for further protection, sanding between each coat once dry.

KEY
1 Carbon Black
2 Rich Gold
3 Yellow Oxide
4 Turner's Yellow
5 Norwegian Orange
6 Napthol Red Light
7 Napthol Crimson
8 Cadmium Scarlet
9 Green Oxide
10 Teal Green

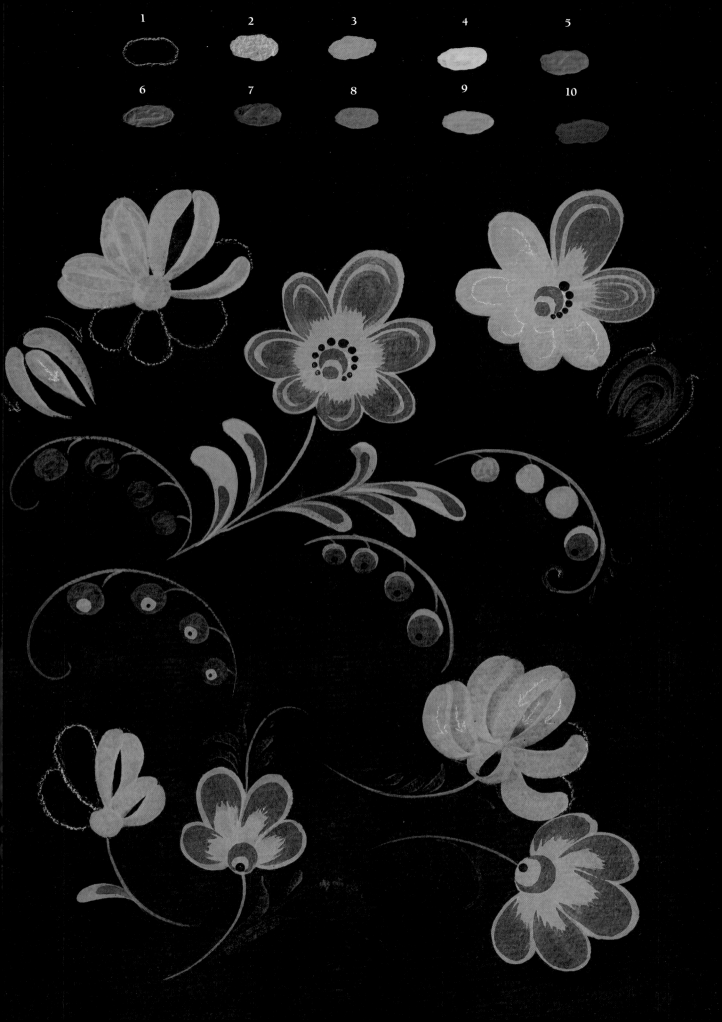

TIN TUB WITH AUSTRALIAN FLORAL THEME

German immigrants first introduced European-style folk art into Australia during the mid-1800s, although little of this early work has survived to the present day. Later, the 1930s and 1940s saw furniture and household goods being decorated with more patriotic Australian floral, bird, and animal motifs.

Recently there has been a strong revival of this decorative art form. The uniqueness and beauty of Australian themes, especially the florals, are very appealing, hence their inclusion here.

The pattern shown uses the flat brush technique combined with simple cotton buds to produce a delightful composition of colourful well-known Australian flowers: the white flannel flower, the yellow wattle, and the red gum blossom.

MATERIALS

• Any galvanized iron container will do.

BASE COAT

• All-purpose sealer and French Blue (Jo Sonja's colour or similar substitute).

FINISH

• Water-based varnish.

PALETTE

• Jo Sonja's colours or similar substitutes: French Blue, Warm White, Pine Green, Moss Green, Yellow Oxide, Yellow Light, Burgundy, Red Earth, Silver, Rich Gold.

BRUSHES

• Large brush or sponge brush for base coating, rake brush for dry-brush work, liner, No. 4 round, ¼in (6mm) flat, ½in (12mm) flat.

OTHER SUPPLIES

• Packet of cotton buds/Q Tips, tracing paper, adhesive tape (e.g. Sellotape/Scotch Magic tape), white graphite paper, metal primer for tin.

INSTRUCTIONS

BACKGROUND PREPARATION

1 Prepare tin container as instructed on page 64.

2 Mix French Blue and all-purpose sealer in the proportions 1:1 for background and paint over the metal primer paint.

3 Centre the pattern on one side of the container using adhesive tape and trace it on (page 72).

RIBBON

1 Mix French Blue and Warm White 1:1 and load flat brush. Then lightly dip the corner of the brush in Warm White. Blend on the palette, and then paint the ribbon with the Warm White highlight to the top.

2 Paint the bows, forming two crescents top and bottom.

3 Paint a small crescent to form the knot in the middle of the bow.

WHITE FLANNEL FLOWERS

1 Mix French Blue, Moss Green, and Warm White 1:1:3 (Green Mix). Load round brush with Green Mix, wipe off the excess, and then load with Warm White. Tip the end of the brush with the Green Mix. Stroke each petal beginning at the tip, which will be tinged with green, and pulling through with the white.

2 Paint the centre with the Green Mix. While still wet, dot a lighter green value across the top, blending into the background. Quickly dab darker value of Green Mix across the bottom and blend until a soft look has been achieved. Use an old brush for a textural effect. Finally, using a liner, lightly paint some Warm White dots across top of the centre as a highlight.

LEAVES

1 Using the Green Mix, tip the round brush in Warm White and paint commas, joining to form greenery for flannel flowers.

2 With a flat brush, paint 'S' stroke wattle leaves using Pine Green and Yellow Oxide with a touch of Warm White.

THE WATTLE

Dip a cotton bud into Yellow Oxide and Yellow Light. Dab randomly as shown but be careful not to overdo it. These are filler flowers and are not meant to dominate the design.

GUM BLOSSOM

1 Using a flat brush, or preferably a rake, load with a mix of Red Earth and Warm White 2:1 toned down with a touch of Moss Green. Remove the excess paint with a rag or paper towel. Test brush on paper until a scratchy look is achieved. Now paint feathery, scratchy strokes outwards from the base of the flower.

2 Paint over a second time with scratchy strokes of a lighter value.

3 Add a touch of Burgundy to Red Mix. Using a liner brush, paint some fine commas to help indicate the shape. Paint from the base outwards.

4 Using a liner brush, dot highlights of white and yellow across the wispy edge. These can also be painted in Yellow Light or Rich Gold.

5 For the stems use a mix of Red Earth, with touches of Warm White and Moss Green. Highlight with a comma stroke of Red Earth. Some of the wattle leaves can also be painted with this mix.

FINISHING

Mix Silver and Rich Gold 1:1, and wipe around the top and handles with a soft rag, letting some background show through. Erase tracing lines. Varnish once all the paint is dry. Three thin coats are better than one thick coat; sand lightly between each dried coat.

KEY		
1 French Blue	4 Moss Green	8 Red Earth
2 Warm White	5 Yellow Oxide	9 Silver
3 Pine Green	6 Yellow Light	10 Rich Gold
	7 Burgundy	

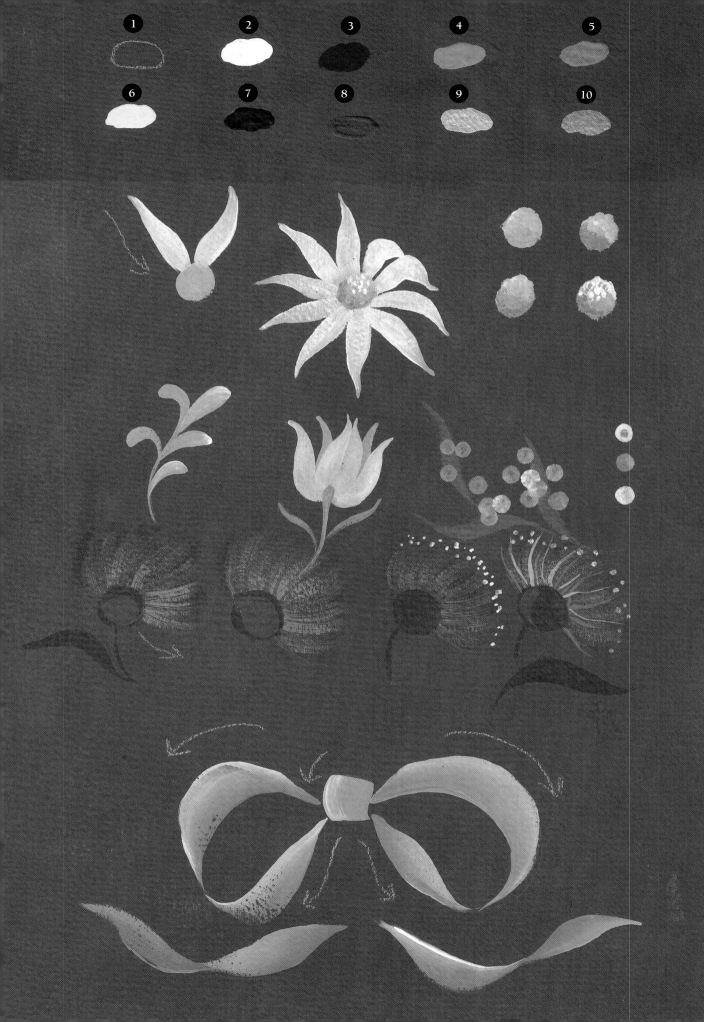

PERIOD ADAPTATIONS OF FOLK ART

The folk art technique adapts well to period themes, so your work does not have to be restricted to designs with a 'folksy' look.

Classical motifs are to be found everywhere. All you need to do is look closely at the details in architecture, furniture, and porcelain (to name but a few) and you will see many decorative enrichments that are really quite familiar. Their subtlety creates a restrained beauty which is in stark contrast to the often bold and quite strident folk motifs.

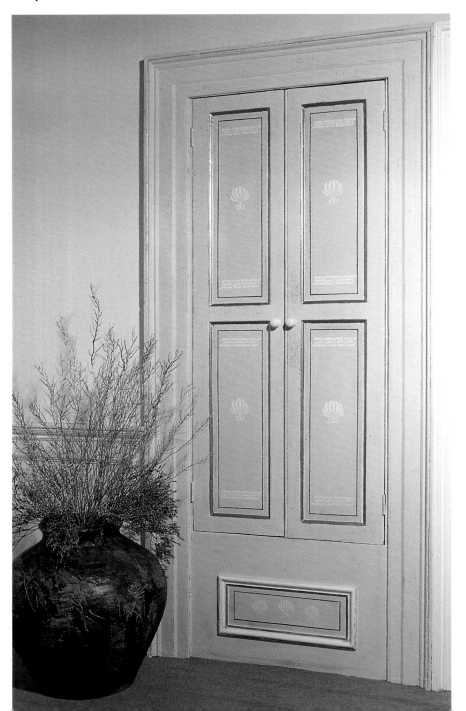

GEORGIAN CUPBOARD WITH PALMETTES

The Palmette motif can be traced far back into Egyptian and Oriental civilizations, but it was during the classical Greek and later neo-classical periods that it really came into its own as a favourite decorative device. No doubt its original meaning was symbolic, probably deriving from the palm or lotus, both connected to the sacred tree of life. Frets (or borders) were also popular in these periods. Here, palmettes and frets were combined in soft muted tones to give special status to a Georgian cupboard found in an eighteenth-century English town house.

MATERIALS
.

• Cupboard or other suitable item of wooden furniture.

BASE COAT
• Terracotta emulsion, Light Jade emulsion (large objects) or Green Oxide/Warm White 1:5 (small objects).

FINISH
• Water-based varnish.

PALETTE
• Jo Sonja's colours or similar substitutes: Jade Green (or Green Oxide), Warm White, Norwegian Orange, Rich Gold.

BRUSHES
• Large brush for base coats, No. 4 round, ¼in (6mm) flat, liner.

OTHER SUPPLIES
• White wax candle, medium grade sandpaper, tracing paper, graphite paper, soft lead pencil, chalk pencil, compass with an ink attachment, ruler with an angled edge.

INSTRUCTIONS

BACKGROUND PREPARATION

1　Apply a coat of terracotta emulsion (latex) and allow to dry.

2　Using a white candle, rub wax into the object in random drifts and as thickly as you can, but fading out at the edges.

3　Cover with a coat of Light Jade emulsion/water-based paint or, if the object is small, Green Oxide/Warm White 1:5. Allow to dry.

4　With medium grain sandpaper, sand the surface lightly. The paint will come off readily over areas where the wax has been applied.

5　Apply a coat of water-based varnish.

RUSSET BORDER

1　Measure out a ¼in (6mm) border all the way round each panel.

2　Using a compass with an ink attachment, load with Norwegian Orange of a reasonably thin consistency. Follow instructions from page 75 to make the border. You may wish to go over it two or three times, perhaps even freehand if you feel confident.

PALMETTES

With a chalk pencil, mark out the positions for the top and bottom of the palmette. Trace the palmette pattern between the markers (page 72). You may prefer to work without using a pattern. This is very easily done with this motif if you work in pairs from the middle outwards.

1　Using a No. 4 round brush, load with a very light tone of Jade Green (i.e. a lighter tone than the background) and paint a teardrop stroke.

2　Reload and paint a stroke over the top of the teardrop. Press and then lift the brush thus creating a blunt-ended stroke.

3　Reload and paint two small commas with the tails overlapping.

4　Reload and paint the central large teardrop.

5　Add each pair of strokes around the central portion loading between each stroke. Add the 'S' strokes at the base. Add the comma stroke wings.

FRETS

Decide the height you wish to make your frets. Use a chalk pencil to make a set of parallel guidelines to mark the top and bottom.

1　Load a ¼in flat brush with light Jade Green, the same value used for the palmettes. Paint the first section of the fret beginning on the vertical line. Using the chisel, paint from bottom to top, then switch to the flat side of the brush and paint across.

2　Reload and now paint the second section beginning on the flat stroke and ending on the chisel vertical stroke. This section of the fret joins up with the first section.

3　Reload and paint the third section, down on the chisel, across on the flat side, thus joining on to the second section of the fret.

You may find that your strokes are not exactly horizontal or vertical. Don't be too hard on yourself; from a distance, the overall effect will be equally impressive.

FINISHING

1　Paint a Rich Gold border lined in Norwegian Orange. For this project a ½in flat brush was used following the indentation of the door panels. Allow to dry.

2　Erase tracing lines. Apply two coats of varnish, sanding lightly between each coat once dry.

KEY

1	*Green Oxide*	*3*	*Norwegian Orange*
2	*Warm White*	*4*	*Rich Gold*

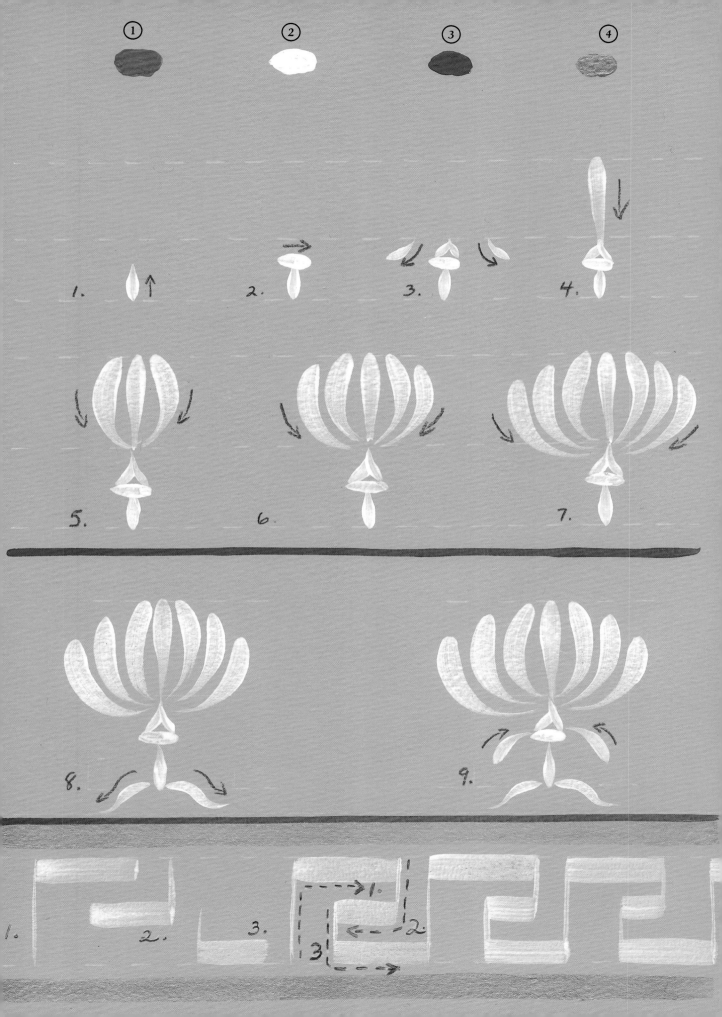

① ② ③ ④

1. 2. 3. 4.

5. 6. 7.

8. 9.

1. 2. 3.

FESTOONS, HUSK DROPS AND BOWS

In classical Greek times, 2,500 years ago, leafy garlands, swags, and festoons were popular decorative devices. For centuries they lay dormant and were finally revived in the neo-classical period of the eighteenth century.
Today the unobtrusive motif of the husk or open seed pod is widely used in drop or swag form to create a formal decorative effect. If this appeals to you, it is very easy to reproduce and, by using different tones of the same colour, can be made very chic as well.

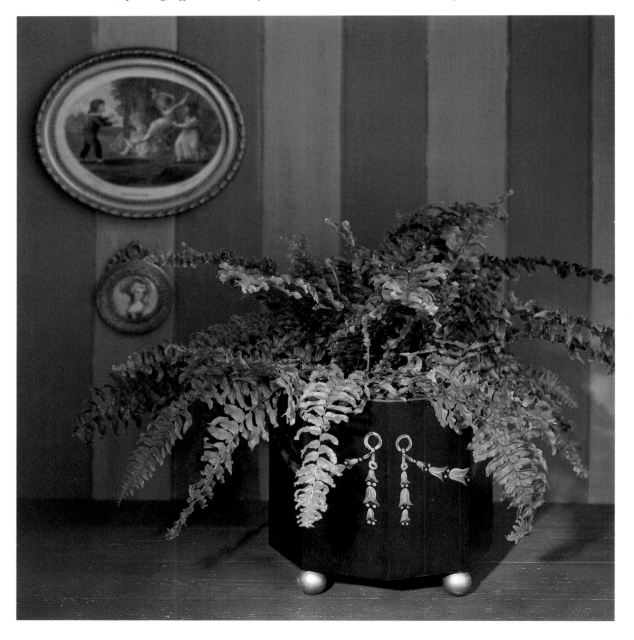

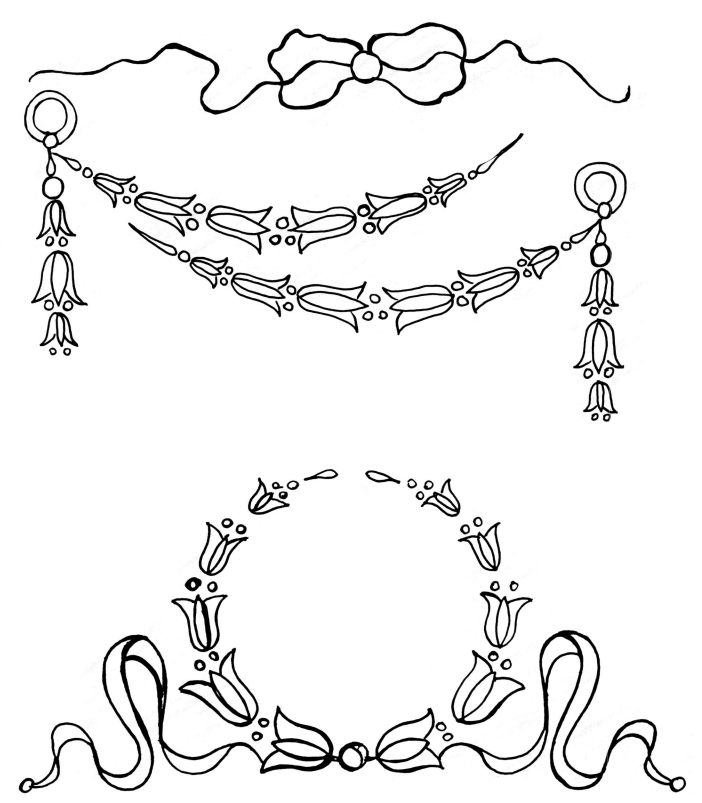

The lower pattern is an alternative to the one used.

MATERIALS

- An octagonal plant holder is used here, but any suitable object could be utilized.

BASE COAT
- All-purpose sealer and Pthalo Blue (Jo Sonja's colour or similar substitute).

FINISH
- Water-based varnish.

PALETTE
- Jo Sonja's colours or similar substitutes: Pale Gold, Rich Gold.

BRUSHES
- No. 4 round and ¼in (6mm) flat.

OTHER SUPPLIES
- Tracing paper, graphite paper, fine grade sandpaper, soft lead pencil, chalk pencil.

INSTRUCTIONS

BACKGROUND PREPARATION
Base coat with all-purpose sealer and Pthalo Blue mixed in the proportions 1:1. Allow to dry. Sand, then apply the pattern (page 72).

SWAG MOTIF
1 Load a No. 4 round brush with Pale Gold and paint all the left and right comma strokes making up the individual bell shapes.
2 Load the same brush with Rich Gold and paint in the central teardrops. These strokes are placed over the two flared comma strokes.
3 Paint in two dots as shown with Rich Gold.

JOINING CLASPS
1 Load a No. 4 round brush with Pale Gold and paint two commas to form a circle.
2 Just below the circle paint a teardrop of the same colour.
3 Load the same brush with Rich Gold and place a dot where the two commas meet.

4 With the same colour paint two small commas below the teardrop.

BOW
1 Load a ¼in flat brush with Rich Gold and paint one side of the bow.
2 Reload and paint the other side of the bow.
3 Reload and paint the ribbon flowing to one side.
4 Reload and paint the other ribbon.
5 With the same brush, paint a crescent stroke to represent a knot.
6 Load a No. 4 round brush with Pale Gold and paint two commas just below the knot.
7 Now add a dot in Rich Gold. The swag motif begins at this point.

FINISHING
Once the paint is dry, erase tracing lines. Apply two or three coats of water-based varnish, sanding between each coat, once dry.

KEY
1 Pale Gold
2 Pthalo Blue
3 Rich Gold

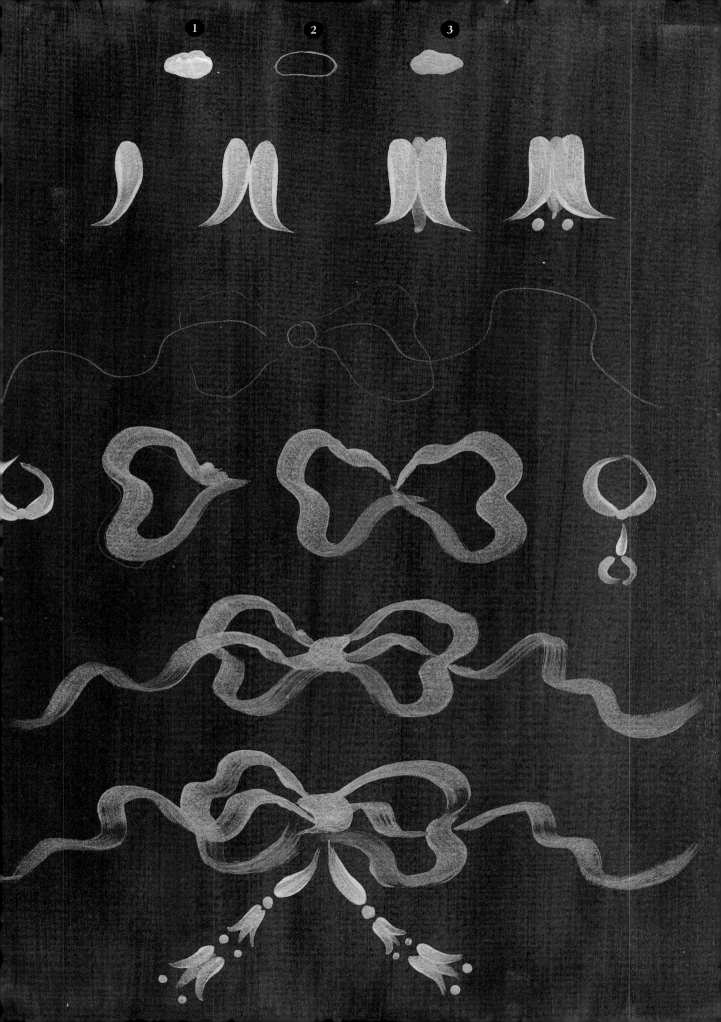

TRAY IN CLASSIC SEPIA TONES

Inspiration for designs can come from the most unusual places. This piece has been adapted from a Pilkington Glass catalogue dated 1899. No doubt it too was an adaptation from some other, possibly earlier, source. Such is the ebb and flow of design moving from age to age to decorate a variety of surfaces whether wooden, glass, plaster, ceramics, metal, or even cement. On this wooden tray, the use of a limited palette in sepia tones creates a pleasing period effect. The flowers are painted using the 'tipping' technique (page 22).

MATERIALS

• Oval wooden tray or any other suitable surface.

BASE COAT
• Warm White (Jo Sonja's colour or similar substitute).

FINISH
• Water-based varnish.

PALETTE
• Jo Sonja's colours or similar substitutes:

Provincial Beige, Raw Umber, Smoked Pearl, Warm White.

BRUSHES
• ¼in (6mm) flat, No. 3 round, No. 4 round, liner.

OTHER SUPPLIES
• Tracing paper, white graphite paper, chalk pencil, palette knife, all-purpose sealer, paper towel, brown paper bag.

INSTRUCTIONS

BACKGROUND PREPARATION

Sand and seal the wood as in the general instructions (pages 62–3). When dry, re-sand lightly with a brown paper bag. Base coat with two coats of Warm White. When dry trace the design and transfer the outline of the pattern using a chalk pencil or coloured graphite paper (page 72). There is no need to trace small details.

PROCEDURE

Mix the following colours with a palette knife in the proportions given:
Provincial Beige and Raw Umber 1:1 (Walnut Grey). Smoked Pearl and Provincial Beige 5:1 (Oyster Grey). Smoked Pearl, Provincial Beige and Raw Umber 5:1:1 (Pewter Grey).

SCROLLS

1 Thin the Oyster Grey mix with just enough water to paint one scroll with a single load.
2 Paint in the longest scroll moving from left to right using a liner. Add the circular tail.
3 Using a No. 3 round brush, add the scroll extensions/leaves and the floral stems.

SMALL FLOWERS

1 Load a No. 4 round brush with Pewter Grey and tip with Walnut Grey.
2 Then make five comma-stroke petals. Paint the centre petal first followed by the inside pair then the outside pair.
3 When flowers are dry, make inner comma strokes with Smoked Pearl, slightly smaller than above. With the wooden end of the brush, add Walnut Grey dots in the centre of each flower.

ROD AND FINIAL

1 Base the tulip-shaped finials and pointed finials in Pewter Grey with a No. 4 round.
2 When dry, add three comma strokes to the pointed finial using Smoked Pearl with the liner.

3 On the tulip finial, over-stroke the base coat with a Smoked Pearl edge again using the liner.
4 To paint the rod, sideload a ¼in brush with Pewter Grey. Begin at one end and make a series of 'S' strokes along each section of the rod.
5 Using a liner, outline the outside of each rod and the 'S' strokes in Pewter Grey.

CENTRE ORNAMENT

Base circle in Pewter Grey using a ¼in flat brush. Add the radial lines in Smoked Pearl using the liner; paint the vertical lines first, then the horizontal ones, then the angled ones at even intervals. Add the Raw Umber dots with the wooden end of the brush.

LARGE FLOWERS

1–2 Using a No. 4 round brush load Walnut Grey and wipe off the excess. Then tip brush with Oyster Grey and paint the centre teardrop followed by the two surrounding commas.
3 Load brush with Walnut Grey and wipe off excess. Then tip brush with Oyster Grey and paint the next pair of commas. Dip brush in Walnut Grey and paint outside pair of commas.
4 Dip brush in Oyster Grey and paint underside commas. Then dip the wooden end of the brush in Walnut Grey and add dots in descending order of size as shown.

OTHER DETAILS

1 Add Provincial Beige comma decorations at each end of tulip finials using the liner.
2 Similarly, add the oval shapes towards the centre. Edge the rim of the tray with Walnut Grey.

FINISHING

When work is completely dry, erase tracing lines. Apply three or four coats of varnish, sanding lightly between coats once dry.

KEY		
1 Warm White	*2 Smoked Pearl*	*4 Raw Umber*
	3 Provincial Beige	

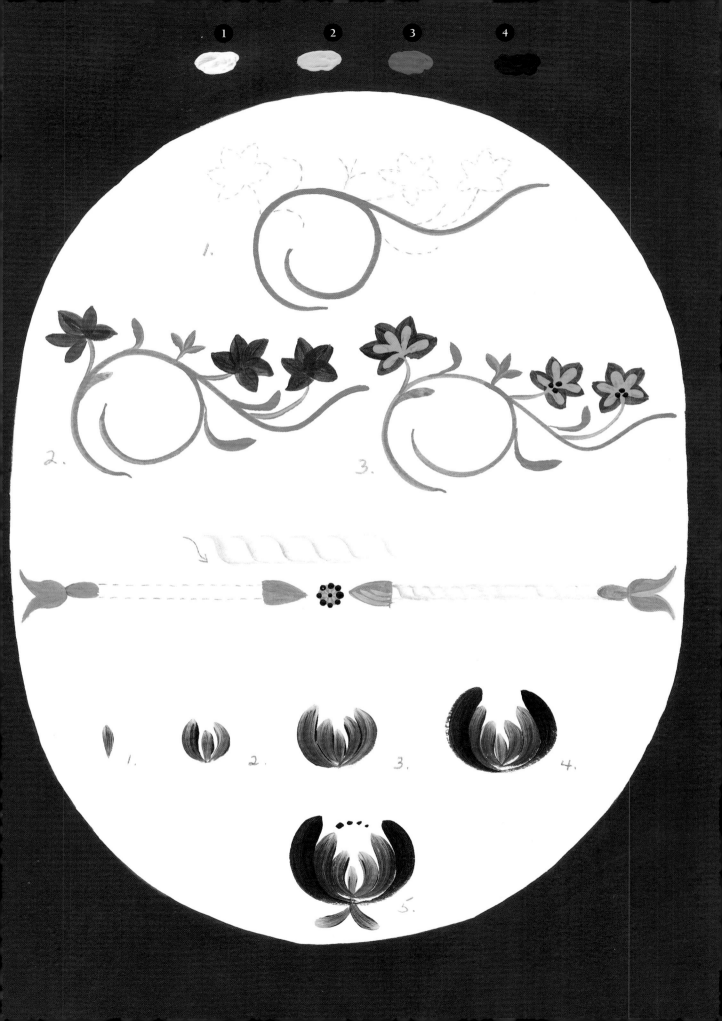

FRUIT AND FLORAL ADAPTATIONS

● Decorative art history has a great deal to offer in terms of fruit and floral compositions. Over the years stylization gradually gave way to realism. In eighteenth-century England and Wales, the charming Chippendale style first appeared. This was a very realistic approach based on highlights and shadows as well as working from transparent to opaque colours and finally floating transparent colour on top.

This fine-art technique, borrowed from the Old Masters, gives a three-dimensional, almost photographic effect much favoured by today's folk artists. The projects in this section illustrate these more advanced techniques which will be well within your capabilities if you have followed the exercises in chapter 5.

FRUIT-IN-A-BASKET CLOCK

Fruit is always a delightful subject to paint. Here we have designed a composition for a clock face appropriate for the kitchen or dining room. The stroke work is straightforward yet challenging, for it utilizes floated brushwork on the fruit to create a luminous effect. The peaches are softened by a stippling method. Finally, the clock face is finished with a crackle effect (see page 71) thus providing an interesting textural contrast.

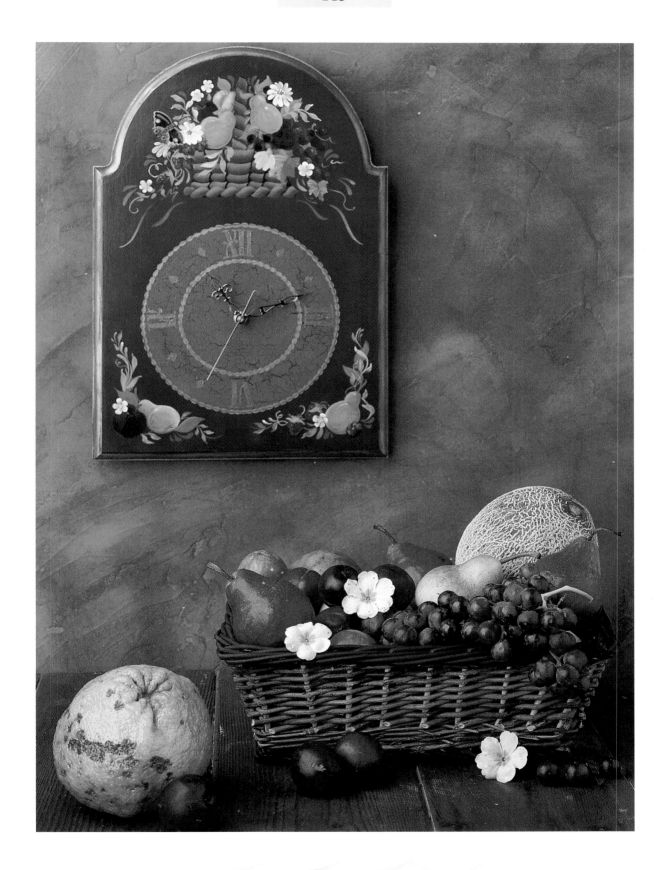

MATERIALS

• Wooden clock cutout, clock mechanism, and hands.

BASE COAT

• All-purpose sealer, Teal Green, and Raw Sienna (Jo Sonja's colours or similar substitutes).

FINISH

• Water-based varnish, Rich Gold (Jo Sonja's colour or similar substitute).

PALETTE

• Jo Sonja's colours or similar substitutes: Burnt Umber, Burnt Sienna, Red Earth, Yellow Oxide, Payne's Grey, Burgundy, Napthol Red Light, Cadmium Scarlet, Dioxazine Purple, Warm White, Green Oxide, Pine Green, Jade Green, Sapphire, Yellow Light, Iridescent Bronze, Rich Gold.

BRUSHES

• ½in (12mm) flat, ¼in (6mm) flat, ⅛in (3mm) flat, No. 3 round, No. 4 round, liner, stippling brush or an old, worn brush, pencil with an eraser top for berry painting, large brush for base coating.

OTHER SUPPLIES

• Tracing paper, adhesive tape (e.g. Sellotape/ Scotch Magic tape), fine grade sandpaper, graphite paper, soft rag, compass and chalk pencil, sealer, Duncan's Quick Crackle Medium or similar substitute.

INSTRUCTIONS

BACKGROUND PREPARATION

1 Mix Teal Green and Raw Sienna in the proportions 1:2.

2 Combine this with all-purpose sealer 1:1.

3 Using a large brush or sponge brush, apply two coats. Sand the first coat once dry before applying the second.

4 Enlarge or reduce patterns to fit the clock shape (page 75). Centre the main pattern on top of the clock and the smaller patterns into the bottom corners.

5 Using a compass, draw a circle around the centre hole making sure all the patterns are clear of the line.

Order of painting: 1 Basket; 2 Peaches; 3 Apples; 4 Pears; 5 Blackberries; 6 Strawberries; 7 Cherries; 8 Blueberries; 9 Daisies; 10 Small flowers; 11 Leaves; 12 Butterfly.

BASKET

The basket weave is painted over a Burnt Umber base coat. Using a flat brush sideloaded with Red Earth and Yellow Oxide, paint 'S' strokes down the handle and onto the basket base. Shallow crescents make up the woven effect. (Refer to page 59 in chapter 5 for a demonstration.)

PEACH (See page 55)

1 Base in Yellow Oxide.
2 Sideload ¼in flat brush with Cadmium Scarlet and paint shadows.
3 Mix a tiny amount of Warm White with a touch of Yellow Oxide. Using a stippling brush, pick up some of the mix and brush it over the surface of the peach to create a light powdered effect.

APPLES (See page 55)

1 Load a No. 4 round brush with Napthol Red Light and Burgundy 1:1; make two commas.
2 Sideload ¼in flat brush with above red mix and Green Oxide 1:1. Using floating technique (page 21) shade side of apple.
3 Highlight the other side of the apple in the same way using Warm White mixed with a touch of Yellow Oxide.
4 With a liner brush, add a tiny highlight in Warm White.

PEARS (See page 55)

1 Using any suitable brush, base in the pears with Yellow Oxide.
2 Using floating technique shade one side of pear with Green Oxide and Burnt Sienna 1:1, then highlight the other side with Yellow Light.

BLACKBERRIES (See page 54)

1 Using any suitable brush, base in the berries with Dioxazine Purple mixed with a touch of Burgundy.
2 Dip round pencil eraser into mixture and press on each berry segment.
3 Using your finger or a cotton bud, rub a tiny amount of Warm White onto a few segments as indicated to create highlights.

STRAWBERRIES (See page 54)

1 Base in berries with Napthol Red Light using any suitable brush.
2 Using ½in flat brush, sideload with Burgundy and Napthol Red Light 1:1 and shade each berry.
3 With the same brush, sideload with Cadmium Scarlet and highlight each berry.
4 Sideload the tip of a round brush with Green Oxide on one side and Yellow Oxide on the other and paint on the seeds.

CHERRIES (See page 54)

1 Base in cherries with Burgundy and Napthol Red Light.
2 Mix Burgundy with a touch of Dioxazine Purple. Sideload a ¼in flat brush and shade on one side of each cherry.
3 Mix Burgundy with a touch of Warm White, and highlight the other side of each cherry.

4 Load a liner with Burnt Umber and add cherry stems.

BLUEBERRIES (See page 54)

Base in the berries with Burgundy mixed with Dioxazine Purple 1:1. Shade using flat brush float loaded with Dioxazine Purple and Burgundy 2:1. Finish with white accents.

DAISIES AND SMALL FLOWERS (See page 32)

1 Use a No. 4 round brush to paint comma-stroke daisy petals. Vary the colour of the petals by adding a touch more Yellow Oxide as required.
2 Load ⅛in flat brush with Warm White and paint small crescent-stroke petals.
3 Finish flower centres with the tip of a round brush tipped first with Green Oxide, then with Yellow Light.

LEAVES

Large leaves are painted as instructed on page 37 in chapter 5. The colours used are Green Oxide for the base, with a sideload of Yellow Oxide. The small leaves are dab leaves, using a mix of Green Oxide, Pine Green, and Yellow Light 1:1:1. The long leaves are a mix of Jade Green and Green Oxide 1:1.

BUTTERFLY

1 Load Payne's Grey on a round brush and base paint main wings.
2 Paint the lower wings with a mix of Dioxazine Purple and a touch of Payne's Grey.
3 With a liner add a line of Yellow Light mixed with a touch of Warm White around the top wing.

4 Paint the body and head with Yellow Oxide using a No. 3 round brush.
5 Using a liner, paint the antennae and body decoration with Burnt Sienna.
6 Add a little colourful decoration using Sapphire with a touch of the Yellow Light/Warm White mix (No. 3 round brush for thicker strokes; liner for thinner strokes).

CLOCK FACE

1 Draw a circle on the clock using a compass fitted with a chalk pencil.
2 With the base-coating brush paint inside of circle with crackle medium, following the instructions on the pack.
3 When touch dry, sponge on a top coat using a mix of Jade Green and Green Oxide 1:1. Work quickly to cover the crackle, keeping the edges clean.
4 Decorate the perimeter of the circle with a series of overlapping Rich Gold comma strokes using a No. 3 round brush.
5 Paint numerals or numbers on the face using a liner brush loaded with Rich Gold and Iridescent Bronze mixed 1:1.

FINISHING

1 Rub Rich Gold around the bevelled edge of the clock face, allowing some of the base paint to show through; use a soft rag.
2 Complete by adding two light coats of varnish.
3 Attach the clock hands. If you find the hands too 'brassy', paint-seal them using all-purpose sealer and paint with a colour of your choice.

KEY		
1 Rich Gold	7 Yellow Oxide	14 Green Oxide
2 Teal Green	8 Payne's Grey	15 Pine Green
3 Raw Sienna	9 Burgundy	16 Sapphire
4 Burnt Umber	10 Napthol Red Light	17 Yellow Light
5 Burnt Sienna	11 Cadmium Scarlet	18 Jade Green
6 Red Earth	12 Dioxazine Purple	19 Iridescent Bronze
	13 Warm White	

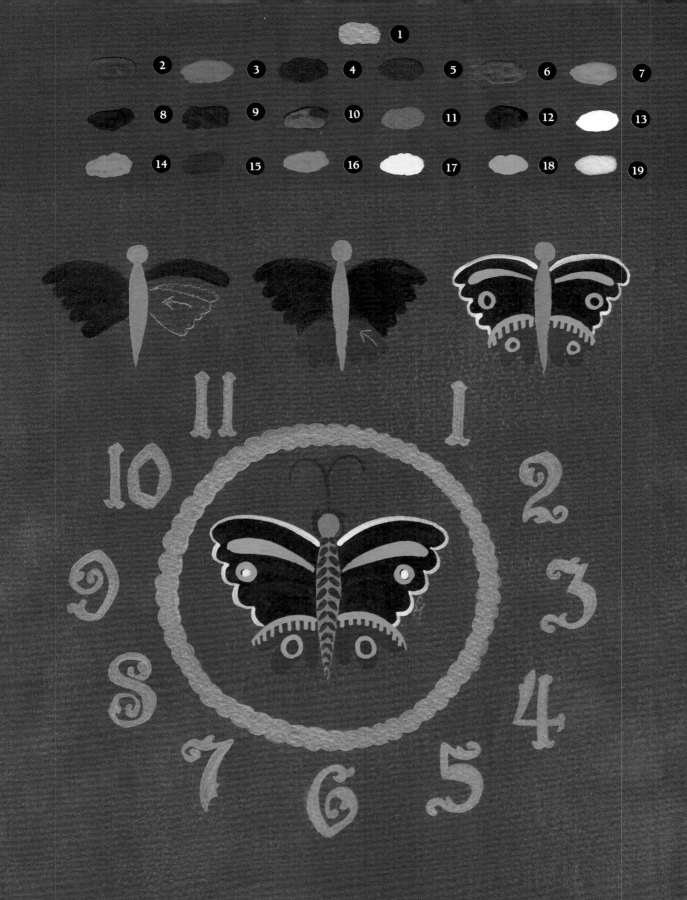

WOOD-TONE FRUIT BLOSSOMS

*Natural wood has been popular since Victorian times when it superseded the fashion for
painted furniture prevalent throughout much of the eighteenth and nineteenth centuries.
More recently, natural pine has been in vogue, its honey-coloured glow and natural grain
typifying the currently popular 'homespun' look. Many people still cannot bear to cover it up
with paint.
This project demonstrates the charming effect of staying close to basics, plain and painted
styles combining beautifully in a mixture of bare wood and subtle tones.
Oils rather than water-based paints have been used to capture the delicately blended tones of
these fanciful flowers. The project can be adapted for acrylics using floats of similar colour
to shade and highlight (page 21).*

MATERIALS

• Wooden memo-pad holder or similar item.
FINISH
• Oil-based varnish.
PALETTE
• Winsor & Newton oils or similar substitutes:
Burnt Umber, Raw Sienna, Titanium White,
Yellow Ochre.

BRUSHES
• ¼in (6mm) chisel blender, ⅛in (3mm) flat,
¼in (6mm) flat sable, liner, mop brush.
OTHER SUPPLIES
• Tracing paper, palette board or paper palette
suitable for oil paint, white graphite paper or
chalk pencil, turpentine or white spirit, oil
paint medium (matt), sealer, oil-based
varnish, fine grade sandpaper.

INSTRUCTIONS

Squeeze a small amount of paint from each tube onto the palette. You will be using paint straight from the tube and not adding thinner or medium directly to the paint. The medium will be on your brush as you dip into the paint. This makes blending easier and also speeds up the drying of the oil paint. After the application of each colour, dip your brush into Yellow Ochre to neutralize it, brushing it back and forth on the palette. Then wipe it on paper towel to remove the excess. Avoid washing it in turpentine or white spirit until you have completely finished the painting. The delicate look is achieved by using very little paint on the brush. Keep this in mind as you proceed through the instructions.

BACKGROUND PREPARATION
Prepare the bare wood as instructed on page 62. Transfer the pattern (page 72).

LARGE FLOWERS
1 Take the ¼in sable brush and dip it into the painting medium. Blot any excess.
2 Sideload with Raw Sienna and dab it onto the base of each petal. This may look messy!
3 Neutralize and dip in medium (see above).

Fig 1

} White

} Yellow Ochre

} Raw Sienna

Then double load with Titanium White and Yellow Ochre, blending evenly on the palette.

4 With white towards the outside edge of the petal, paint around the edge of each. Don't worry about gaps in the paint as they will be blended in the next step. You should neutralize, dip, and reload before painting each petal.

5 Now blend the original application of Raw Sienna with Yellow Ochre. Use short choppy strokes as you blend the two colours together. If the white edge should disappear, sideload with more white paint, blending it into the Yellow Ochre. A mop brush may make the final blending easier. Use it dry, dusting over the completed petal. Add more highlight or shade to bring forward or set back individual petals.

6 Load an old worn brush sparingly with Burnt Umber. Dab lightly up and down in the centre for a soft look.

PETAL CURL
1 Decide which petal to curl, then sideload the ¼in flat brush with Raw Sienna mixed with a touch of Burnt Umber.

2 Paint in this shade colour by painting across the petal with one edge of the brush abutting the centre. Dip the brush as you sweep it across the petal to create the curled look.

3 Blend lightly if necessary. Add a white highlight to the new edge of the petal with a side loaded flat.

STAMENS AND POLLEN
1 Thin some Burnt Umber with turpentine or white spirit to a creamy consistency.

2 Using a liner brush, add the stamens by pulling out from the centre.

3 Thin some Titanium White as above. With a toothpick or stylus, scatter dots over the flower.

LARGE LEAVES
1 Dip ¼in flat brush into a small amount of medium, blotting the excess. Sideload with Raw Sienna, blending well on your palette.

2 With the brush on the chisel edge, place on the surface wiggling it back and forth as it pivots a quarter turn while working from the base of the leaf to the tip. Repeat for the other side.

Fig 2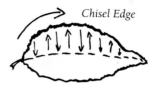

Chisel Edge

3 Decorate the leaves with teardrop strokes painted with thinned Burnt Umber using a liner brush. Pull the stroke from the base of the leaf and then just lightly sit the side of the brush down on the surface to make a tiny knobble.

SMALL LEAVES
1 Using a ⅛in flat brush or smaller, load with Raw Sienna. Paint a series of 'S' strokes.

2 Using a liner, add the stems with a mix of Raw Sienna and Burnt Umber 1:1.

SMALL FLOWERS
1 Using a very small round or flat brush, pick up Titanium White, Yellow Ochre, and Raw Sienna and paint a five-petalled flower (page 73). Vary the order in which the paint is picked up to get a slightly different effect on each petal.

2 Add a dot of Burnt Umber for the centre.

FINISHING
1 With a liner brush, add teardrop strokes where necessary. Allow the paint to dry and cure for one month before varnishing.

2 Erase any tracing lines if necessary.

3 Apply two or more coats of varnish, sanding lightly between coats once dry.

KEY		2 Yellow Ochre	4 Burnt Umber
1 Titanium White		3 Raw Sienna	

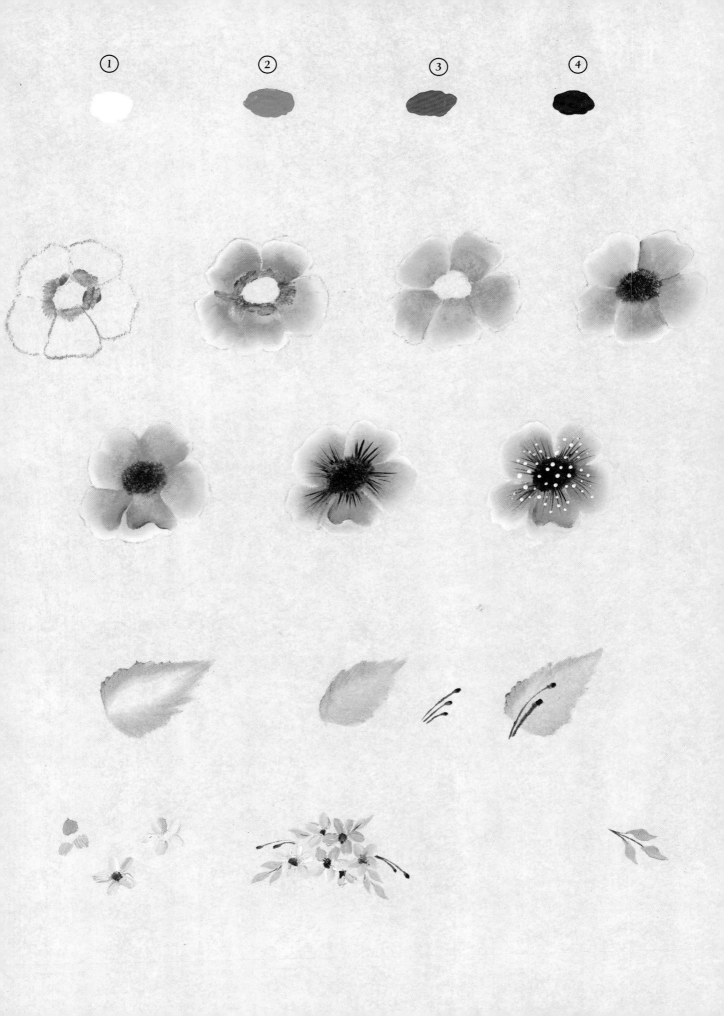

DAISIES-AND-ROSES DOOR PLATES

Elegant realism is the mood created on these door plates using the ever-popular theme of roses and daisies. The plate can be painted with the classic rose as well as the traditional wild rose and daisies. You will find instructions for the classic rose on page 35. These door plates make lovely, understated features when passing from room to room.
If you become hooked on this hobby, you may want to try different brands of paint to compare results in texture and colour. You will discover that the water-based brands can intermix with pleasing results, despite manufacturers' advice to the contrary! This project uses two brands very successfully. If you prefer to stick to Jo Sonja's brand, the substitutes are provided.

MATERIALS

• Wooden door plate(s).

BASE COAT

• All-purpose sealer and Carbon Black (Jo Sonja's colour or similar substitute).

FINISH

• Water-based varnish.

PALETTE

• Jo Sonja's colours or similar substitutes: Carbon Black, Nimbus Grey, Smoked Pearl, Storm Blue, Warm White, Yellow Oxide.

• Delta Ceramcoat Artists' Colours (Jo Sonja's equivalents in brackets):

Black Green (Pine Green and Carbon Black 1:1);

Bouquet (Plum Pink and Nimbus Grey 1:3);

Lavender Lace (Titanium White and French Blue 3:1);

Misty Mauve (Opal and Burnt Sienna 3:1);

Queen Anne's Lace (Warm White with a touch of Norwegian Orange);

Stonewedge (Smoked Pearl and Jade Green 2:1);

Spice Brown (Raw Sienna with a touch of Brown Earth).

BRUSHES

• ⅜in (9mm) flat shader, ⅛in (3mm) flat, ¼in (6mm) flat No. 5 round, liner.

OTHER SUPPLIES

• Tracing paper, white graphite paper, chalk pencil, stylus or toothpick, flow medium (optional), brown paper bag.

INSTRUCTIONS

BACKGROUND PREPARATION

1 Mix Carbon Black and all-purpose sealer 1:1.

2 Base coat the door plate excluding the trim area.

3 For trim, mix Nimbus Grey, Storm Blue, and Warm White in the proportions 1:2:6 (Blue Mix). Alternatively, use Delta's Lavender Lace mixed with sealer 1:1.

4 When dry, sand lightly with a brown paper bag.

5 Apply the main outline of the design (page 72). The details will be added later.

The design is painted from back to front beginning with the leaves which sit behind the flowers.

WILD ROSE

1 With a ¼in flat brush, base coat the whole flower with Misty Mauve. Apply two coats if necessary for even coverage.

2 Re-apply pattern if necessary.

3 Sideload ⅛in flat brush with a tiny amount of Bouquet, blending on the palette. Depending on size of petal, over-paint each with two or three crescent strokes as shown opposite.

4 Sideload ⅛in flat brush with Queen Anne's Lace. Blend on the palette and lightly highlight the edge of each petal.

5 For the centre, follow instructions 5–8 for daisies (page 153).

DAISIES

1 Load a No. 5 round brush with the Blue Mix used for the trim.

2 Undercoat each of the petals.

3 With the blue still in the brush, dip into Warm White. Paint comma strokes over each undercoated petal. Use two strokes for the larger petals.

4 Fill in the gaps with more petals using Warm White only.

5 Mix Yellow Oxide and Smoked Pearl 1:1 and paint the centre. Allow to dry.

6 Sideload a ¼in flat brush with Spice Brown and shade the lower edge of the centre.

7 With the same colour, sideload the brush and add a crescent stroke in the middle to create a depression.

8 Thin some Warm White and some Spice Brown with water or flow medium. Using a toothpick or stylus, add dots in each colour.

LEAVES

1 Double load ⅜in flat shader with Stonewedge and Black Green, and blend on the palette.

2 These leaves are painted by making two ruffle strokes. The action is to wiggle the brush in a push–pull motion. The brush is pivoted the last quarter-inch, ending at the leaf tip. Keep the lighter value to the top of the leaf.

HALF ROSE, CALYX, AND SEPALS

1 Base coat with Misty Mauve.

2 Shade on each side of the centre petal with a sideload of Bouquet using the ¼in flat brush. Highlight top edge of each petal with a sideload of Queen Anne's Lace.

3 Load a liner with Stonewedge. Paint the calyx.

4 Using a liner, pull out the sepals, finishing off the stroke with a wiggly motion.

5 With Stonewedge still in the brush, pick up Black Green and shade the calyx and sepals lightly. Add a highlight with Queen Anne's Lace.

DAISY BUDS

1 Undercoat petals with Blue Mix using the ⅛in flat brush. Then dip brush in white and over-paint each.

2 Load a liner with Stonewedge and paint sepals. Shade with Black Green.

ROSE BUDS

1 Double load a ¼in flat brush with Misty Mauve and Queen Anne's Lace. Blend on palette.

2 Paint two interlocking crescents as shown opposite. Add calyx in Stonewedge using a wiggly stroke. Add stems.

STEMS

Dip a liner into Stonewedge and Black Green; blend on the palette and stroke in the stems. You may need to thin paint with water or flow medium.

SMALL LEAVES

Using a ⅛in flat brush loaded with Stonewedge, paint 'S' stroke leaves.

FINISHING

1 Allow paint to dry and cure overnight. Erase all uncovered design lines before applying a water-based varnish.

2 Apply two or more coats of varnish, sanding lightly between each coat once dry.

KEY

1 Carbon Black	*6 Pine Green and Carbon Black 1:1*	*French Blue 3:1*	*11 Smoked Pearl and Jade Green 2:1*
2 Nimbus Grey	*7 Plum Pink and Nimbus Grey 1:3*	*9 Opal and Burnt Sienna 3:1*	*12 Raw Sienna with a touch of Brown Earth*
3 Smoked Pearl	*8 Titanium White and*	*10 Warm White with a touch of Norwegian Orange*	*13 Storm Blue*
4 Warm White			
5 Yellow Oxide			

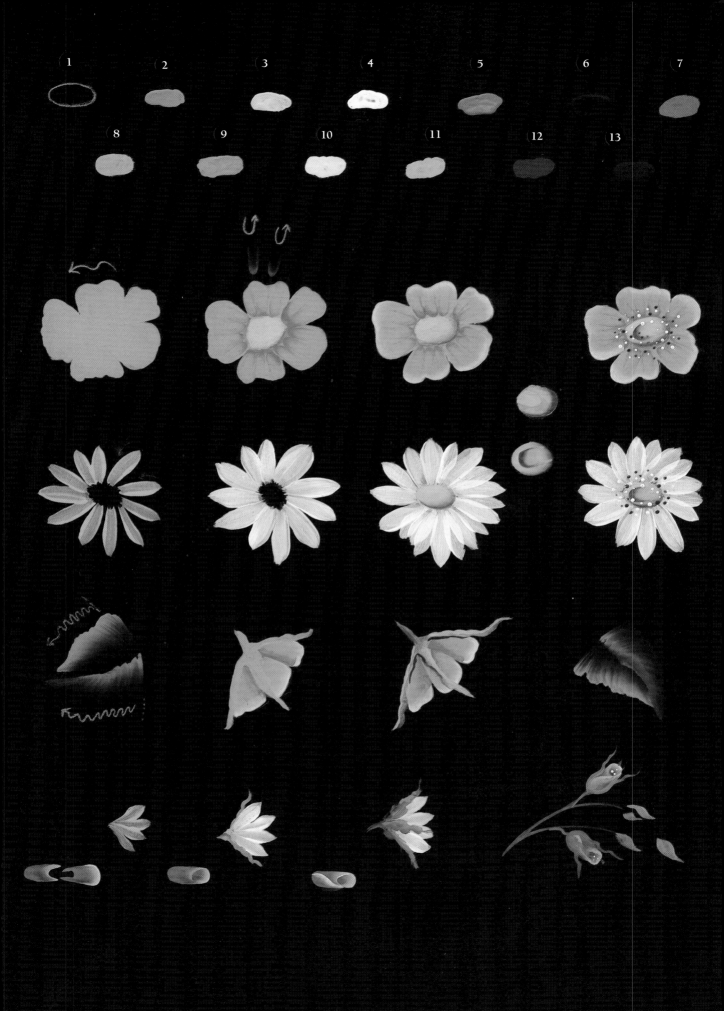

INNOVATIVE ADAPTATIONS OF THE FOLK ART TECHNIQUE

● To conclude the project section, we will break new ground with the techniques you have learned! Sources of inspiration are endless – books, magazines, architecture, nature, foreign lands, and many more. Study your source material and transcribe it into stroke work to create your own designs.

The Art Nouveau project, for example, is based on a 1903 design by Felix Aubert for a lace collar. The garden seat that follows it was inspired by a trip to Australia.

ART NOUVEAU TULIPS

The tulip has undergone numerous stylizations throughout its decorative history (see pages 84 and 92). The sinuous and slightly exaggerated but graceful lines of this design offer another variation expressed in the Art Nouveau style which was part of the general arts and crafts movement begun in England in the mid-nineteenth century. The movement began as an attempt to counter the negative effects of the Industrial Revolution on the skills and craftsmanship of the pre-industrial era of decorative art and furniture painting. This revivalist movement naturally borrowed from the available source material, but found new ways of expression both in terms of design and in the use of new materials and technology such as iridescence. Art Nouveau design was mainly a European expression of the times. It is highly individualistic as well as easily adapted to the folk-painting technique.
The table featured here is second hand. The top was very battered, and it was necessary to cut out a hardboard circle of the same size and glue it over the original surface.

MATERIALS

• • • • • • • • • •

• Round-topped table.

BASE COAT

• Carbon Black (Jo Sonja's colour or similar substitute) mixed in equal proportions with all-purpose sealer.

FINISH

• Water-based varnish.

PALETTE

• Jo Sonja's colours or similar substitutes:

Transparent Magenta, Iridescent Red, Iridescent Green, Payne's Grey, Rich Gold.

BRUSHES

• No. 4 round.

OTHER MATERIALS

• Tracing paper, white graphite paper, chalk pencil, fine grade sandpaper.

INSTRUCTIONS

• • • • • • • • • • •

BACKGROUND PREPARATION

Enlarge or reduce the pattern to suit the size of table top (page 75). Mix equal amounts Carbon Black and all-purpose sealer; apply and allow to dry. Then trace on the pattern (page 72).

TULIPS

1 Load a No. 4 round brush with Transparent Magenta. Begin painting the upright tulip petals: outside petals first, middle petal last. When these are completed, paint all the right-hand top petals, then all the left-hand top petals. Allow to dry.

2 Over-paint all the petals in the same order with Iridescent Red.

3 Mix a dark value (page 18) using Payne's Grey and Iridescent Green in the proportions 2:1

and paint the stems and inner leaves.

4 Mix Payne's Grey and Iridescent Green in equal amounts and paint the next pair of leaves.

5 Using Iridescent Green straight from the tube, paint the outer heart-shaped loop.

6 Mix a dark value of Payne's Grey and Iridescent Green 2:1 and paint the right-hand side of the figure-eight shapes. Then mix an even darker value of the same colours 3:1 and paint the left-hand side of the figure-eight shapes.

7 Load the brush with Rich Gold and paint a border round the edge of the pattern.

FINISHING

Erase tracing lines. Apply two or three coats of varnish. Sand lightly between each coat once dry.

KEY
1 Carbon Black
2 Transparent Magenta
3 Iridescent Red
4 Iridescent Green
5 Payne's Grey
6 Rich Gold

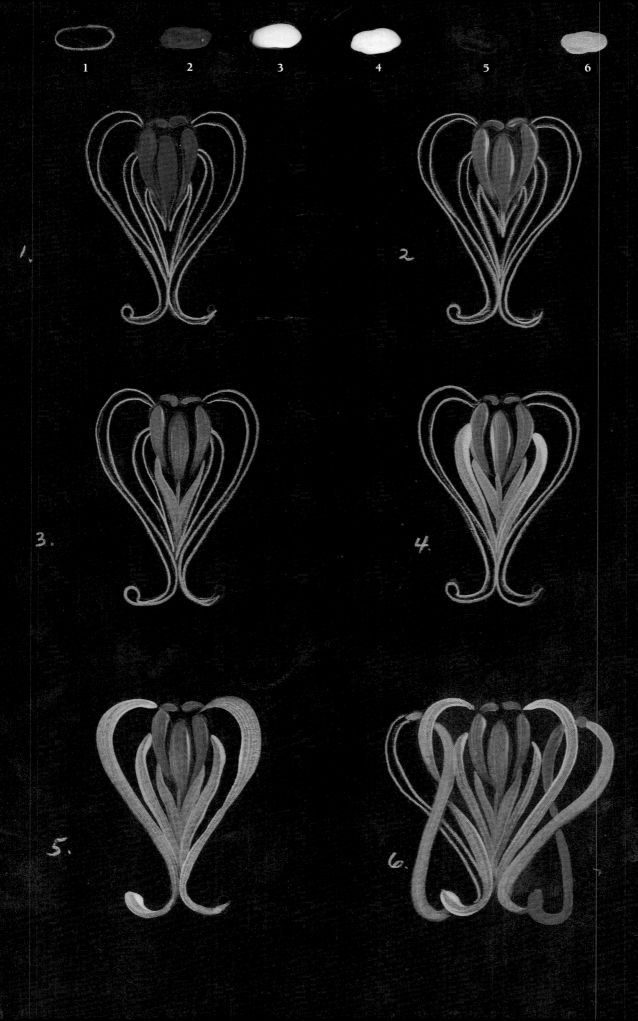

GARDEN SEAT IN ABORIGINAL AND SETTLER STYLE

As a reasonably qualified folk artist, you should now be ready to try your hand at making your own design, and then developing your own colour and painting schemes.

This is what I was prompted to do after visiting Australia where I was introduced to two dynamic folk art cultures: Aboriginal art and a developing form of European folk painting as practised by the 'settler' population. It was fascinating to learn that Aboriginal art, with its folk art origins, has also become part of the contemporary fine art movement owing to its depth of expression which extends beyond the pure 'method' approach of traditional folk art. 'Settler' folk art was also breaking new ground by developing a typically Australian floral language. This project sets out to create something uniting the two folk art traditions.

The design process can be a rather slow one, with many false starts. The main thing is just to let yourself brainstorm with your pencil. Remember, design is a very personal process: you are aiming to create something that pleases you. If someone else likes it too, so much the better.

The overall objective was to recreate the mood of my visual experience of Australia.

A garden bench was the perfect object since I spent most of the time outside. Also, its interesting shapes and variable planed surfaces allowed plenty of scope for imagination to run riot! The Aboriginal movement centred around Alice Springs in Northern Territory paint in 'dot' formation. It is so distinctive and exciting that I was compelled to follow suit. I also wanted to incorporate Sturt's Rose, because it is the floral emblem of Northern Territory. Painting this, I reverted to the stroke-work style of the 'settler'.

I made a paper sketch of the bench, photocopied it several times, and then began to doodle. I produced several rather uninspiring drawings using a variety of motifs before finally deciding on the plant-like motif as my dominant feature. I then translated my design into patterns of the right size to fit on to the object, The pattern of this motif is a poor replica of my original drawing, and I think the finished object suffers for it!

On the painted object you will notice that I haven't adhered faithfully to the layout on my paper design. This happens quite often: a layout may prove to be impractical or difficult to paint (as this was because I couldn't get my hand in the right position to paint the lines which have been omitted in the far corner of the seat). I also decided that repositioning the snakes would improve matters.

DESIGN DEVELOPMENT

1 *The circular motifs seemed too dominant and oversized. Three turtles struck me as being too many.*

2 *Two turtles seemed right, but overall the design looked boring.*

3 *A plant-like motif came to mind. This would also go well with Sturt's Rose. A good idea perhaps, but this rendition looked very ugly!*

4 Adding circular motifs to the slats was an improvement. The plant motif also started to gain form. Adding a few halo lines sparked something as well as positioning Sturt's Rose in the corner.

5 Drawing in the full halo looked pleasing. I could visualize the effect of sand, sea, and desert coming together. A colour scheme as well as a few more ideas like the snake and the floral motifs, fell into place.

6 I washed on some colours, liked what I saw, and set to work.

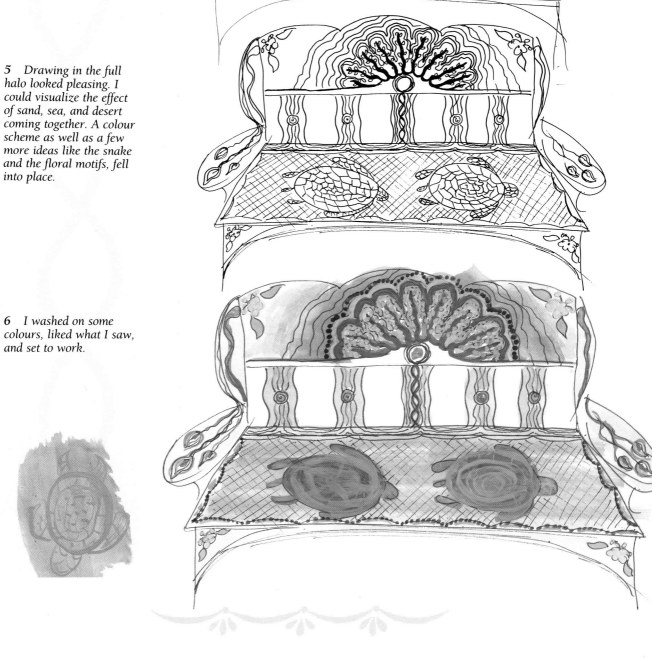

MATERIALS

• Garden seat.
BASE COAT
• All-purpose sealer, Pthalo Blue (Jo Sonja's colour or similar substitute).
FINISH
• Water-based varnish.
PALETTE
• Jo Sonja's colours or similar substitutes: Pthalo Blue, Warm White, Carbon Black, Raw Sienna, Turner's Yellow, Norwegian Orange, Dioxazine Purple, Burnt Sienna, Iridescent Orange, Burgundy, Green Oxide, Yellow Light.
BRUSHES
• Large brush for base coating, No. 4 round, ⅜in (9mm) flat, liner.
OTHER SUPPLIES
• Tracing paper, chalk pencil, graphite paper, masking tape, medium grained sandpaper.

INSTRUCTIONS

These are guidelines rather than step-by-step instructions. Try and improvise using the colour work for inspiration.

1 I traced or drew all the design elements onto the object.

2 Painting began with the plant-like motif. The long finger shapes were painted first with long white squiggly strokes. The motif was then outlined in black followed by the application of dots, using an eye-dropper (page 22) in Raw Sienna.

3 I then applied a Pthalo Blue wash over the whole seat. This pigment is particularly good for achieving a toned, washed-out effect. I applied the paint in paste form between the fingers of the plant-like motif on the back of the seat, but then as I moved outwards, I began to apply water to draw out the concentration in the pigment. You need not worry about being meticulous at this stage; and don't be discouraged if it looks messy – a seemingly haphazard application of washes, one over the other as each dries, will create a pleasing effect. In places, you will find that the wash does not seem to adhere properly owing to the greasy deposits left by your fingers when handling, but again don't worry – it blends in with the overall effect.

4 I wanted to create a light halo effect, so I washed in some Burnt Sienna.

5 Then the finer detail of painting round the fingers began. I wanted to create an eye-catching combination of complementary colours. Note the band of Pthalo Blue dots.

6 The slats were painted next, also using the Aboriginal dot technique.

7 I then added the border round the turtles.

8 The various turtle features were then outlined using orange and Turner's Yellow. Once the outlines were dry, a Burnt Sienna wash was applied over the top. This technique produces a more vibrant outline than painting lines over the base colour. I then applied some Iridescent Orange to highlight the turtle shell segments.

9 An unevenly coloured Pthalo Blue wash was then applied round the turtles. This created the effect of dark and light patches of water. A few squiggly lines made with Turner's Yellow were then added.

10 The dot technique was used for the snake.

11 Sturt's Desert Roses were produced by using the crescent-stroke technique and a flat brush as outlined in chapter 5. Pages 42–3 are particularly relevant.

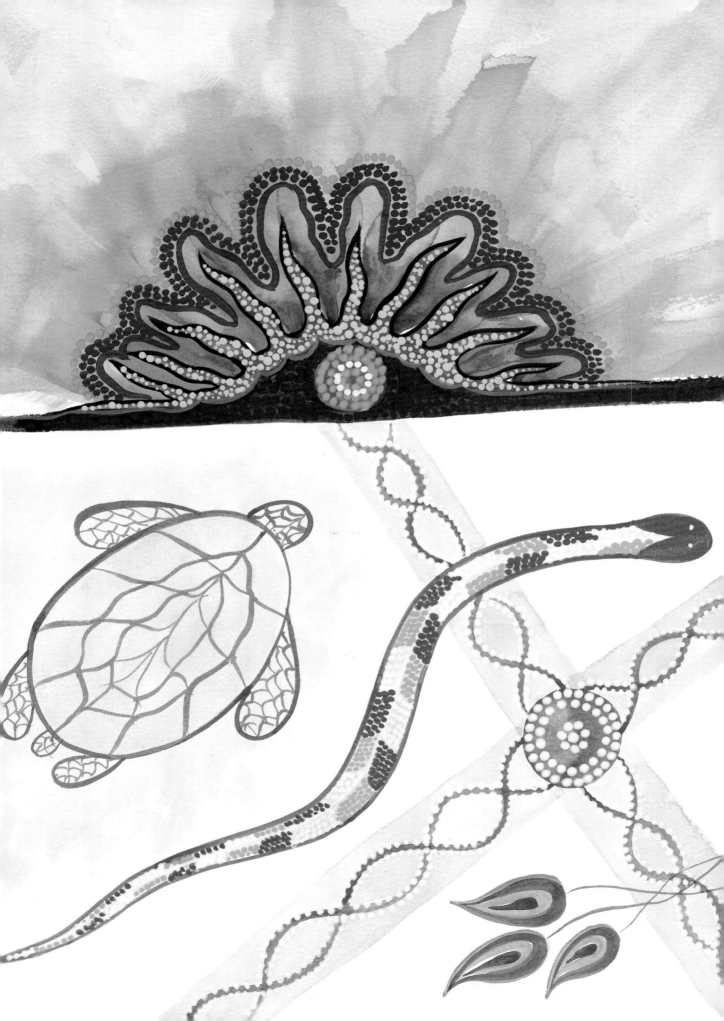

..... LIST OF SUPPLIERS

BRUSH DISTRIBUTORS

UK
Raphael Brushes
Cottage Folk Art
7 Church Street
Beaminster
Dorset DT8 3BA

USA
Loew Cornell Brushes
563 Chestnut Avenue
Teaneck
NJ 07666–2490

PAINT DISTRIBUTORS

(Water-based paints and
related products for the
decorative art market)

Chroma Colour products
UK
Chroma Colour
Cartoon House
16 Grange Mills
Weir Road
Balham
London SW12 0NE

Decoart products
UK
DecoArtistic
Studio House
Rotherwick
Basingstoke
Hampshire RG27 9BG

USA
DecoArt
PO Box 386
Stanford
KY 40484

Delta Ceramcoat products
UK
George Weil & Son Ltd
The Warehouse
Reading Circle Road
Redhill
Surrey RH1 1HG

Liquitex products
UK
Binney & Smith
(Europe) Ltd
Amphill Road
Bedford MK42 9RS

USA
Binney & Smith Inc
1100 Church Lane
PO Box 431
Easton
PA 18044–0431

CANADA
Binney & Smith
(Canada) Ltd
Toronto Sales &
Distribution Office
40 East Pearce Street
Richmond Hill
Ontario L4B 1B7

AUSTRALIA
Binney & Smith
(Australia) Ltd
599 Blackburn Road
Clayton North 3168

PO Box 684
Glen Waverly 3150
Victoria

Jo Sonja products
UK
Tomas Seth & Co
Holly House
Castle Hill
Hartley
Kent DA3 7BH

USA
Chroma Acrylics Inc
205 Bucky Drive
Lititz
PA 17543

AUSTRALIA & JAPAN
Chroma Acrylics (NSW)
Pty Ltd
PO Box 3B
Mt Kuring-Gai
NSW 2080

SUNDRY ITEMS

(Unfinished wooden
objects, tinware, ceramics,
brushes, paints, sealer,
medium, books and
publications.)

NB: In the USA, Canada
and Australia, decorative
art products are widely
available. Individual
suppliers for these
countries are therefore not
listed; in the event of
difficulty, please contact us
via the publisher.

UK
Afonwen Craft & Antique
Centre
Afonwen
Caerwys
Nr Mold
Clwyd CH7 5UB

Belinda Ballantine (mail
order)
The Abbey Brewery
Malmesbury
Wiltshire SN16 9AS

Sandy Barnes (mail order)
49 Corfe Way
Broadstone
Poole
Dorset BH18 9ND

Bradshaws
11 Park Street
Minehead
Somerset TA24 5NQ

Carmichael
Components Ltd
(Duncan Quick-Crackle)
26 Pield Heath Road
Uxbridge
Middlesex UB8 3NG

Cottage Folk Art
7 Church Street
Beaminster
Dorset DT8 3BT

The Decorative Arts Co.
Ltd (mail order)
5 Royal Crescent
London W11 4SN

Hudson Gool Heirloom
(mail order)
Pells Farm
Pells Lane
West Kingsdown
Kent TN15 6AU

Zoe Rogers (mail order)
47 Woodland Road
Kenilworth
Warwickshire CV8 2FT

Decoy Duck Supplies
UK
Pintail Decoy Supplies
20 Sheppenhall Grove
Aston Heath
Nantwich
Cheshire CW5 8DS

USA
Stoney Point Decoys Ltd
US Route 13
Oak Hall
VA 23416

OTHER USEFUL ADDRESSES

UK
The National Decorative
and Folk Art Painting
Society
The Studio
Parson's Lane
Bisley
Gloucestershire
GL6 7BB

USA
Artist's Journal
PO Box 9080
Eureka
CA 95501

This is a decorative art
journal published quarterly
by Jo Sonja Inc.

The Decorative Painter
PO Box 808 – Newton
KS 67114

This magazine is published
bi-monthly by the Society
of Decorative Painters.

Society of Decorative
Painters
PO Box 808 – Newton
KS 67114

........ BIBLIOGRAPHY........

Bridgewater, Alan and Gill, *Traditional and Folk Designs* (Search Press 1990)

Christie, Archibald, *Pattern Design – An Introduction to the Study of Formal Ornament* (Dover Publications 1969)

Clifton-Mogg, Caroline, *The Neo-Classical Sourcebook* (Cassell 1991)

Crump, Derek, *The Complete Guide to Wood Finishes* (HarperCollins 1992)

de Dampierre, Florence, *The Best of Painted Furniture* (Weidenfeld & Nicolson 1987)

Dresdner, Michael, *The Woodfinishing Book* (The Taunton Press 1992)

Graburn, Nelson H. H., *Ethnic and Tourist Arts – Cultural Expressions from the Fourth World* (University of California Press 1979)

Hardy, William, *A Guide to Art Nouveau Style* (Magna Books 1992)

Jones, Owen, *The Grammar of Ornament* (Studio Editions 1986)

Lichten, Frances, *Folk Art Motifs of Pennsylvania* (Dover Publications 1954)

Miller, Judith and Martin, *Period Finishes and Effects* (Mitchell Beazley 1992)

Parry, Linda, *William Morris and the Arts & Crafts Movement – A Source Book* (Portland House 1989)

Peesch, Reinhard, *The Ornament in European Folk Art* (Alpine Fine Arts Collection 1983)

Ridges, Bob, *The Decoy Duck from Folk Art to Fine Art* (Dragon's World 1988)

Ritz, Gisland, *The Art of Painted Furniture* (Von Nostrand Reinhold Company 1971)

INDEX

Numbers in *italic* indicate illustrations

Base coating, 62–5
 canvas, 65
 ceramics, 65
 one operation sealing
 and base coating, 66
 pottery, 65
 tin, 64–5
 wood, 63–4
Background effects, 66–71
 aged plaster, *67*, 70
 crackling, 70
 dragging, *69*, 70
 marble, *70*, 71
 rag rolling off, 68
 rag rolling on, 68
 spirit rub, *69*, 70
 sponging off, 68
 sponging on, 68
 stippling, *68*, 69
 wax resist, 70
Borders, 33, 75
Brush control, 20–7
 balance, 20
 how to hold, 20
 movement, 20
 pressure, 20
Brush loading methods, 4,
 20–2
 dotting, 22
 double loading, 22
 dry brushing, 22
 floating, 21
 full loading, 21
 side loading, 21
 tipping, 22
Brush stroke formation,
 23–61
 circle stroke, 26
 combining strokes,
 46–61
 comma stroke, 23, 30–3,
 36–7
 crescent stroke, 23, 25,
 42–3
 flat stroke, 44–5
 leaf stroke, 26, 44–5
 scrolls, 25, 27
 's' stroke, 24, 38–41

 teardrop, 27
Brushes, 10–12
 care of, 11–12
 cleaning, 12
 sable, 10
 starter kit, 11
 synthetic, 10

Colour, 14–19
 advancing, 18
 basic pigments, 14
 complementary, 15
 conversion chart, 19
 intensity of, 17
 intermediate, 15
 primary, 14
 secondary, 14
 temperature, 16
 tertiary, 15
 trials, 75
 value, 18

Correcting paint errors, 75

Design development,
 162–3

Effects, *see* Background
 effects; Finishing
 techniques

Faux effects/finishes, *see*
 Background effects
Finishing techniques, 76–7
 antiquing, 76
 fly-specking, 76
 shellacking, 77
 varnishing, 77
 waxing, 77
Folk art
 definition of, 6
 history of, 8–9

Glazing, 64

Motifs, 28–61
 animals, 48–50
 basic rose, 34
 baskets, 59
 berries, 54
 birds, 46

 borders, 33
 chrysanthemum, 31
 classic rose, 35
 daisy, 32
 formal ornament, 58,
 60–1
 fruit, 55
 insects, 51
 leaves, 37, 44–5
 people, 52–3
 tree of life, 47
 tulips, 36, 40–1
 vases, 59

Paint, 12
 acrylic, 12
 acrylic gouache, 12
 alkyd, 12
 compatibility of, 12, 79
 consistency of, 20–1
 oil, 12
Palette, 13
 ceramic, 13
 paint mixing surface, 13
 paper, 13
 plastic, 13
 wooden, 13
Pattern transfer tricks,
 72–5
 application, 72–3
 centre point
 identification, 74
 enlargements, 75
 reductions, 75
 repeat patterns, *74*, 110
 simplification, 73
Pickling, 64
Preparation of surfaces,
 62–5
 canvas, 65
 ceramics, 65
 new tin, 64
 old tin, 65
 painted wood, 63
 unglazed pottery, 65
 virgin wood, 62
 waxed or oiled wood, 63
Projects, 80–165
 Art Nouveau Tulips,
 156–9
 Bavarian Box, *88–91*

 Brides Boxes, c1778
 100–5
 Common Loon Decoy,
 106–9
 Daisies-and-Roses Door
 Plates, *152–5*
 Festoons, Husks, Drops
 and Bows, *135–7*
 Fruit & Floral
 Adaptations, *142–7*
 Garden Seat in
 Aboriginal and
 Settler Style, *160–5*
 Indian Chest, *110–13*
 Japanese Cherry
 Blossom Place Mat,
 114–17
 Mexican Marigolds,
 118–21
 Palmette, *131–3*
 Pot of Tulips, *84–7*
 Rogaland Rosemaling,
 96–9
 Russian Table, *122–5*
 Sewing Table with
 Romanian Design, *93–5*
 Tin Tub with Australian
 Floral Theme, *126–9*
 Tray in Classic Sepia
 Tones, *138–41*
 Tree of Life, *80–3*
 Wood Tone Fruit
 Blossoms, *148–51*

Rust removal, 65

Sealing, 62–3, 66–7
Staining, 64
Start up kit, 10–13
 brushes, 10–12
 paints, 12
 palette, 13
 palette knife, 13
Stripping, 63
Surface preparation, *see*
 preparation of surfaces
Symbolism, 8–9, 16

Temperature, 16
Value scales, 18, *see also*
 Colour